T0162942

Leonardo da Vinci

The Complete Works

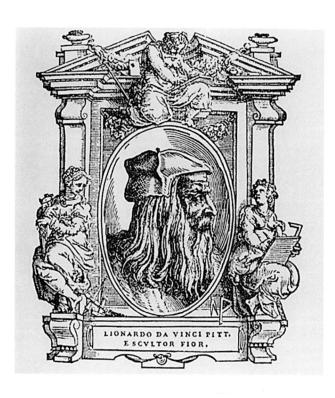

LIONARDO DA VINCI PITT.
E SCVLTOR FIOR.

Cristofano Coriolano, *Portrait of Leonardo da Vinci*, 1568,
by Giorgio Vasari, *The Lives of the Most Excellent Painters,
Sculptors and Architects*, part III, Giunti, Florence 1568.

SIMONA CREMANTE

Leonardo da Vinci

THE COMPLETE WORKS

co-ordination and introduction
by CARLO PEDRETTI

DAVID & CHARLES

www.davidandcharles.com

A DAVID AND CHARLES BOOK
Copyright © David and Charles, Ltd 2006

David and Charles is an imprint of David
and Charles, Ltd
Suite A, Tourism House, Pynes Hill,
Exeter, EX2 5WS

First published in the UK in 2006

Originally published in Italy in 2005
© Giunti Editore S.p.A., Florence-Milan
www. giunti.it

Copyright © 2005 Giunti Editore S.p.A.,
Florence-Milan
Introduction: © 2005 Carlo Pedretti

A catalogue record for this book is available
from the British Library.

ISBN-13: 9780715324530 hardback

Printed in China through Asia Pacific
Offset for David and Charles, Ltd
Suite A, Tourism House, Pynes Hill, Exeter,
EX2 5WS

20 19 18

Project design: Franco Bulletti
Editorial manager: Claudio Pescio
Editor: Augusta Tosone
Translation: Catherine Frost
Iconographic research: Aldo Cecconi and
 Cristina Reggioli
Pagination and Photolithograph: Fotolito
 Toscana, Florence

David and Charles publishes high-quality
books on a wide range of subjects. For more
information visit www.davidandcharles.com.

Contents

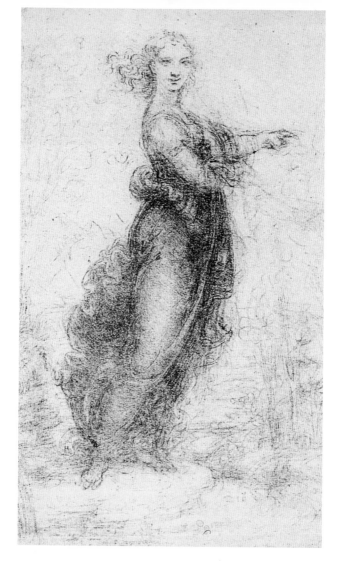

INTRODUCTION

The small monograph, of which this volume on Leonardo is an example, is a category of book that continues to play a role in the critical interpretation of an artist's work. It is addressed to the general reader who is looking for an introduction to the work of the great painters. In the 19th century the major European publishers were known for their editions of classic texts, introduced by the scholars of the day and illustrated by famous engravers such as Gustave Doré. But alongside these academic publications they also produced a large number of low-cost booklets that targeted a market they called 'the studious youth'. This euphemism was used to flatter and appeal to an increasingly educated and demanding public with limited means at their disposal but with an appetite for knowledge. Throughout Europe, society at that time was in a state of renewal while at the same time looking back to the great heroes of history and culture both nationally and internationally. This new readership's thirst for knowledge

*Woman standing near a stream
(A Pointing Lady),
c. 1518; Windsor Castle, Royal Library.*

guaranteed the success of this kind of mass-market publishing and fully justified the publishers' commitment to producing it.

This approach to publishing lasted for over a century and now, at the start of the third millennium, it has a new impetus, driven by mass communication and the globalization of cultures, to continue to produce easily accessible scholarly works for the wider public. With the advent of computerization and the Internet, today's bright young men and women can afford even the most expensive tools of research. This has presented something of a paradox. Academic specialization is not limited by the need for mass publication; instead this information can be made freely available to all. At the same time the rise in the numbers of visitors to museums and art galleries, many of who spend money in the bookshops and thus contribute to their profitability, confirms the need for well-produced books at an affordable price. Today's readers are owed more than summary information, trivial anecdotes or apocryphal stories. Unlike the past when a few wealthy aristocrats, with an educated background, planned their Grand Tour with care and discernment, today's tourists are guided by a well-informed mass media while at the same time they are looking for as profound

*Facing busts of old man
and adolescent boy,
c. 1490–5;*
Florence, Gabinetto dei Disegni
e delle Stampe degli Uffizi.

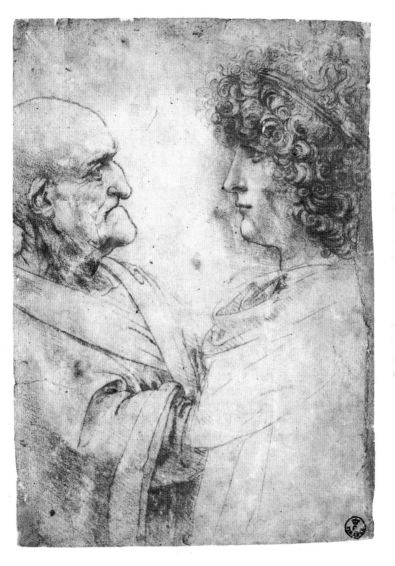

an intellectual and spiritual experience as that experienced by Shelley or Byron.

To fulfil this need, Simona Cremante's excellent monograph is a brilliant and thorough synthesis, which brings together everything the reader could wish to know about Leonardo from his few but sublime paintings, his marvellous drawings and extraordinary manuscripts. This is a book that even specialists can appreciate as a practical, reliable work of reference. But above all it is a book that demonstrates that brevity, like poetry, can be a virtue when a great deal is expressed in a few words. The high standards set by the text are maintained in the illustrations and the impeccable quality of the reproduction. The book answers the needs of a sophisticated public, increasingly demanding to be well informed and never to be underestimated. For those who have encountered Leonardo for the first time, perhaps through Dan Brown's world-wide bestseller The Da Vinci Code, it explores the temperament of the artist and the innermost recesses of his subconscious, even beyond the limits reached by Freud and whether it is possible that Leonardo really was the gran maestro of a secret society of heretical inclination.

The great interpreters of Leonardo's thought and feelings in the last 150 years have always avoided facing head on the problem of the relationship between Leonardo, his art and religion. It has been a disturbing, if not thorny problem since the time of Vasari, who, in the first edition of his Lives published in 1550, states:

'And many were his whims, that philosophising on natural things, attempting to understand the properties of herbs, and

constantly observing the motions of the sky, the course of the moon and the behaviour of the sun. For all of which, he formulated in his soul a concept so heretical, that it was far from any religion, reckoning himself to be more a philosopher than a Christian.'

In the second edition, published in 1568 in the midst of the Catholic reform movement, this last sentence was simply suppressed, although the final statement in the Life of Leonardo was retained as proof of a sort of conversion of the artist on his deathbed, when:

'recounting his misfortunes and the events involved in it, he showed how deeply he had offended God and the world of men, by not having worked in art as he should have,'

as if to say that Leonardo's art could not be considered sacred art.

This is, of course, the wrong conclusion. Only in recent times has quite different historical testimony emerged – that of Giovan Paolo Lomazzo of Milan, who in 1560 wrote a book modelled on Lucian's Dialogue of the Dead called the Libro dei sogni (Book of Dreams). The manuscript is in the British Museum but the work was only published in 1973. In it one of the personages evoked is Leonardo who is engaged in a dialogue with Phydias. It should not surprise us that Lomazzo ascribes to Leonardo original ideas about his life and work, since he could have gathered first-hand information directly from Leonardo's still-living pupils. Lomazzo has Leonardo say:

'Thus I hope to say that in movements and drawing I was so perfect as regards the things of religion, that many people were moved to inspiration by the figures that I had drawn be-

fore they were then painted by my creati *(pupils).'*

He then specifies that:

'*among them were those of* The Last Supper *in the refectory of Santa Maria delle Grazie in Milan, which are so divinely varied, and of such grievous faces, according to the success of their term, that nothing more, I believe, can be conceded as a painter, and thus with many other figures that are now in France and diverse other places.*'

This extraordinary self-characterization of Leonardo, transmitted in Lomazzo's vivid style, finds confirmation in the writings of Leonardo himself. In fact, on a folio in the Windsor Collection containing the study for the head of one of the Apostles in The Last Supper, *the following words appear:*

'*When you make your figure consider well what it is and what you want it to do, and be sure that the work reflects the intention and the purpose.*'

This is a reminder to himself that is reiterated in almost the same words on a folio in the Codex Atlanticus *from that time:*

'*Painting. Ensure that the work resembles the intent and the purpose, that is, when you make your figure, consider well what it is and what you want it to do.*'

Study for the Apostle James the Greater in The Last Supper *and architectural sketches, c.* 1495; Windsor Castle, Royal Library.

·4·4·

Clearly, Leonardo was echoing here a famous piece of advice in Dante's Convivio, *which he transcribed in a manuscript dating from this time:*

'He who paints a figure, if he cannot be that figure he cannot paint it.'

And so the painter is like an actor who must identify himself with the personage to be interpreted. He must 'learn the part' in order to make himself 'perfect in the things of religion'. Only in this way will the character impersonated – in this case the painted figure – be able to attract the spectator, or even, as we would say today in the case of politicians, to magnetize a crowd.

This brings to mind the description by Vasari of the occasion when Leonardo's Saint Anne cartoon was exhibited in Florence in 1501:

'When it was finished, in the room where it was displayed men and women, young and old, flocked to see it as if they were going to a solemn festival, to gaze upon the marvels of Leonardo, which amazed the entire populace.'

For Leonardo – and again it is Lomazzo who has him say it – all this was derived from drawings, that is to say from the

Study for mechanical wing,
c. 1493–5;
Milan, *Codex Atlanticus,* f. 844r.

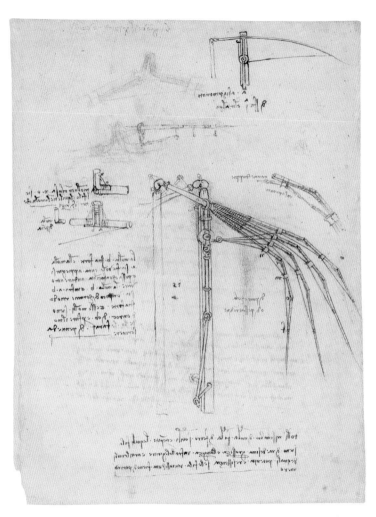

idea or concept, which could be transposed into painting by the pupils, the creati, who follow the creations of the master. This was exactly the principle that Raphael, 20 years later, was to follow in decorating the Vatican Stanze.

But there is still more. All of this has been confirmed by no less than the immense commentary of Alessandro Vellutello to Petrarch's Canzioniere published for the first time in 1535. Vellutello frequented the court of Pope Leo X at the time when Leonardo was there as the guest of Guiliano de' Medici, the Pope's brother, and when Raphael and his assistants were engaged in the task of decorating the Vatican Stanze according to the iconographic precepts of the humanists in residence. Vellutello's commentary on the sonnet that begins:

'In what part of the sky, in what idea,
Was the example; from which nature took,
that fine gracious face…'

'And in what idea, in connection with Plato's belief that the images of things were all created in the beginning by the Divine mind, since the Idea is that image of a thing which is formed before we undertake to do it, as for the figure, Leonardo Vinci wants to imagine the Virgin Mary, but before he sets his hand to his work, he has established in his mind what size and what actions and dress and what features he wishes to have…'

Observing the faces of Leonardo's Madonnas, who can still doubt that he has taken the idea expressly from Petrarch's Hymn to the Virgin? Who can still doubt that he had always present before him Dante's advice:

'He who paints a figure, if he cannot be that figure he cannot paint it'?

Leonardo the painter is thus capable of being both actor and director, and as the cinema teaches us, an actor or director who interprets a great religious personage or a great religious subject may not necessarily be religious himself. So there is also room for those who continue to maintain that Leonardo was not religious. Their argument is based on a testimony as persuasive as that of Vasari, the principle that is no less than a text by Leonardo himself. On a folio of anatomical studies at Windsor dating from 1510, Leonardo – then approaching the age of 60 – defines the human body as an admirable machine invented by Nature, which instils into it:

'the soul of which the body is the container, that is, the soul of the mother, who first composes in her womb the figure of the man and in due time wakens the soul of which it is the inhabitant, which before remained sleeping and protected by his mother's soul.'

(which he had already hinted at around 1493 – 'Avicenna contends that the soul gives birth to the soul, and the body to the body and every other member'). Leonardo concludes with a confession that has become famous:

'This discourse does not belong here, but concerns the composition of animated bodies. And the rest of the definition of the soul I will leave to the minds of the friars, fathers of the people, who by inspiration know all of the secrets.'

To which he immediately adds,

'Leave the crowned letters alone, because they are the highest truth.'

It may be thought, as it has been for the most part, that Leonardo here intended to scorn the theologians and their idea

of the soul, but his pronouncement in another text, also from 1510, on an anatomical folio also at Windsor, arouses serious doubts:

'And you, O man, who will discern in this work of mine the wonderful works of Nature, if you think it would be a criminal thing to destroy it, reflect how much more criminal is to take the life of a man; and if this, his external form, appears to thee, marvellously constructed, remember that it is nothing as compared with the soul that dwells in that structure; and truly, whatever it may be, it is a thing divine, so let it dwell in its work in peace, and do not let your rage or malice destroy such a life'

In this definition of the soul – 'whatever it may be, it is a thing divine' – and in the respect for 'such a life', lies all of the religion of Leonardo. And it is by no means little.

Carlo Pedretti

Study for the mould of the horse for the 'Equestrian Monument to Francesco Sforza', 1491; Madrid, Ms II, f. 157r.

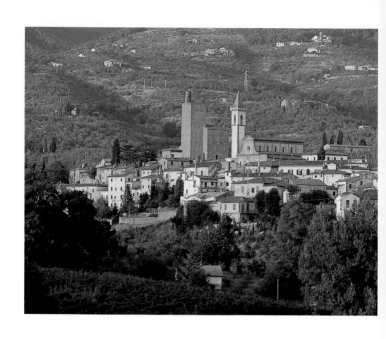

View of Vinci, near Florence,
the birthplace of Leonardo.

The artist's life

Vinci. Leonardo was born in 1452 in Vinci, a little town in the hills not far from Florence; the appellative 'da Vinci' was not merely an indication of his birthplace but was also his family's surname. The first document in which Leonardo is mentioned is a 'memorandum' written by his paternal grandfather Antonio da Vinci who, as was the custom of the time, meticulously recorded the date and hour of his grandson's birth on the last page of an old family book: '1452. A grandson was born to me, the son of my son Ser Piero, on the day of 15 April, a Saturday, at the third hour of the night. He was named Lionardo.' The mother's name was not mentioned. Leonardo was an illegitimate child, born out of wedlock, and was raised in the home of his paternal grandparents. Ser Piero, his father, followed the profession of notary in Florence, where members of the da Vinci family had been notaries for generations, since the time of Dante. In an official document, the child's grandfather Antonio reported to the Land Office the presence in his home of 'Leonardo son of the aforesaid Ser Piero, not legitimate, born of him and of Chaterina'. This was, then, the name of Leonardo's mother, whose identity is still mysterious today. She may have been a peasant woman, or perhaps a girl from an important family, now fallen in rank, as is suggested by the words of one of Leonardo's earliest biographers, 'He came of good blood on his mother's side.' Although he was not raised by his mother, Leonardo must have retained some

ties with her, however, because when he was 40 years old and living in Milan, he took her into his home ('Caterina came on 16 July 1493') and kept her with him for two years, until her death ('Expenses for burying Caterina', he was to note in his papers).

Florence. In 1468, at the age of 16, Leonardo left Vinci to join his father in Florence; by this time he must already have given proof of his talent for drawing. In fact, Giorgio Vasari records that, 'He [Ser Piero] took one day some of Leonardo's drawings and brought them to Andrea del Verrocchio, who was a good friend of his, and urged him to say whether Leonardo would profit by studying drawing. Andrea was amazed when he saw Leonardo's extraordinary beginnings ...' The young Leonardo thus became an apprentice in Verrocchio's workshop, one of the most flourishing of the day, which received important commissions even from the powerful Medici family.

Leonardo's training at this time consisted of acquiring a wide range of skills, not only in the field of painting and sculpture but also in the new technical and scientific

House of Leonardo
at Anchiano
near Vinci, Florence.

Seal of the town of Vinci
(14th century); Florence,
Museo Nazionale del Bargello.

conquests that were a vital factor in the flowering of the Florentine Renaissance. The Florence of Leonardo's youth was, in fact, pervaded by the concepts of Brunelleschi, who had established the principles of linear perspective and had raised the cupola over the Duomo without a supporting frame. The great copper sphere that was placed atop the marble lantern in 1472 to complete Brunelleschi's dome was fabricated in Verrocchio's workshop. In Rome, over 40 years later, the memory of this feat was still vivid in Leonardo's mind as he endeavoured to solve the problem of constructing burning mirrors. To assemble the parts, he reminded himself of the technique used in the workshop of his apprenticeship: 'Remember the welds that were used to join the ball over Santa Maria del Fiore.'

Training with Leonardo in Verrocchio's workshop were other young painters destined to become some of the greatest artists of the late 15th and early 16th centuries: Sandro Botticelli, Perugino, Lorenzo di Credi and Domenico Ghirlandaio (in whose workshop the young Michelangelo was later to serve his apprenticeship). The learning methods were based on drawing from models, copying from antique works of art, rendering the effects of light and shadow and studying drapery. Vasari remarks on how greatly Leonardo was interested from the start in 'painting from nature' and 'making models of clay figures'. At this time he was refining the tools at his disposal for practising observation of natural life and was beginning to formulate, as in 'some heads of women who are laughing', what he was later to describe as '*moti mentali*', or 'motions of the mind'.

By 1472 Leonardo was enrolled as painter in the register of the Compagnia di San Luca. This means that, at the age of 20, he was already qualified to accept independent commissions. Dating from 1473 is the drawing *Landscape of the Arno Valley*, as it appears from Montalbano in the vicinity of Vinci; this is his first known work. Still working in the workshop of Verrocchio, he collaborated with the latter on *The Baptism of Christ* (Florence, Galleria degli Uffizi). This episode gave rise to the anecdote related by Vasari, significant although without historic proof, that the master, upon seeing himself surpassed by his pupil, 'never again wanted to touch colours, indignant that a young boy understood them better than he did'. Among Leonardo's first independent works are *The Annunciation* (Florence, Galleria degli Uffizi), the *Portrait of Ginevra Benci* (Washington, National Gallery) and some Madonnas that have been identified as *The Madonna of the Carnation* (Munich, Alte Pinacoteche) and *The Benois Madonna* (St Petersburg, Hermitage), dating from a few years later. In 1476 Leonardo was involved in a trial for sodomy; he was acquitted, along with other young men from the workshops of artists and artisans, but also from the aristocracy. But it may be that Giovanni Santi, Raphael's father, was referring expressly to both the artistic talent and the inclinations of the young Leonardo when in his *Rhymed Chronicle* he hailed Leonardo and Perugino as 'Two youths equal in station and in love'.

In 1478 Leonardo received an important commission to paint an altarpiece for the Chapel of San Bernardo in the Palazzo Vecchio, but this work was never accomplished,

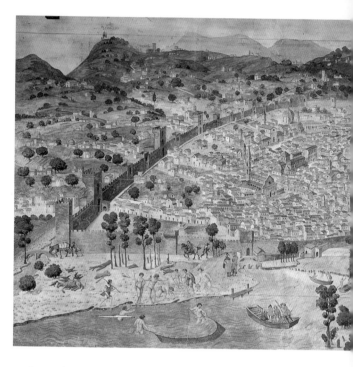

perhaps due to the political upheaval occurring in that year as a result of the Pazzi Conspiracy. Lorenzo de' Medici, after escaping from the conspirators who had assassinated his brother Giuliano, managed to consolidate his power and, with consummate political and diplomatic skill, to inaugurate a time of peace and a flourishing of the arts, not only in Florence but throughout Italy. It was in fact Lorenzo the Magnificent who sent Leonardo to Milan, to the court of

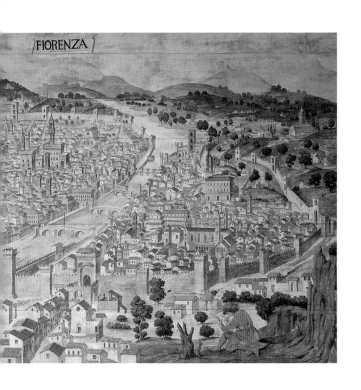

Fiorenza (map known as '*della Catena*'),
c. 1472;
Florence, Museo di Firenze com'era.

Ludovico Sforza, known as 'il Moro', in an initiative that was both diplomatic and cultural. As an envoy, Leonardo served not only as a painter but also as a musician and inventor, devising a lyre shaped like a horse's skull, a 'bizarre and new thing'. Departing from Florence for Milan in 1482, at the age of 30, Leonardo left two paintings unfinished: the great panel depicting *The Adoration of the Magi* (Florence, Galleria degli Uffizi) and the *Saint Jerome* (Vatican City, Pinacoteca Vaticana).

Milan. In addition to the gift of the extraordinary musical instrument, Leonardo presented a letter to Ludovico il Moro, in which he offered his services and described his manifold capabilities. In this document Leonardo displayed the full range of the fields of competence he had

Portrait of Lorenzo de' Medici,
1483–5;
Windsor, RL f.12442r.

Florence. Section of the Vasari
Corridor leading from Lungarno
degli Archibusieri to the Ponte Vecchio.

mastered. Activities of various kinds are listed: from military engineering, to which a large part of the letter was devoted, with the promise of new kinds of weapons, carriages and bridges, to architecture, sculpture and painting. From the letter emerges the picture of a 30-year old Leonardo who, in writing about himself, is fully aware of the value of his amazing versatility: 'according to the different cases, I will compose an infinite variety of things ...'

For the next 17 years Leonardo remained at the court of 'il Moro'. As ducal engineer he engaged in hydraulic engineering initiatives, regulated water sources by organizing a network of canals, and designed an ideal city built on several levels, based on the principle of separating its various functions. His presence at the Sforza court also satisfied Ludovico's ambition to confer prestige on his duchy by creating a refined humanistic ambience. In this atmosphere, rich in intellectual stimuli, Leonardo developed the thesis of the *Paragone*, maintaining the supremacy of painting over the other arts (poetry, music and sculpture). His manuscripts are filled with allegories, riddles, emblems, mottos, witticisms, fables and prophecies, which he must have used

Angiolo Tricca, *Leonardo as a Boy in Verrocchio's Workshop, c.* 1845; Borgo San Sepolcro, Palazzo delle Laudi.

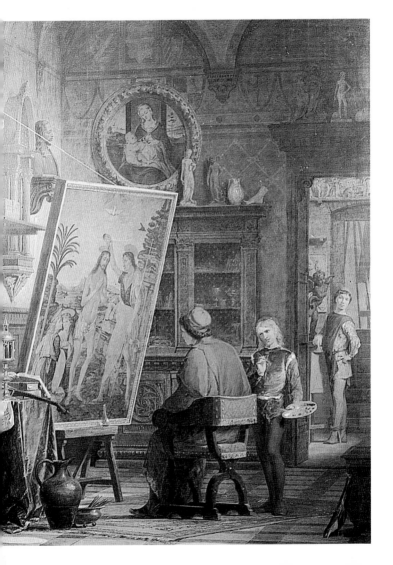

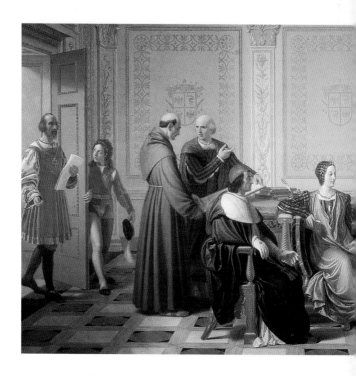

to entertain his highly cultured audience at court. It was
here, in fact, that Leonardo came into contact with eminent
personages, among them Castiglione, who mentions him in
the *Cortegiano* and shows familiarity with his writings in the
Paragone proclaiming the nobility of painting.

During his first years in Milan Leonardo signed a con-
tract to paint *The Virgin of the Rocks*, painted the *Portrait of
a Musician* (Milan, Pinacoteca Ambrosiana), and drew up a

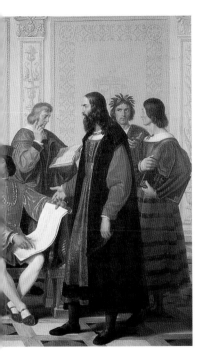

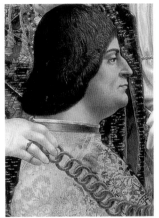

Giuseppe Diotti,
The Court of Ludovico il Moro,
1823;
Lodi, Museo Civico.

Anonymous Lombard painter,
The Sforza Altarpiece,
late 15th century,
detail with Ludovico il Moro;
Milan, Pinacoteca di Brera.

Cherubino Cornienti,
*Leonardo in the Refectory
of the Grazie*, 1857;
Milan, Galleria d'arte moderna.

series of projects for the lantern on the Duomo. At court he
designed elaborate decorative sets for wedding celebrations
and organized numerous festivals and performances. On
these occasions Leonardo perfected scenic devices of his
own invention, designed to amaze the spectators. In 1490

the famous Festa del Paradiso (Paradise Feast) was held, for which he designed a complicated theatrical machine that reproduced the heavens, the planets and the stars, with 'special effects' provided by moving parts and the play of lights. For 'il Moro' Leonardo painted two portraits of women:

first the young Cecilia Gallerani, the *Lady with an Ermine*, and then Lucrezia Crivelli, the *Portrait of a Lady (La Belle Ferronnière)*. In court circles he was now hailed as the new Apelles, capable, like the legendary Greek artist, of challenging nature itself with the life he instilled in his figures ('From Florence an Apelles has been brought here').

In the years he spent in Milan, Leonardo assiduously studied the human figure and the proportions of the body, as is superbly demonstrated by his famous drawing called *Homo Vitruvianus*. Along with his theoretical studies, Leonardo began to extend the field of his research on humankind with direct observation conducted through anatomy, physiognomy and the analysis of movement.

In 1494 he began a series of drawings and preparatory studies for *The Last Supper*, on which he was to work, in the Refectory of Santa Maria delle Grazie, until 1498. In the Castello Sforzesco he decorated the Sala delle Asse with a different kind of wall painting. At the same time, during the last decade of the 15th century, Leonardo worked on the project of a great equestrian statue dedicated to Francesco Sforza, father of 'il Moro', intended not only as a celebration of the ducal family but also as a technical achievement without precedent. 'See how in the Court he orders made of metal/ In memory of his father a great colossus:/ I firmly and without doubt believe/ that neither Greece nor Rome ever saw its like in size.'

Not only was Leonardo's work compared to ancient sculptures, such as the *Regisole* that he had admired in Pavia, but also with the equestrian monuments that two other

Florentines had been called upon to sculpt in Northern Italy: the *Gattamelata* by Donatello in Padua and the *Colleoni* by his master Verrocchio in Venice. The clay model erected by Leonardo in the Corte Vecchia stood over 7m/23ft high. In 1493 he was already preparing to cast the enormous amount of metal required, a procedure for which he planned to use three furnaces at the same time. But the colossus made of clay was to remain such. In 1499 Milan was occupied by the troops of Louis XII, King of France. Leonardo, with the eyes of a spectator of history, recorded the dramatic events in a note: 'The chamberlain taken prisoner/ the Vice-Count overthrown and then his son dead/ [...] the Duke has lost the State and his property and his freedom/ and no work will be finished for him.' The last reference is to himself, to those projects commissioned by 'il Moro' that would never be completed, first among them the horse. The great clay model was destroyed by the invading soldiers, who used it for target practice. And so in 1499 Leonardo decided to leave Milan, in the company of his friend Luca Pacioli. The mathematician Pacioli had arrived at the court of 'il Moro' three years earlier, having published in Venice the *Summa de Arithmetica Geometria Proportioni et Proportionalità*, a book that Leonardo had immediately purchased, as he mentioned in a note.

His contacts with Luca Pacioli encouraged Leonardo to intensify his study of mathematics and geometry, providing him with a reference point for confronting the questions of theoretical nature that were emerging forcefully in his research ('learn from Master Luca'). In 1498 Pacioli had

completed his treatise on the *Divina proportione* and had asked Leonardo to draw the illustrations of the Platonic solids, or regular polyhedrons, the models of perfection understood to be the harmony of proportional relationships. The work was published in Venice in 1509. In the preface, Pacioli declared that the drawings 'of all of the regular bodies [...] have been made by the most worthy painter, perspective architect, musician and man endowed with all virtues Lionardo da Vinci Florentine in the city of Milan [...] from where we then together [...] departed...'

Mantua, Venice, Florence. Upon leaving Milan, Leonardo first stopped at Mantua, where he was welcomed by Isabella d'Este. The duchess posed for a preparatory drawing for a portrait she had requested from Leonardo as a worthy addition to her precious art collection. Leonardo then journeyed to Venice, where the government of the Most Serene Republic needed a plan for defending an area along the banks of the river Isonzo, which was exposed to attack from the Turks. Leonardo designed an integrated system of fortifications, canals, locks and flooded plains. Before returning

Gaetano Callani,
Leonardo da Vinci in his Studio,
c. 1872;
Parma, Biblioteca Palatina.

Leonardo da Vinci

to Florence in 1501, he may have travelled to Rome, as seems probable from one of his notes: 'In Rome. In old Tivoli, the house of Hadrian.' If this note does not refer to an actual voyage, it reveals in any case Leonardo's new interest in the remains of antiquity: an indispensable reference point for his studies on architecture, as well as for his painting, which, precisely from the first years of the 16th century, starts to reveal motifs inspired by classical statuary.

Back in Florence after an absence of almost 19 years, Leonardo lodged at the Monastery of Santissima Annunziata. Here he was visited by Pietro da Novellara, sent by Isabella d'Este to demand news of the portrait she was eager to receive. But the news the Marchesa received from Novellara was not encouraging: 'His mathematical experiments have so distracted him from painting, that he cannot bear to see a brush.' Commissioned by the monks of the Annunziata, Leonardo was, however, engaged in preparing a cartoon for an altarpiece to be placed above the high altar, portraying *The Virgin and Child with Saint Anne and a Lamb*. When this work was finished, relates Vasari, Leonardo opened his studio to the public. To see the

Jac. Barb. Vigonnis,
*Portrait of Fra Luca Pacioli
with a Pupil*, 1495;
Naples, Museo e Gallerie
Nazionali di Capodimonte.

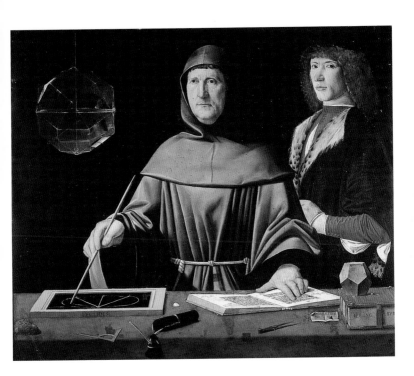

43

cartoon, now lost, flocked 'men and women, old and young, as if going to a solemn Festivity, to see the marvels of Lionardo, by which they were all amazed.' He also painted *The Madonna of the Yarnwinder*, two versions of which have survived, painted by pupils with the probable assistance of the master. But in the following year Leonardo, who had reached the age of 50, was again on the move.

Montefeltro. In 1502 Leonardo entered the service of Cesare Borgia, the son of Pope Alexander IV, who aimed to unite under his own rule the regions of Romagna, Marche, Umbria and Tuscany, thus creating a single strong state in central Italy. Such a multi-faceted personality as Leonardo was crucially important to the expansionist ambitions of Borgia, who, in pursuing his plans with lucid, relentless logic, was the model for Machiavelli's *The Prince*. Leonardo, in his capacity as 'Architect and General Engineer', was responsible for supervising the entire defensive structure of the territory: fortifications, bastions and encircling walls, especially in the lands of the Duchy of Urbino, which had fallen into the hands of Borgia. With a special safe-conduct

Leonardo and assistants,
The Madonna of the Yarnwinder,
1508;
New York, private collection.

On pp. 46–7:
Anonymous, *Tavola Doria*,
1503–4,
copy of the central part
of Leonardo's cartoon
for *The Battle of Anghiari*.

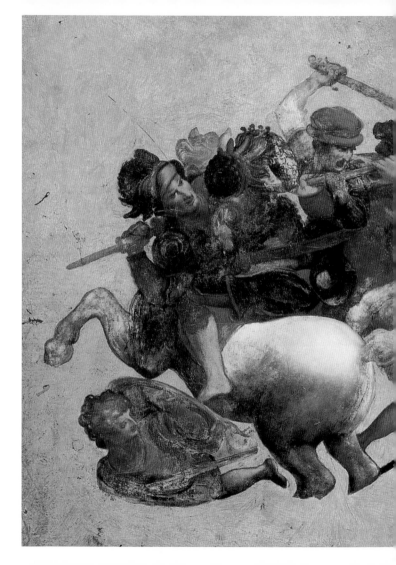

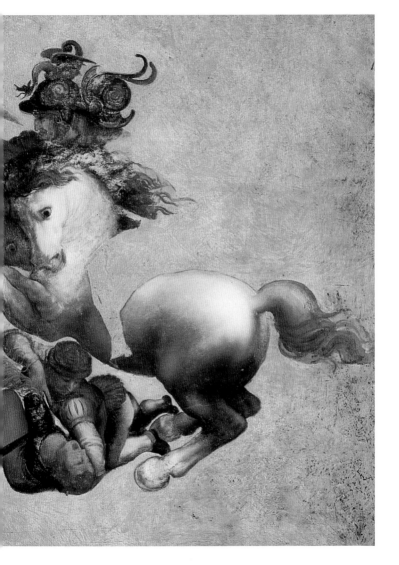

authorizing him to move about freely, Leonardo travelled, measured, inspected, surveyed and jotted down notes in his pocket notebook.

Florence. A year later, in 1503, having abandoned Borgia to his enterprise, which was doomed to failure, Leonardo was back in Florence. Here, since 1494, the Medici had been driven out and a republic proclaimed. After the period of radical reform instigated by Girolamo Savonarola, who had then been burned at the stake, the city was now governed by the Gonfaloniere Pier Soderini, elected in 1502. Niccolò Machiavelli was Secretary of the Florentine Republic.

Plans had been made to decorate the Sala del Maggior Consiglio in the Palazzo Vecchio, and Leonardo was commissioned to paint *The Battle of Anghiari*. In the same hall, on the left-hand side of the same wall, Michelangelo was summoned to paint *The Battle of Cascina*. At the same time the republic asked Luca Pacioli to construct models of his regular polyhedrons. In this iconographic scheme the two *Battles* were supposed to inflame the spirits of the Florentines with civic virtue, while the models of the

Anonymous,
Leda and the Swan,
copy from Leonardo,
1506–8;
Florence, Galleria degli Uffizi.

On pp. 50–1:
Cesare Maccari, *Leonardo painting the 'Mona Lisa'*, 1863;
Siena, Soprintendenza per i Beni Artistici e Storici.

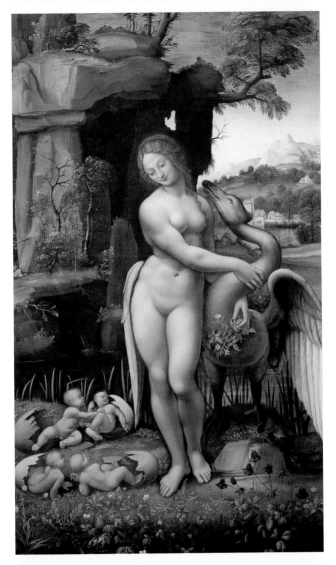

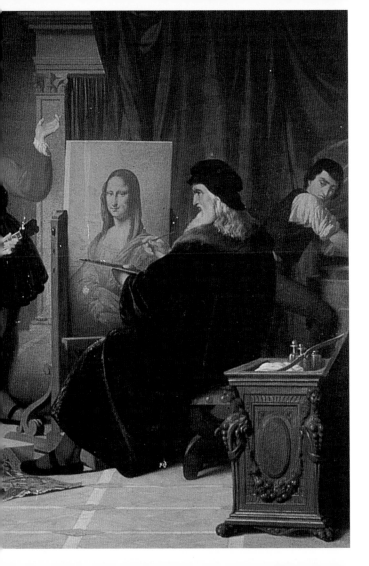

Platonic solids would inspire a sense of harmony and equilibrium. Leonardo worked on the preparatory cartoon for *The Battle of Anghiari* in the Monastery of Santa Maria Novella; meanwhile, for its execution, he developed an experimental technique similar to ancient *encausto*, but this method was to prove a failure. On the walls of the hall he painted only the central scene of the great design he had conceived, a chaotic struggle of horses and riders.

The group, which Leonardo began to paint in 1505, is documented by a few copies, drawings and paintings, among them the *Tavola Doria*, completed while Leonardo's painting was still visible; that is, before it was destroyed or concealed behind the remodelling work done by Vasari in 1563, when the hall became the Salone dei Cinquecento of today. Michelangelo also failed to complete his *Battle*, but by 1504 he had finished the statue of *David*, and Leonardo was invited to join the commission appointed to decide where the statue should be sited. It was decided to place it, as a symbol of the young Florentine Republic, directly in front of the façade of the Palazzo Vecchio. Of the two great *Battles* commissioned from Leonardo and Michelangelo there remained the cartoons, now lost, which served as models for the following generations of painters, and were so authoritative as to be called 'the school of the world'.

According to tradition, it was during these first years of the 16th century that Leonardo began the portrait of Monna Lisa del Giocondo (known as the *Mona Lisa*, or *La Gioconda*), a painting on which he was to continue working until the end of his life. Another of his paintings from this

time was the *Leda,* now lost. Leonardo's development of this theme has survived in a series of studies, and the many 16th-century replicas it inspired bear witness to the fame of his painting. One of those most faithful to Leonardo's original is the *Leda* now in the Galleria degli Uffizi (formerly in Rome, Spiridon Collection).

In Florence Leonardo delved more deeply into the study of geometry, finding in the library of the Monastery of San Marco the treatises and manuscripts he needed to carry out his research. For the Florentine Republic he proposed a project for diverting the Arno, to make the river navigable from Florence to its mouth and to facilitate the conquest of Pisa by cutting off its outlet to the sea. During these years Leonardo practised anatomical dissection in the Hospital of Santa Maria Nuova, while at the same time conducting research into one of the subjects that most fascinated him – flight. This was the time of his *Codex on the Flight of Birds* and his scientific observations led him to construct a machine designed to take flight after being launched from Monte Ceceri, near Fiesole, in the hills above Florence. But the enterprise failed, and Leonardo's great technological dream of human flight was never to be fulfilled.

The cartoon for *The Virgin and Child with Saint Anne and Saint John the Baptist* (London, National Gallery) incorporates figurative themes that were developed in the following years in *The Virgin and Child with Saint Anne and a Lamb* (Paris, Louvre) and *Saint John the Baptist.* These are the paintings, along with the *Mona Lisa,* that Leonardo later carried with him wherever he went.

Milan. By 1506 Leonardo had left Florence to return to Milan, where the French governor of the city had consulted him on architectural and engineering projects. Since Leonardo was still under contract to the Florentine Signoria for *The Battle of Anghiari*, he promised to return to Florence within three months, but failed to keep his promise. In the next two years he travelled frequently between the two cities before settling definitively in Milan. There he completed, with the aid of assistants, the second version of *The Virgin of the Rocks*. In the territory of Lombardy he carried out accurate hydrographic surveys as part of a project for channelling the Adda river. He also worked on the design of a new equestrian monument, that of Gian Giacomo Trivulzio, Marshal of France, but this sculpture, though considerably smaller than the old project for the Sforza family, was never to be executed by Leonardo.

Above all, during his second stay in Milan, Leonardo intensified his research in anatomy, dissecting corpses in collaboration with Marcantonio della Torre, a physician at the University of Pavia, and in 1510 he completed an entire treatise on the subject: 'This winter of 1510 I hope to complete

Raphael, *Portrait of Leo X with Cardinals Giulio de' Medici and Luigi de' Rossi*, 1518; Florence, Galleria degli Uffizi.

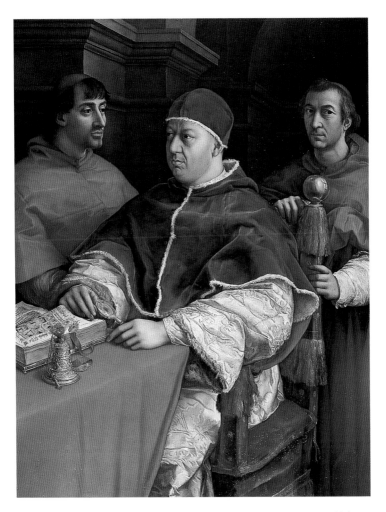

all of the anatomy.' In 1512 the Holy League established by the pope to combat the French brought about the restoration of the Sforza dynasty in Milan, and the following year Cardinal Giovanni de' Medici was elected pope.

Rome. In 1513 Leonardo, now aged 61, moved to Rome, where Giuliano de' Medici had requested his services. Giuliano, a poet and patron of the arts, was the son of Lorenzo the Magnificent and the brother of the new Pope Leo X. He lodged Leonardo in the Vatican, at the Belvedere, where the artist was to stay for three years, engaging mainly in scientific and technological research. For Giuliano, Leonardo conducted a series of studies for draining the Pontine swamps, and also designed a new port to be constructed at Civitavecchia, where he examined the ruins of the ancient Roman port. His growing interest in the study of water in this period was reflected in a series of drawings of *Deluges*. Increasingly absorbed by his vision of the upheavals generated by the forces of nature, Leonard sought to evoke an extremely remote past, traces of which he detected in the fossils he found on Monte Mario. In Rome he continued to

Raphael, *The School of Athens*, 1510,
detail with Plato and Aristotle;
Vatican City, Vatican Palaces,
Stanza della Segnatura.

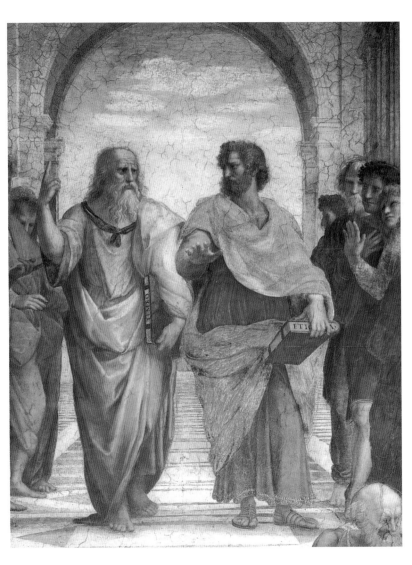

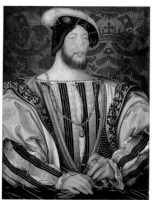

dissect corpses, a practice that led him to be accused of witchcraft. Pursuing his speculative interests, Leonardo kept himself apart in a city that had also attracted the artistic talents of Bramante, occupied in the Vatican with the grandiose undertaking of Saint Peter's Basilica; Michelangelo, who had

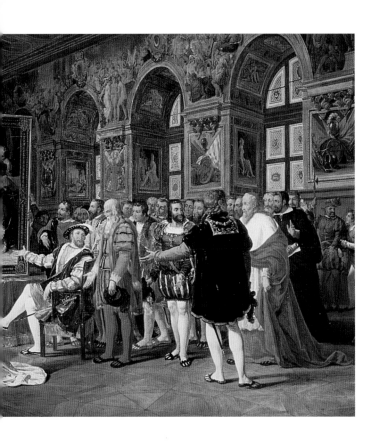

Jean Clouet,
François I, c. 1525;
Paris, Musée du Louvre.

Anicet-Charles-Gabriel Lemonnier,
The Century of François I, 1813;
Rouen, Musée des Beaux-Arts.

just finished the frescoes on the ceiling of the Sistine Chapel; and Raphael, who had given the features of Leonardo to the Plato he painted in the Vatican Stanze.

In 1515 Leonardo created an amazing mechanism: the automaton of a lion, which could move about, advance, rear up on its hind legs and then open its chest, displaying within it the lilies of France. The mechanical lion had been designed in honour of the new king of France, François I, and was sent as homage from Florence to Lyon, where great festivities were being planned for the king's entrance into the city. Symbolically, the lion alluded not only to Lyon but also to Florence, whose emblem was the Marzocco lion, as well as to Pope Leo X, who sought the friendship of the French king and had arranged a marriage between the king's aunt and his own brother Giuliano, Leonardo's protector.

France. The death of Giuliano de' Medici, in 1516, must have contributed to Leonardo's decision to accept the invitation of François I and move to France, to the court of Amboise, site of the royal palace. Nearby, at Cloux, the king offered him as residence the little castle of Clos-Lucé, where Leonardo went to live in the company of some of his pupils, remaining there for nearly three years, until his death. The king appointed him 'Premier peintre & ingégnieur & architecte du Roy, méchanicien d'estat, & c'. For François Leonardo planned work on the watercourse of the river Loire and designed a royal residence to be built at Romorantin. He planned a model town provided with channels that would feed a modern system of running water, as well as fountains

in the gardens and a pool for aquatic jousts. At the court of France Leonardo also organized festivals and celebrations, designing theatrical machines and sets for spectacles in which his famous automated lion was still used. He had brought with him from Italy the *Mona Lisa*, the *Saint Anne* (Louvre), and the *Saint John the Baptist*, continuing to work on these paintings over the years; but otherwise it seems that, in his last years in France, Leonardo painted no more, although he never stopped drawing and recording notes in his papers. In 1517 he received a visit from Cardinal Luigi d'Aragona, whose secretary described the meeting with the elderly Leonardo, eager to speak of the vast amount of research he had accomplished and the wealth of knowledge conserved in his manuscripts: 'And he said that he had practised anatomy on over 30 bodies, both male and female, of every age. He has also written on the nature of waters, on various machines and on other things, as he stated, an infinity of volumes …'

In his will, dated 23 April 1519, Leonardo, who had only just reached the age of 67, appointed as executor his favourite pupil Francesco Melzi; to him he left all his drawings, manuscripts and the instruments he had with him at the time. Leonardo died just ten days later, on 2 May 1519. He was buried, as he had requested, in a church whose name is significant: Saint Florentin. The church was severely damaged during the wars of religion and was totally destroyed in 1808. Later, some fragments of stone bearing the inscription 'LEO … INC …/… EO … DUS VINC …' were found, as well as a large skeleton: the remains of Leonardo, now lost.

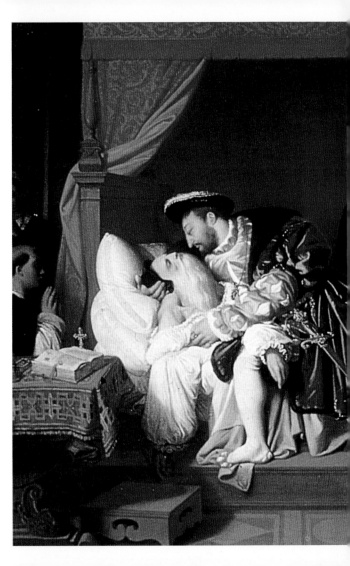

The legend persists that Leonardo died in the arms of François I. Historically, this could not have happened, since the king was elsewhere and it was Melzi who brought him the news, but certainly the French king, his last patron and admirer, must have retained a vivid memory, coloured by amazement and esteem, of Leonardo. Testimony to this is provided by Benvenuto Cellini. Over 20 years later, finding himself at the court of King François, Cellini heard him recall the great master, declaring: 'Never was there any other man born in the world who knew as much as Lionardo, and not so much of painting, sculpture and architecture as for the fact that he was a very great philosopher.' Inseparable from the figure of Leonardo is the legacy of his relentless search for knowledge, in keeping with his concept of the artist, the painter, for whom he claimed the universal nature and boundless faculties of the Renaissance man: 'If the painter wishes to see beauty that enthralls him, he is master to create it, and if he wishes to see monstrous things that are frightening, or that are funny or laughable, or truly compassionate, he is their lord and god. [...] And in effect, all that which exists in the universe as essence, presence or imagination, he has it first in his mind, and then in his hands.'

On pp. 62–3:
Jean Auguste Dominique Ingres,
François I Receiving the Last Breath of Leonardo da Vinci, 1818;
Paris, Musée du Petit Palais.

Facing page:
The Church of Saint Florentin at Amboise, where Leonardo da Vinci was buried, in a photograph from the early 20th century.

LEONARDVS·VINCIVS·

The paintings

In his *Paragone*, Leonardo compares painting, sculpture, music and poetry in various ways, and claims that painting is superior to all the other arts. Sculpture lacks the component of colour and the effects of light and shadows: 'It cares not for shadows nor light, [...] for colour nothing.' Compared to painting, which endures, music is ephemeral, being 'as swift to die as to be born'. Regarding poetry, Leonardo demonstrates the vast difference that exists between the arbitrary nature of words and the universality of images. As an example, he refers to humankind: 'Now see which is most pertinent to man, the name of man or the likeness of man? The name of man is different in different countries, but the form is changed only by death.' And it is here that painting shows its superiority over nature itself, for the power it possesses of rendering eternal that which is destined to perish in nature: 'How many pictures have conserved the image of a divine beauty that time or death has destroyed in such brief time ...'

Cristofano dell'Altissimo,
Leonardo da Vinci, 1566–8;
Florence, Galleria degli Uffizi.

THE BAPTISM OF CHRIST

This is the painting on which Leonardo collaborated in Verrocchio's workshop. The panel was painted for the Monastery of San Salvi in Florence, where in the 16th century it was recorded as the 'Baptism of Christ by Verrocchio', but also as 'an angel by Leonardo da Vinci'. In fact it is the angel on the left, seen from behind in the act of turning to the right, in which Leonardo's hand has always been recognized in this work painted by his master. *The Baptism of Christ* appears to be a typical example of the production of Verrocchio's workshop, where the master and his pupils cooperated without any great distinction being made between the different hands.

Verrocchio, having received the commission, must have painted the two main figures of Christ and Saint John the Baptist, leaving the rest of the work to be completed by his pupils. The participation not only of Leonardo but also of other painters can be seen in this work. The angel on the right may have been painted by Botticelli, who was

The Baptism of Christ, 1475–8;
Florence, Galleria degli Uffizi.

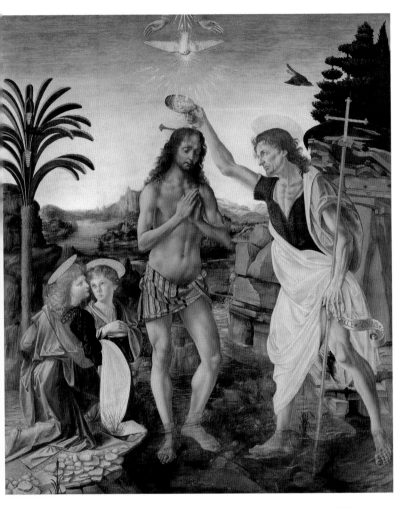

apprenticed to Verrocchio at the same time as Leonardo. Some parts of the picture are attributable to a painter of lesser skill: the palm tree on the far left, the rocks on the right and the hands of God the Father at the upper centre are all rigid and conventional in concept. The section painted by Leonardo stands out in striking contrast to this unnatural stiffness.

According to Vasari, this assignment was the pupil's first trial, conducted under the watchful eye of his master Andrea del Verrocchio, 'who was completing a panel showing Saint John baptizing Christ in which Leonardo worked on an angel holding some garments; and although he was a young boy, he painted the angel in such a way that it appeared much better than the figures by Andrea. This was the reason why Andrea never wanted to touch colours again, indignant that a young boy understood them better than he did.' Verrocchio did, of course, continue to paint in subsequent years, but it is true that Leonardo's work on this painting reveals not only skilful technical ability but also a remarkable talent for composition. In addition to the rendering of the figure obtained by subtle employment of the *sfumato* technique, the concept of the angel seen from behind is crucially important to the composition of the painting as a whole. The painting was actually finished around 1475, or soon after, at a time when Leonardo was already working as an independent painter, and it is probable that he was assigned the duty of completing the work. This was not an easy task, due to the stylistic imbalance of the composition resulting from its being the work of

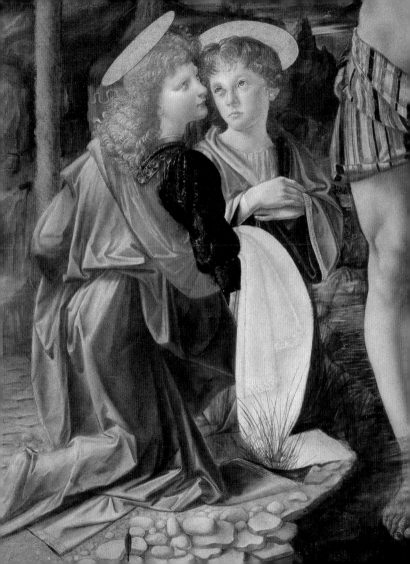

different artists. The invention of the angel turning his head in a twisting movement to direct his gaze at the face of Christ creates a guiding line that draws the spectator's attention from the outer margin to the centre. This solution balances the guiding line opposite, provided by the entire figure of John the Baptist. The hand of Leonardo can also be recognized in the glimpse of a distant landscape above the angels' heads. Here the river Jordan, on whose bank the Baptism is taking place in the foreground, flows through a broad valley, whose bright surface reflects the light of the sky. Suddenly the receding planes take on depth, starting from the detail of the plant in the foreground, which stands out against the light-coloured surface of the robes held by the angel, and continuing as far as the distant horizon.

Radiographic examination of the painting has revealed the presence of portions completed in oil over the tempera undercoat. The parts painted in oil are the face of the angel on the left and some elements of the landscape in the background, as well as the hair and the body of Christ. And in fact, it is to Leonardo that the almost impalpable effects of the hair and the translucent layers of paint that gently soften the anatomy of the Christ figure must be attributed. It is here that scientific examination has revealed traces of Leonardo's fingerprints, in places where he worked the paint directly with his hands.

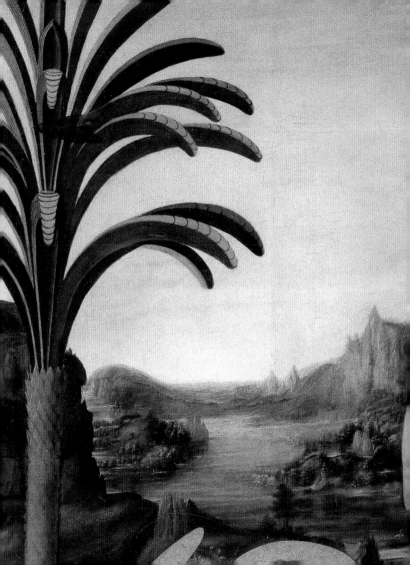

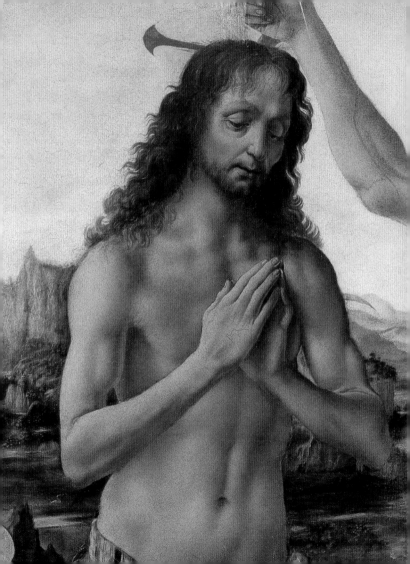

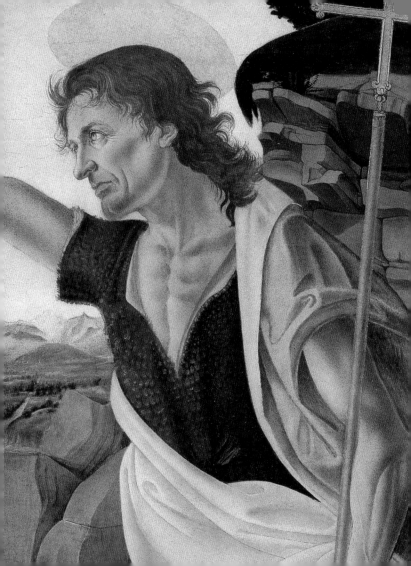

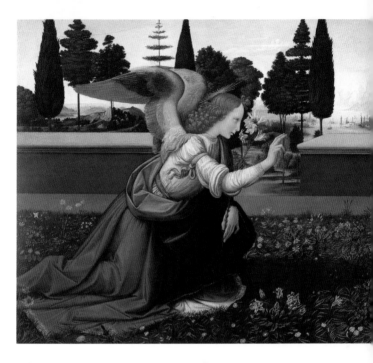

THE ANNUNCIATION

This is the first large work painted by Leonardo, in which he was obliged to confront the problems of the general organization of a painting and the arrangement of figures in space. The work, painted for the Monastery of San Bartolomeo a Monteoliveto, was moved to the Uffizi in 1867.

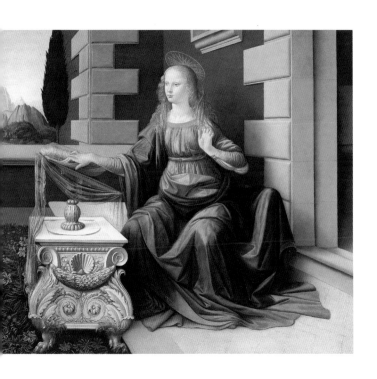

The Annunciation, 1475–8;
Florence, Galleria degli Uffizi.

Leonardo was only a little more than 20 years old when he painted it. And in fact, many aspects of the work call to mind his apprenticeship in Verrocchio's workshop.

In some preliminary studies that have survived Leonardo sketched, with great precision, the drapery of the figures he would later transfer to the painting. These studies were made according to a precise workshop method, using the highly refined technique of brush tip on linen.

The striking variety of naturalistic details in the representation of the flower-strewn meadow is another element drawn from the teachings of Verrocchio. And the marble base of the Virgin's lectern shows a similar precision of description. The rich bas-relief decoration of scrolls and floral motifs, where the extremely precise details seem wrought by a goldsmith's chisel, recalls the elaborate sculptural works of Verrocchio. Moreover, the detail of the gossamer-light transparent veil falling over the side of the lectern, to brush gently against the majestic marble base, looks like a demonstration, exhibiting the artist's consummate skill at imitating in paint the consistency of the most diverse materials.

At some points in the ornamental bas-relief, as well as on the fingers of the Virgin's right hand, traces of Leonardo's fingerprints have been detected. These fingerprints, found in some of his youthful works such as this one, *The Baptism of Christ* and the *Portrait of Ginevra Benci*, bear witness to the fact that Leonardo was accustomed to work on the picture's surface with his fingers, to make even finer adjustments to get precisely the effects he wanted.

In addition to the refined technique required to execute the individual parts, Leonardo had to deal with the construction of the painting as a whole. Clearly, the lectern, the flooring and the architecture are formulated according to the principles of linear perspective, as taught in the pictorial tradition of the Florentine Quattrocento. But uncertainties appear within the perspective scheme, as in the dark area between the rusticated stones of the architecture and the isolated tree on the right. Careful examination reveals an anomaly within this rigorous basic construction according to which the various elements are positioned in space. Another irregularity that fails to fit into the scheme can be seen in the Virgin's right arm, reaching forward. The Virgin is in fact seated too far back from the lectern, in a position from which she could not reach the left margin of the book and touch the pages with the fingers of her right hand. Was this due to an error made by the youthful Leonardo, who had not yet achieved perfect mastery of his means? Or, in a different hypothesis, is this apparent deformation really intentional, designed expressly to function when the painting is looked at from the side? The latter suggestion implies that Leonardo knew the exact place where the painting would be hung and foresaw that it could not be looked at directly from the front.

But apart from each individual detail, Leonardo manages to confer compositional unity on the picture in an entirely new way, going beyond the boundaries of linear perspective with his invention of atmospheric perspective. In contrast to the extreme clarity of the elements in the

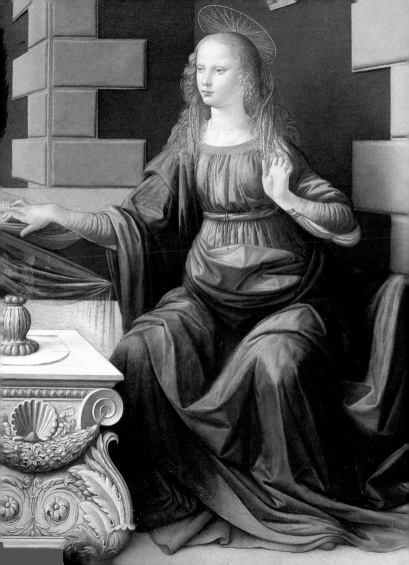

foreground, the misty landscape in the background is glimpsed through distant layers of air. The diffused luminosity barely reveals a city overlooking water, a port and boats, a remote life appearing below high mountains that are almost invisible. The sense of this undefined depth, rendered visible through the air, reverberates on the figures and the portentous moment in which they are fixed in the painting. The angel's gesture traverses space horizontally to arrive at the Virgin's hand, raised to welcome him. The two figures communicate through the exchange of their corresponding gestures and gazes.

It was expressly the concept of annunciation to which Leonardo was referring when he defined the need to express intentions and thoughts through the attitudes and gestures of his figures with the words, 'let movements announce the motion of the soul ...'

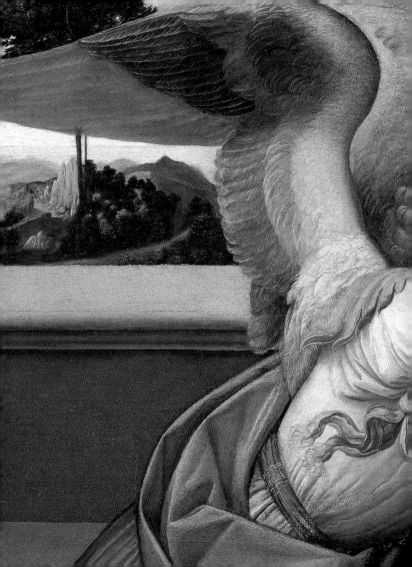

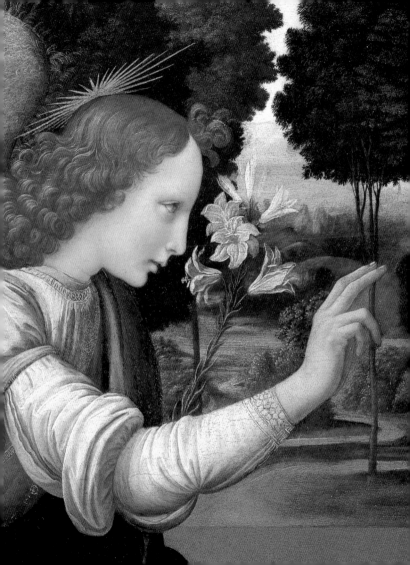

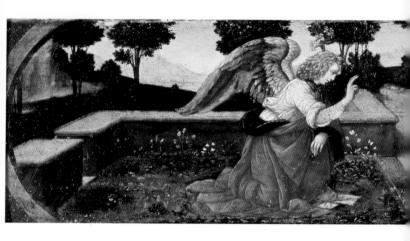

THE ANNUNCIATION

The small panel with *The Annunciation* was a part of the predella that framed *The Madonna enthroned with Saint John the Baptist and Saint Donato*, a work commissioned from Verrocchio for the Duomo of Pistoia. This great altarpiece, also known as *The Madonna di Piazza*, was painted in Verrocchio's workshop in the years 1478 to 1486, and was mainly the work of Lorenzo di Credi. This young painter had assumed a leading role among Verrocchio's pupils, especially after the master was called to Venice, commissioned by the Senate of the Most Serene Republic to sculpt the equestrian monument to Bartolomeo Colleoni.

The Annunciation, c. 1478;
Paris, Musée du Louvre.

The compartment that depicted the scene of *The Annunciation* must have been the central element of the predella. Leonardo worked on it before leaving for Milan in 1482. His unmistakable style is clearly recognizable in the scrupulous attention with which the drapery of the two figures is rendered. But even more clearly, the hand of Leonardo reveals itself in the overall conception of the scene and the restrained gestures of the two figures. The heads bending forward toward each other establish a silent dialogue between the Archangel and the Virgin.

The attitude of the female figure, absorbed in meditation, is reflected in a delicate drawing, now in the Uffizi, in which Leonardo describes in subtle chiaroscuro the effects of light on the planes of the face. The spatial organization of the small panel in the Louvre is similar to that of the Uffizi's great *Annunciation*, with the scene unfolding outdoors between a flower-strewn meadow and a kind of open-air room created by the architectural structure. In both paintings, the space in the foreground is enclosed within a garden (*hortus conclusus*) beyond which a distant landscape opens out.

In spite of its small format and the fact that it was painted for a predella, this representation also shows how Leonardo conceived the gestures of his figures as expressions of the intentions of the soul, harmonizing exterior attitudes with inner feelings.

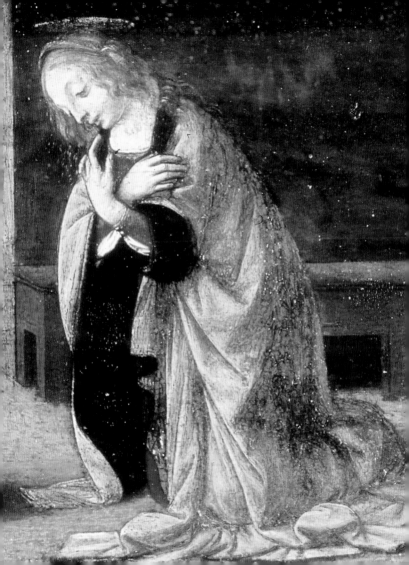

PORTRAIT OF GINEVRA BENCI

This is the first portrait painted by Leonardo. Writers in the past praised its extraordinary likeness, one of them claiming that the artist 'painted in Florence from life Ginevra d'Amerigo Benci, with such great success that not the portrait, but the real Ginevra it seemed'. The painting could date either from 1474, the year when the 17-year-old Ginevra married Luigi di Bernardo di Lapo Niccolini, or from the next few years. Ginevra was the daughter of the Florentine banker Amerigo, a member of the wealthy Benci family, which was closely linked to Medici circles. Incidentally, Leonardo left the great altarpiece of *The Adoration of the Magi*, unfinished, with the Benci family when he left Florence for Milan in 1482.

The juniper plant (*ginepro* in Italian) whose dark mass of pointed leaves frames the young woman's face with its ivory-white complexion, alludes to her name. The diaphanous texture of the image is further emphasized by the almost imperceptible detail of the transparent veil tied

Portrait of Ginevra Benci, c. 1474;
Washington, National Gallery.

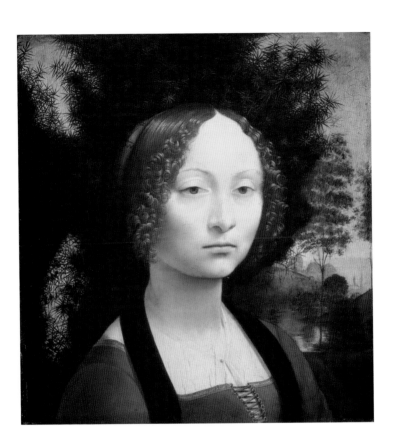

under the woman's neck. For this figure Leonardo appears to have been inspired by the example of Verrocchio's sculpture, as it shows a close relationship with the marble bust of the *Noblewoman with a Bouquet* (Florence, Museo Nazionale del Bargello) sculpted in those same years. In comparing the two portraits of women, one pictorial, the other sculptural, the absence from Leonardo's painting of the lower part, in which the young woman's hands with their sensitive gestures must have appeared, is striking. Leonardo's original idea for the missing hands is indicated in a study now at Windsor. The lower part of the painting may have been trimmed off because it was damaged or because it had remained in the state of a sketch.

The fact that the painting was cut off at the bottom, reducing its height by about one-third, and may also have been trimmed at the sides by a small amount, is confirmed by an examination of the emblem painted on the back of the panel. A juniper branch appears in the centre, framed by a palm leaf and a laurel branch, to form a garland that must have been tied at the bottom to hold the three fronds together. Surrounding these plants, which are laden with

Emblem bearing the motto 'VIRTUTEM FORMA DECORAT', painted on the back of the *Portrait of Ginevra Benci*.

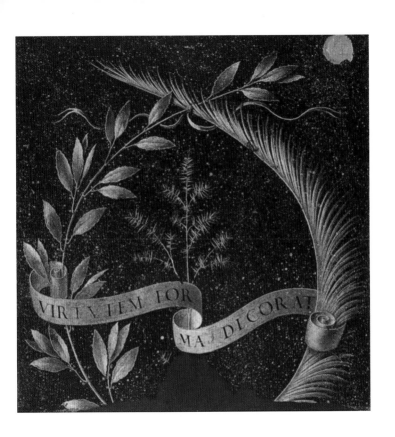

symbolic meaning, is a scroll bearing the inscription 'VIR-TUTEM FORMA DECORAT' ('beauty adorns virtue'), indicating that outer beauty is merely the ornament of inner virtue. The motto serves to underline the moral dimension attributed by Leonardo to the portrait of Ginevra, with her enigmatic expression and the powerful impact of her presence and her gaze.

The back of the panel is painted to resemble a slab of porphyry. In effect, the entire work, both front and back, shows how the artist was experimenting with pictorial techniques to achieve illusionist effects. Here Leonardo shows how painting is capable of representing a great variety of natural effects. His analytical attention to the rendering of details reflects examples of northern European painting, so much so that this portrait was once thought to be the work of Lucas Cranach. But, in accordance with his growing sensitivity to atmosphere, Leonardo introduces a subtle vibration in the surface of the picture, from the soft scrolls of the curls framing the young woman's face to the distant trees reflected in the waters of a lake. And he investigates the effects of the light that, in the foreground, falls from above to create shimmering reflections on the hair, while further back the clear sky contrasts sharply with the dark tips of the juniper leaves seen against the light. Lastly, in the landscape opening out on the right, the high line of the horizon can be distinguished, suggested through the gradual fading of the colours as the distance increases.

A close examination shows that Leonardo used his fingers to distribute the colour on the juniper leaves and even

more on the young woman's face, around the eyes, to confer on the modelling a fine skin-like effect. Fingerprints left by Leonardo on the surface of the painting are found only in this portrait and some of his other paintings from the first Florentine period, including *The Annunciation* (Florence, Galleria degli Uffizi) and *The Baptism of Christ* (Florence, Galleria degli Uffizi). The adoption of this method shows how the artist sought to apply the paint with an even greater effect of *sfumato* than could be obtained with the brush.

It has been suggested that this painting may have been commissioned from Leonardo by Bernardo Bembo, who had been sent as an ambassador to Florence from Venice, and who felt for Ginevra Benci a neo-Platonic love of which poetic testimony has survived. Should this be true, it would be important because it allows a close tie to be established between this work and Venetian circles. More specifically, it would indicate that Giorgione drew direct inspiration for his 1506 *Portrait of Laura* (Vienna, Kunsthistorisches Museum) from Leonardo's concept. Giorgione's portrait is organized along similar lines, with the presence of a laurel bush, whose branches frame the face of the woman portrayed, clearly alluding to her name.

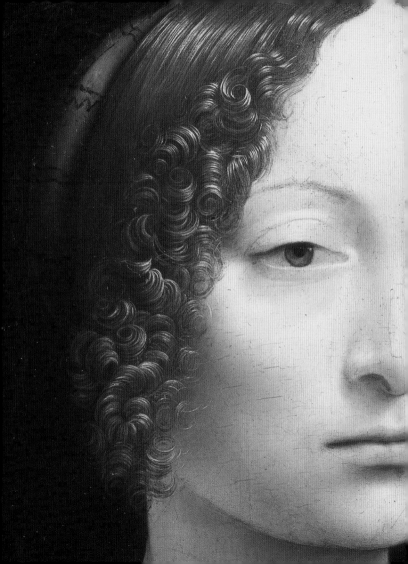

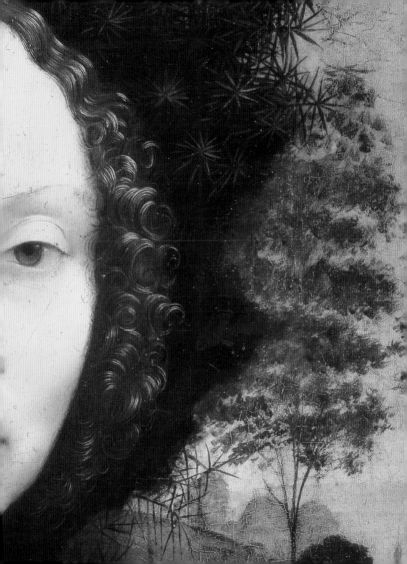

THE MADONNA OF THE CARNATION

This painting is considered to be one of the first independent works accomplished by Leonardo in Florence. The pose of the Madonna, with her hand raised, delicately holding a flower in her fingers, is borrowed from Verrocchio's models; and her face resembles a type of female head included in the repertoire of the workshop where Leonardo had served his apprenticeship. Moreover, the painting is closely related to another Madonna and Child, the *Dreyfus Madonna* or *Madonna of the Pomegranate* (Washington, National Gallery) painted by an artist in Verrocchio's circle, perhaps by Leonardo himself while still very young.

With regard to Leonardo's earliest activity, some contributions have been recognized dating from the time when he had not yet received independent commissions and was collaborating on pictures produced in the workshop. These have been found in three pictures, all portraying the Madonna and Child, in which Leonardo seems to have

The Madonna of the Carnation, 1473–8;
Munich, Alte Pinakothek.

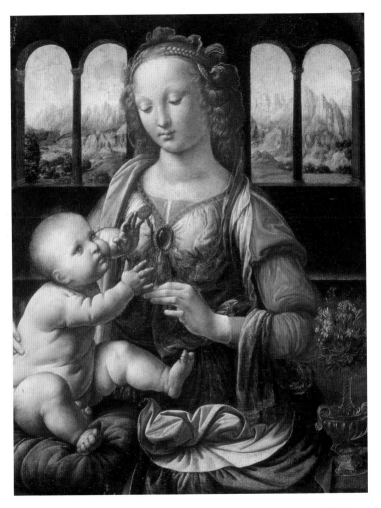

painted a lily held by an angel and a rocky peak in the landscape (in a painting in London, National Gallery) and the details of rocks in the background (in two paintings in Berlin, Staatliche Museen). Lastly, in *Tobias and the Angel* (London, National Gallery), attributed to Verrocchio, Leonardo probably painted the little dog and the fish, giving early proof of his ability to instil painted objects with the vitality of nature.

In the painting now in Munich the Madonna's head stands out against a dark background, adorned by the luminous, transparent lace of the veil that embellishes her elaborate hairstyle. The refinement of the details distinguishes this figure and the entire composition, from the delicate colours of the garments, the reflections of the brooch framed in pearls and the elegant gesture of the hand holding out the bright red carnation, to the balustrade in the foreground. On this are placed the soft cushion on which the Child rests, then the drapery with its chiaroscuro effects and lastly the precious vase of flowers.

Here Leonardo reproduces with consummate skill the effect of the transparency of the ornate glass. The presence of this very detail suggests that the work should be identified as a painting described by Vasari, *The Madonna of the Carafe*. This work was owned by Pope Clement VII, a member of the Medici family. The detail of the carafe is praised as a fine example of the remarkable illusionist effects of Leonardo's painting, which, in imitating nature, seems to bring it to life. Vasari writes: 'He painted a carafe filled with water with some flowers in it, where, apart from the mar-

vellous naturalness, he had imitated the dewy drops of water on it so well that it seemed livelier than life itself.'

To render more effectively the transparency of the skin, Leonardo seems to have attempted an experimental application of oils and paints, which are visible today under close examination because they have clotted on the surface of the painting. The areas involved are the Madonna's face and the Child's body. Here, especially on the arm, Leonardo intensified the chiaroscuro effects, as in his studies of drapery, to represent in detail the folds of flesh typical of infants. In addition to the flesh tones, great attention to colour combinations can be observed in this painting, especially in the Madonna's robes. Leonardo's youthful works, in particular, show his tendency to employ a specific range of colours for garments – red, green, yellow, blue and violet. In his subsequent theoretical treatises Leonardo stated his preference for colour combinations of this type: 'The colours that go well together are green with red or violet or mauve, and yellow with sky blue.'

The figure of the Madonna appears framed between two mullioned windows, each embellished by a slender central column, beyond which the view sweeps over a vast landscape. In this broad horizontal panorama the tones gradually fade, from brown in the foreground to faint blue in the farthest distances.

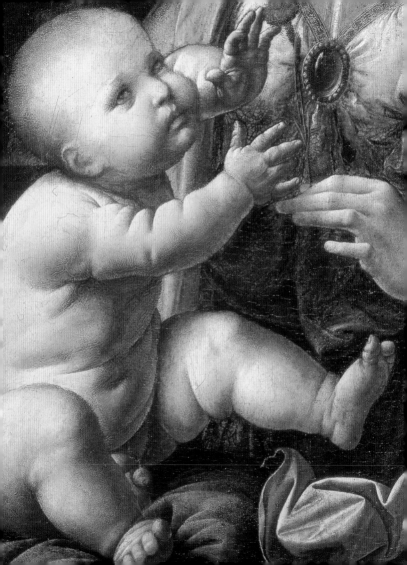

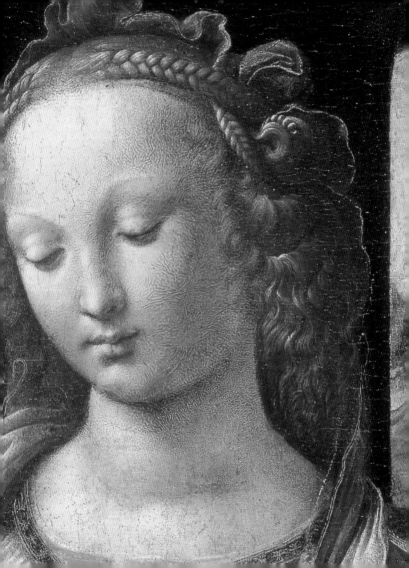

THE BENOIS MADONNA

This painting has been identified as one of the two pictures of the Madonna that Leonardo began to paint in Florence in 1478, a circumstance of which he himself informs us in a note: '[Decem]ber 1478 I began the 2 Virgin Marys.' Unlike the traditional type of standing Madonna, to which *The Madonna of the Carnation* still belongs, here the young mother is shown in a very informal attitude, with the fulcrum of the painting consisting of the affectionate relationship that binds her to the Child seated in her lap. The innovative aspect of this small painting is, in fact, the intimacy in which the two figures are enveloped. Not by chance was Leonardo to repeat the position of the leg extended diagonally, draped in blue, over 30 years later in 1510, for the Madonna stretching out her arms toward her son in the painting of *Saint Anne* (Paris, Louvre). But here the affectionate exchange lies in the barely visible smile on the lips of the young mother, whose suspended emotion Leonardo captures superbly. This figure clearly shows a

The Benois Madonna, c. 1478;
St Petersburg, Hermitage.

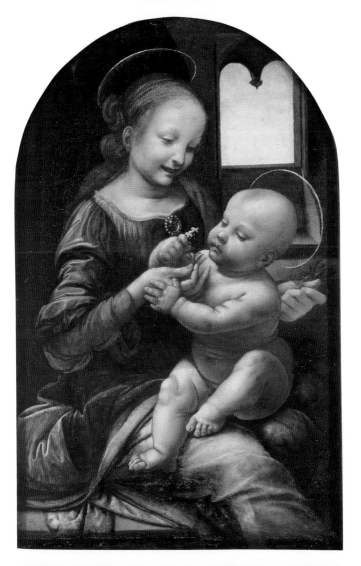

transposition of Leonardo's studies of what he was to call the '*moti dell'animo*' ('motions of the soul'), and the painting, in this sense, foreshadows *The Adoration of the Magi*. Since those 'heads of some women laughing' sculpted by the young Leonardo have now been lost, *The Benois Madonna* is the earliest display, in another medium, of his efforts to portray that expression, which is perhaps fixed here for the first time in a painting: the delicate smile expressed by the vivacious eyes and the barely open mouth showing a glimpse of the teeth.

The Child is intent on studying the object held out for his attention. One of his hands rests on that of his mother, as if to hold it still, while with the other he grasps the little flower, gazing at it in curiosity. In this case the white flower that the Madonna is offering her child is a crucifer, recognizable as a symbol of the Passion, but the symbolic meaning of the scene, which thus alludes to the sacrifice of Christ, is fused in the painting with the spontaneity and naturalness conferred on the two figures by Leonardo. The Virgin, holding the Child in her lap, is depicted in a bare, enclosed space. Through the little window at the back only a portion of luminous sky can be seen. Scientific examination of the painting has shown that the window once opened on to a landscape, which was later painted over, probably because it had remained unfinished. In any case the figures, placed in a domestic interior, are enveloped in shadow and brought into relief by the direct light falling on them from above. Here Leonardo begins to conceive of painting as experimentation in the optical phenomena that

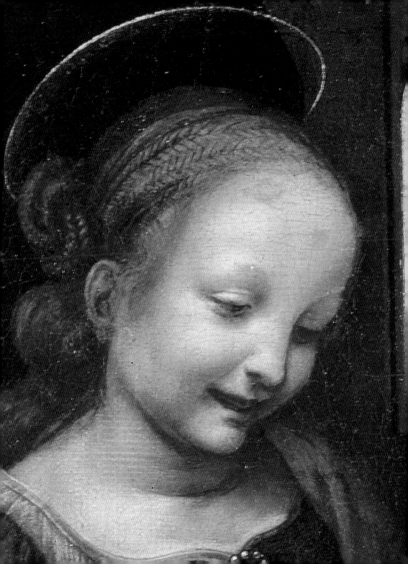

occur in relationship to the figures, according to a concept he was to develop still further in the paintings done during his years in Milan.

For its innovative characteristics of unity and vivacity, this work was immediately acclaimed by his contemporaries, and became the model for a number of paintings of the Madonna and Child. Copies by many painters have survived, among them one by Filippino Lippi at the Galleria Colonna in Rome. Other replicas differ in some points but clearly reveal their relationship to Leonardo's invention. One of these, now in Dresden, was painted by Lorenzo di Credi, who had also been apprenticed to Verrocchio.

It has been suggested that the work should be considered a Medici commission, due to its dating of around 1478, the year of the Pazzi Conspiracy in which Giuliano de' Medici, brother of Lorenzo the Magnificent, was assassinated. In the Child clutching the flower symbolic of martyrdom, Leonardo may have portrayed Giuliano, a son of Lorenzo the Magnificent, born in 1479 and named after his uncle in memory of him. If this is so, Leonardo would have portrayed, in this infant, that same Giuliano de' Medici who, almost 35 years later, was to invite him to Rome, where Leonardo remained in his service for nearly three years before deciding to leave for France, immediately after Giuliano's death in 1516.

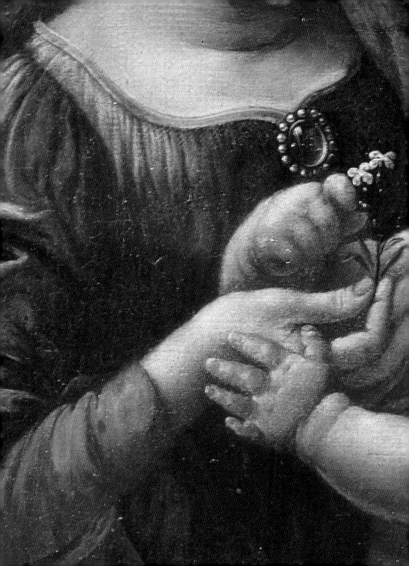

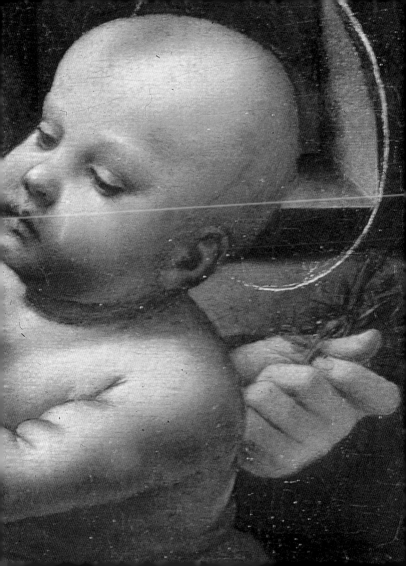

The Adoration of the Magi

The commission for this altarpiece dates from 1481; this is the only official documentation of a work painted by Leonardo during his first Florentine period. The great altarpiece was painted for the Monastery of San Donato a Scopeto, near Florence.

The commission was probably conferred on Leonardo through his father's connections, as Ser Piero acted as notary for the monks in the monastery. However, Leonardo left for Milan the following year, leaving the panel in its unfinished state to be safeguarded in the home of Amerigo Benci, the father of the Ginevra whose portrait he had painted some years earlier. Fifteen years later Filippino Lippi was to paint for San Donato a Scopeto an altarpiece representing *The Adoration of the Magi*, now in the Galleria degli Uffizi, which in part reflects the original design of Leonardo.

Vasari provides information on the work, including mention of the incompleteness that was distinctive of so many of Leonardo's artworks: 'He began a panel with the

The Adoration of the Magi, 1481;
Florence, Galleria degli Uffizi.

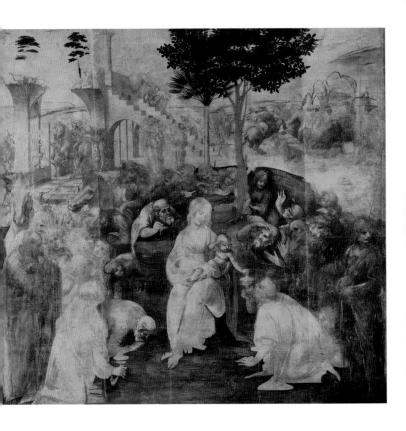

Adoration of the Magi on which are many beautiful things, especially the heads [...] which too remained imperfect like his other things.'

In this work, Leonardo took up the challenge of historical painting, that type of representation in which many figures are present to illustrate the unfolding of an event of historical, religious or mythological nature. A theoretical basis for this figurative genre had been provided by Leon Battista Alberti, who in his treatise *De Pictura* defined *historia* as a narration acted out by various people before the eyes of the observer. The great trials undertaken by Leonardo in the field of historical painting were to be *The Last Supper* in Santa Maria delle Grazie in Milan and *The Battle of Anghiari* in the Palazzo Vecchio in Florence, which would have been a monumental demonstration of the rich potential Leonardo saw in this form of representation.

The general organization of this scene conceived by Leonardo reveals his great innovative talent in interpreting a subject, such as the Adoration of the Magi, that was strongly rooted in the Tuscan figurative tradition. The fulcrum of the painting is the figure of the Madonna seated in the foreground with the Child in her lap; around this central core Leonardo orchestrates, in a spiralling motion, the crowd of people surrounding her.

Preliminary drawings show that Leonardo had originally designed a strictly perspective scheme within which to place his figures; he later abandoned this idea in favour of a freer definition of space, obtained through the effects of light and shadow and the movements of the bodies.

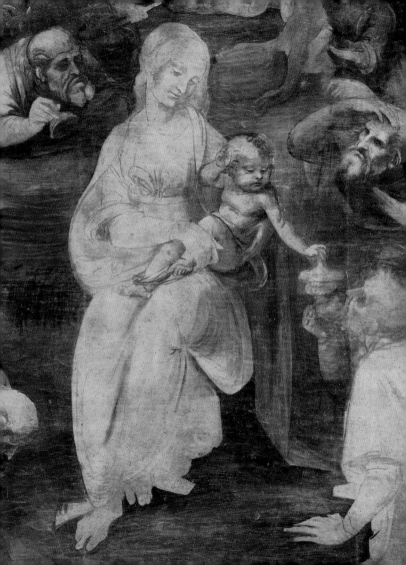

In Leonardo's vision, the unified composition of *The Adoration of the Magi* is achieved through the positioning of a multitude of figures, each of them expressing a different emotion before the revelation of the Epiphany. In the figures who appear in this painting, Leonardo deepens his study of variations in the movements of bodies, the gestures of hands, in physiognomies, ages and facial expressions (creating those 'heads' praised by Vasari).

Although the great panel was left in the state of a monochrome sketch, Leonardo went beyond the stage of a detailed preparatory drawing so far as to achieve a fine modulation of chiaroscuro, with transitions in tones ranging from black to brown, to red and then to a greenish tint. The dark brushstrokes create areas of shadow, pushing them into the background so that the light-toned preparatory base emerges to form the lighted surfaces. This technique gives the figures a strong effect of relief, although the reading of the work is now impaired to some extent by the presence of areas of severely oxidized paint on the surface.

In the background, on the left, is a crumbling architectural structure, alluding to the ruins of the pagan world, with pilasters and tiers of steps thronged with figures. In the upper right-hand corner, above the barely sketched figures of the ox and the ass, appears the sloping roof of the hut of the Nativity, almost outside the composition and thus indicating a moment in time prior to that of the scene of the Adoration, which Leonardo sets in a different space, outdoors. Still on the right, in contrast to the scene unfolding in the foreground, the territory between the ruins

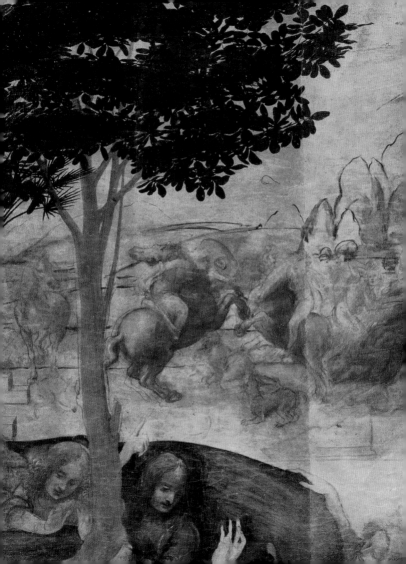

and the hut is occupied in depth by a battle fought by men on horseback. Here, the artist's intention of rendering the impetus of the clash anticipates the basic concepts of the plan for *The Battle of Anghiari*, which Leonardo was to work on 20 years later, after his return to Florence.

On the far right and the far left two standing figures, like the wings of a stage, introduce the spectators to the scene. The one on the left, an old man wrapped in a cloak and absorbed in contemplation, occupies the space in the foreground next to a figure seen from behind, kneeling, who recalls the angel painted by Leonardo in Verrocchio's *Baptism of Christ*. The equivalent figure on the right is a young man whose gaze is turned outward, beyond the edge of the picture, while his right arm is raised, pointing toward the centre of the composition. It has been suggested that this figure, whose presence sanctions the transition from the outer space of the observer to the inner one of the painting, is a self-portrait of Leonardo at about the age of 30.

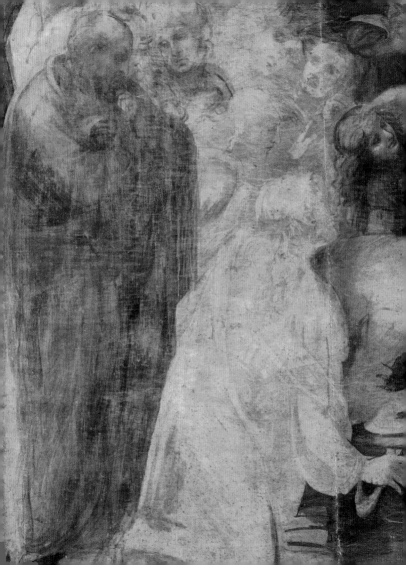

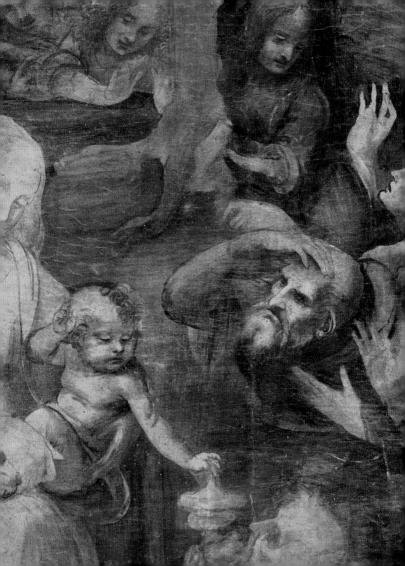

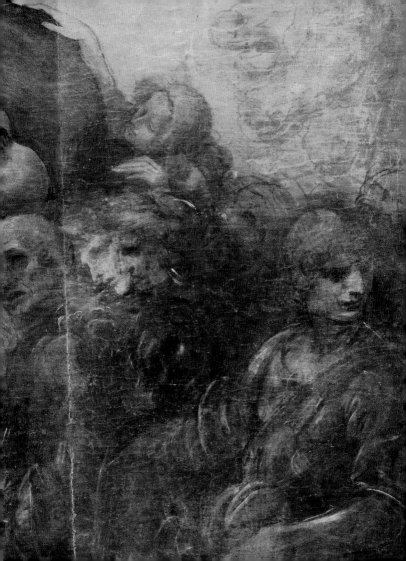

SAINT JEROME

Since the client who commissioned the *Saint Jerome* is unknown, the intended destination of this painting, begun by Leonardo in Florence shortly before he left for Milan, is also unknown. The work remained unfinished, like *The Adoration of the Magi*, as a monochrome painting.

The theme of the penitent Saint Jerome served as the inspiration for Leonardo to depict a scene in which the dramatic atmosphere is determined by the subject's facial expression and the portrayal of his body.

In Leonardo's composition, the saint is shown in the act of beating his breast with a stone grasped in his fist, while with the other hand he pulls aside his garment to reveal the structure of his body, strongly modelled by chiaroscuro in high contrast. The anatomical study of the figure, with the neck and collarbone standing out in accentuated relief, is striking. However, compared with Leonardo's subsequent scientific research, conducted through the dissection of corpses, this is still an artistic kind of anatomy, aimed at

Saint Jerome, 1480–2;
Vatican City, Pinacoteca Vaticana.

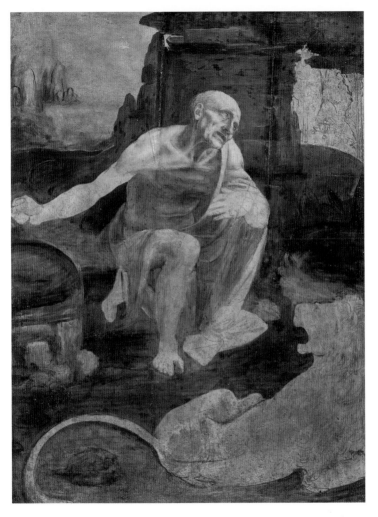

rendering the external aspect of the body rather than revealing its inner structure. But what is exceptionally effective is the synthesis of the figure, resolved in the dynamic force of the gesture.

With one knee extended in the opposite direction to that of the arm, the body reveals the three-dimensional quality of space. The arm stretches out, like the pointer of a compass, as far as the left margin of the picture and is ready to rotate, hinged on the shoulder. The entire painting is occupied by this action, which suggests the movement itself, the moment before and the moment after.

Framed by rocks both nearby and far away, foreshadowing the setting of *The Virgin of the Rocks*, the figure of the saint stands out against dark background. The landscape opens out to the left to reveal the steep profile of the distant mountains, delineated with long brushstrokes. On the right, through an opening in the rocks, appears the view of an architectural structure seen in perspective. This sketch has been identified as a representation of Santa Maria Novella, the Florentine church whose façade had been completed by Leon Battista Alberti some ten years earlier. The gap between the rocks is bounded, on the far right, by a foreshortened Christ on the Crucifix, whose barely suggested profile bends to meet the saint's gaze. The light-coloured profile of the lion, scored by brushstrokes to indicate the thick mass of its mane, forcefully suggests the impetus of its roar.

It has been observed that the figure depicted in *Saint Jerome* could be one of the throng of people who appear in

The Adoration of the Magi; it is, in fact, in these two works that Leonardo depicted the physiognomy of old men for the first time. Later, in his writings, he was to express the need to diversify the figures according to age, illustrating in detail the changes that occur in the body from youth to maturity, and then to old age. The painter, according to Leonardo, should delineate figures in these terms: 'Young men with few muscles in their limbs, and veins of delicate surface, and rounded limbs of pleasant colour. In mature men, the limbs will be muscular, showing the nerves. In old men, they will be wrinkled, rough and full of veins, and the nerves very evident.'

Over the course of time this panel has been severely damaged. The section containing the saint's head was actually removed and used as the seat of a stool, while the rest of the wooden panel was used as the cover for a box. The two parts were found again by Cardinal Joseph Fesch, Napoleon's uncle, and were then reassembled.

THE VIRGIN OF THE ROCKS

The first document to mention Leonardo's presence in Milan is the contract for *The Virgin of the Rocks*, dating from April 1483. This painting was commissioned by the Confraternity of the Immaculate Conception, and the names of the brothers Ambrogio and Evangelista de Predis appear in the document along with that of Leonardo. The project called for several painted panels, which were to be inserted within the complex structure of a carved and decorated wooden altar, already completed by Giacomo del Maino. The work as a whole thus included both painting and sculpture, and was destined for the Chapel of the Immaculate Conception in the Church of San Francesco Grande in Milan, now destroyed.

Leonardo's collaborators would therefore have been Evangelista de Predis, who was to refinish and decorate the wooden altar, and his brother Ambrogio, who was to paint eight musical angels, four on each side, for the side panels. Leonardo was to paint the central element, in which he was

The Virgin of the Rocks, 1483–6;
Paris, Musée du Louvre.

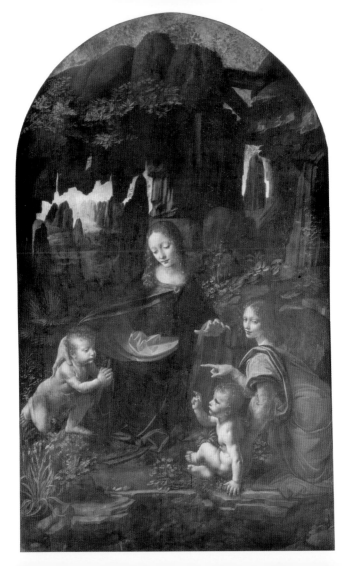

requested to portray 'Our Lady', the Virgin, in honour of the doctrine of the Immaculate Conception.

Two versions exist of the work known as *The Virgin of the Rocks*, painted by Leonardo, one in Paris in the Louvre, the other in London in the National Gallery. Identical in size, the two versions differ significantly in composition and style. The one in the Louvre, originally painted on a panel but transferred to canvas in the 19th century, is the first, and the only version entirely by the hand of Leonardo. Echoing his previous Florentine experience, it can be dated to the 1480s on the basis of stylistic evidence.

Leonardo envisaged a scene abounding in complex symbolic implications, starting with the setting in a rocky landscape, traversed by streams flowing away to be lost in the distance. Within this scenery, created by the geological stratifications in which the figures are immersed and surrounded by flourishing vegetation, looms the dark cavity of the grotto, evoking the mysteries of nature and the origin of life.

The observer is summoned to enter the composition, introduced into the scene by the Archangel Gabriel, on the right, who turns on us a gaze both eloquent and enigmatic, accompanied by a gesture of the hand pointing to the infant Saint John, while with his other hand he supports the Christ Child. In his treatment of the angel's head, Leonardo echoes a drawing, now in Turin, in which he depicts the face, with the same evocative gaze directed at the observer, of a young woman who resembles Cecilia Gallerani (*Lady with an Ermine*).

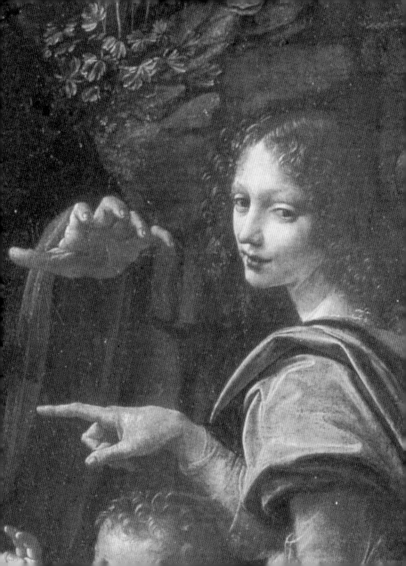

The pyramid-like arrangement holds the four figures in a tight exchange of gestures and gazes. At the apex is the Virgin who, her hand raised as if in a solemn act, holds her open palm over the Child, seated in the foreground below her. The angel's hand, occupying precisely the space between the Virgin's hand and the Child's head, introduces a straight horizontal line, as if to form the sign of an invisible cross. The Christ Child's gesture of benediction is directed at the infant Saint John, kneeling with hands joined as if in prayer. The circle is closed by the ample movement of the Virgin's arm, extending to include the infant Saint John and opening her mantle to reveal the luminous surface of the lining.

The figures emerge from the darkness, brought out by the light falling from the upper left-hand side. Through the stratagem of placing the figures on the threshold of a shadowy space, in this case the grotto, and lighting them from above, Leonardo verifies an optical phenomenon he had already experimented with on a smaller scale in *The Benois Madonna* (*c.* 1478). Transposed here to the majestic setting of the rocks, this condition heightens the intensity of both lighted zones and shadows, demonstrating a technique defined by Leonardo in his theoretical writings as 'augmentation of shadows and lights': in other words, chiaroscuro. The effect of the extreme contrast in lighting almost entirely nullifies the half-tones, the intermediate transitions between light and shadow, so that the lighted parts have no shadow tones while their light, luminous reflections cannot be distinguished in the dark

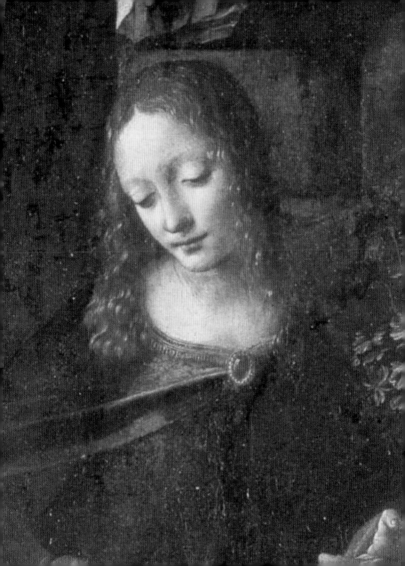

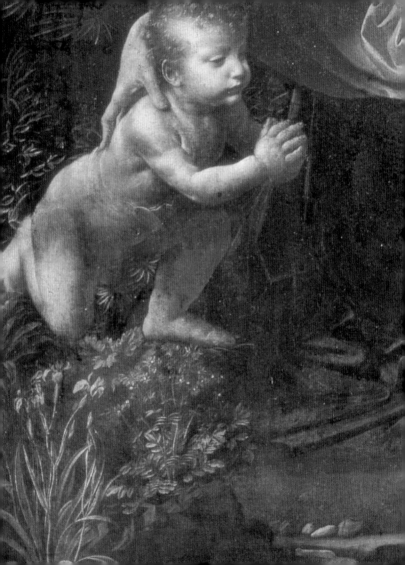

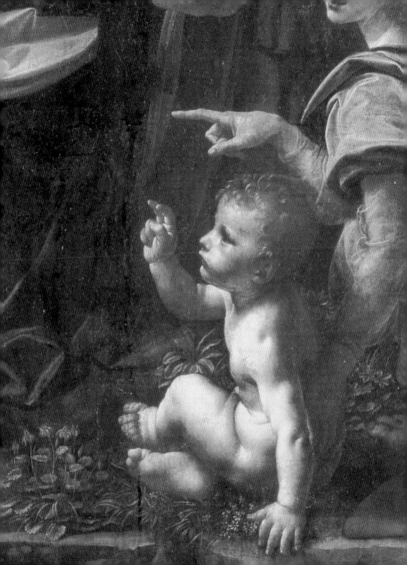

shadows. The theory was explained by Leonardo himself: 'Due to this augmentation of shadows and lights the face appears in sharp relief, and in the lighted part the shadow is almost imperceptible and in the shadowy part are almost imperceptible lights.' This is apparent in the figures, where the light falls only on the surfaces turned upward, leaving wrapped in shadow, in the central part of the picture, the bodies of the Virgin and the infant Saint John, the Christ Child's back, and the angel's left hand and right foot, barely perceptible in the semi-obscurity.

In the almost monochrome background, the contrast between light and dark zones is based on distance, with the dark, sharp contours of the rocks in the grotto directly juxtaposed, as if as in a jigsaw, with the hazy profiles of the light peaks of the distant mountains. Here Leonardo recreates the phenomenon of layers of moist air, interposed between the eye and the landscape, which blurs the view.

THE VIRGIN OF THE ROCKS

(second version)

This is the second version of *The Virgin of the Rocks*, painted by Leonardo with the aid of assistants. The picture, now in London, is documented as coming directly from the Church of San Francesco Grande in Milan. It may thus be identified as the panel that was eventually placed at the centre of the altar in the Chapel of the Immaculate Conception, as stipulated by the original contract dating from 1483. The first version was probably completed within a few years but, instead of being consigned to the Confraternity that had commissioned it, was sold for 100 ducats to either the King of France or Ludovico il Moro, who may have then presented it to Emperor Maximilian I. In any case, that painting, now in the Louvre, already formed part of the French royal collections in the first half of the 17th century.

It is possible that in place of the first version, which is imbued with obscure symbolic significance, it was decided

The Virgin of the Rocks,
1491–5 and 1506–8;
London, National Gallery.

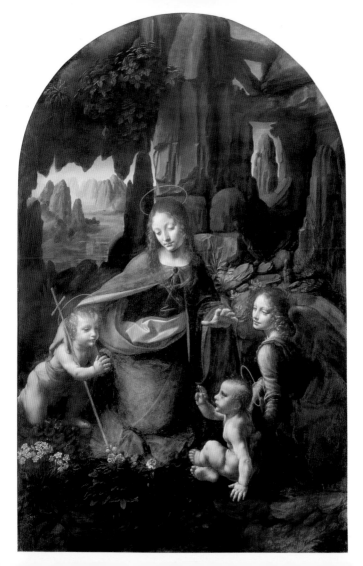

to have a second version painted, introducing simplifications that are apparent in this panel in the collection of the National Gallery. For the iconographic scheme, centred on the figure of the Virgin, Leonardo was probably inspired by the Gnostic vision of the Blessed Amedeo Mendes da Silva, whose text *Apocalypsis Nova* he may have owned. In this interpretation, a fundamental role was assigned to Saint John (as indicated in the first version by the gesture of the angel emphatically pointing to him), while the Virgin represented the fullness of perfection; with reference to wisdom she was identified with the idea of universal knowledge, one of her attributes being the gift of 'total science'.

As regards the composition, obvious changes can be seen, especially in the figure of the Archangel Gabriel. These changes were probably made at the request of the monks of the Confraternity, who may have been disturbed by the importance given to the infant Saint John in the previous version. Accordingly, both the pointing hand and the gaze with which the angel invited the observer to approach the mystery of the representation were eliminated. The angel now has a dreamy, absorbed expression and the painting as a whole has lost that complex spatial network of mutual references represented by the interwoven gestures and glances of the figures. In this version the message is conveyed by more conventional elements, such as the halos and the cross borne by the infant Saint John, which renders him easily recognizable; but these details could also have been added during the course of the following centuries, since they do not appear in old copies of the painting.

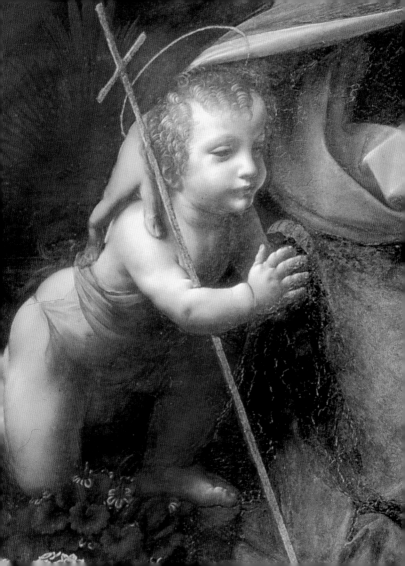

The picture was painted by Leonardo in the 1490s, although it remained unfinished, as proven by the fact that he was urged to return to Milan to complete it in 1506, while he was living in Florence. However, much of the work was delegated by Leonardo to his collaborators, Ambrogio de Predis, who is mentioned in the contract, and perhaps also Marco d'Oggiono and Giovan Antonio Boltraffio, his most important Milanese pupils. Under X-ray examination the London painting shows a great number of corrections, especially in the positions and heads of the figures, as if the final result was achieved by successive adjustments. Leonardo must have made the preparatory brush drawing, and then added the final touches to the painting at the end.

The second version, as compared to the first, represents an evolution in the monumental sense, with a more sculptural rendering of the figures and the structure of the rocky landscape around them. The subtle atmospheric effects typical of Leonardo are entirely lacking here, and the background, with the mountains appearing lighter in the distance, gives the impression of a lesson learned and schematically repeated by assistants.

The true hand of Leonardo can instead be seen in the fingerprints with which, in the final stage, he perfected the *sfumato* of the faces; and in the long, slender stalks of the plant, standing out against the rocky pinnacle on the far right, which is formed of a series of dark brushstrokes, without any drawing, applied over the existing layer of paint. Most particularly his hand is evident in the area at

the lower right, which is left unfinished, where the jagged rocky wall at the bottom of the painting is skilfully sketched in monochrome.

The distinctive element common to both versions of *The Virgin of the Rocks* is Leonardo's conception of pictorial space as a dark cavity, permeated by the vital forces of nature, concealing within it a revelation.

Among Leonardo's papers is the story of an experience, perhaps imaginary, perhaps real, in which he wandered through a dark, rocky landscape and arrived at the mouth of a large cavern. The description conveys the vast number of meanings associated by Leonardo with this concept of a space within which lies the unknown; meanings linked to the search for knowledge, the mysteries of nature and the conflicting emotions of curiosity and dread, desire and fear: 'And drawn on by my ardent desire, yearning to see the great number of strange and various forms created by the artifice of nature, wandering long amid the shadowy rocks, I came to the entrance of a great cavern [...] I was assailed at once by two things, fear and desire; fear of the dark, threatening cavern, desire to see if any miraculous thing should lie within it.'

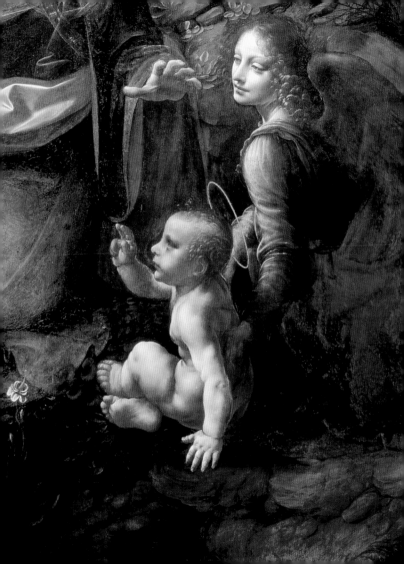

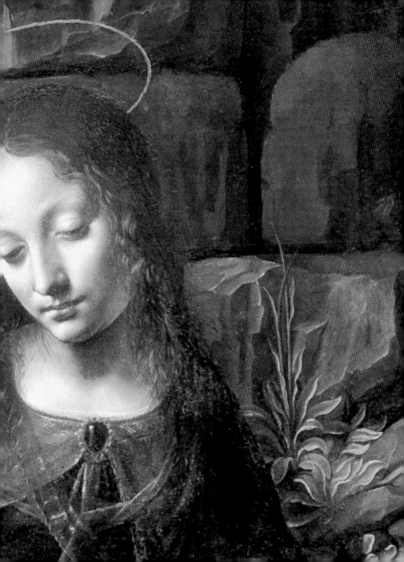

PORTRAIT OF A MUSICIAN

This portrait dates from Leonardo's first years in Milan. In that city, at the court of Ludovico il Moro, Leonardo had arrived expressly in the capacity of musician and inventor of a bizarre, original musical instrument, which he presented to the duke: a lyre in the shape of a horse's skull. This was a *lira da braccio*, meant to be played with a bow, and we know that Leonardo excelled at playing this instrument, accompanying himself as he improvised songs or recited poetry. Regarding Leonardo's innate talent for music, Vasari reports: 'He studied music for some time, and soon decided to learn to play the lyre, as one on whom nature had bestowed a refined and elevated spirit, accompanying himself as he sang and improvised divinely.'

In his writings Leonardo extolled the qualities of music, based on the concepts of harmony and proportion, indispensable factors in pictorial composition as well. It was in these terms that he formulated his definition of the relationship between the two arts: 'Music can be called no

Portrait of a Musician, c. 1485;
Milan, Pinacoteca Ambrosiana.

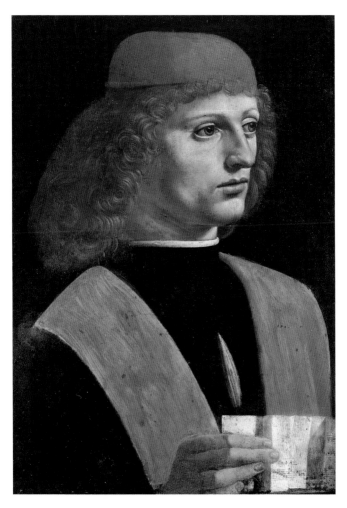

other than the sister of painting [...] it composes harmony by conjoining its proportional parts ...' But music was only a little sister of the art deemed supreme by Leonardo – painting. It is pre-eminent and 'reigns supreme', he declared, 'because it does not die immediately after its creation, as does hapless music, but remains in being ...' Thus the portrait conserves the likeness of a person beyond the limits imposed by nature and time.

In the attempt to identify the musician portrayed by Leonardo, one of several names that have been suggested is that of Josquin des Prez, a French musician at the court of 'il Moro'. In another hypothesis the sitter is thought to be Franchino Gaffurio, author of the treatise called *Angelicus ac divinum opus*, which is perhaps referred to by the fragmentary inscription 'CANT[UM] ANG[ELICUM]' that appears on the musical score painted by Leonardo.

However, Gaffurio, who had been chapel master of the Duomo in Milan since 1484, was nearly 40 years old at the time this portrait was painted. Leonardo could, instead, be portraying here the 20-year-old Atalante Migliorotti, who had accompanied him from Florence on the musical mission to Ludovico il Moro ordered by Lorenzo the Magnificent. Atalante is said to have learned the art of playing the lyre expressly from Leonardo. And Leonardo, in turn, had portrayed the features of his music pupil in a drawing mentioned in his papers as 'a head portraying Atalante, raising his face'.

The head of the musician in this portrait is raised in an erect position. His face, in the relief of the cheekbones and

the jaw, echoes the anatomical research on the bones of the cranium conducted by Leonardo at this time. The eyes are fixed on a distant point, and the deeply absorbed gaze seems to allude to the sense of hearing, as if the subject were listening intently to a melody, or were about to burst into song himself.

At some time in the past the hand holding the folded paper with the musical score was painted over, so that it was covered by the black colour of the gown and the ochre tint of the two vertical bands on the unfinished stole. It was only in the early years of the 20th century that a restorer brought back to light the crucially important detail of the paper that identifies the subject as a musician. With this restoration the painting became once more a testimonial to Leonardo's desire to allude, through painting, to the art that was its 'little sister' – music.

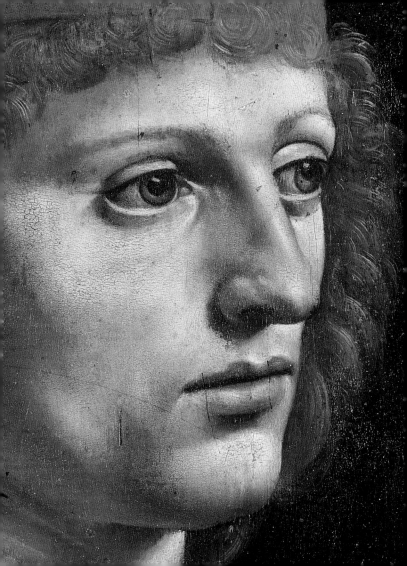

LADY WITH AN ERMINE
(PORTRAIT OF CECILIA GALLERANI)

Commissioned from Leonardo by Ludovico il Moro, this painting portrays Cecilia Gallerani, the duke's mistress, distinguished in his court for her intellectual gifts and her love of music, philosophy and literature. Here she is shown in the act of turning to the right, her gaze sweeping across the space of the picture, her eyes lit up in a barely suggested greeting, her lips imperceptibly smiling.

Leonard's striking ability to catch the spontaneity of an attitude and the mobility of an expression suggest that he may have been applying here his theory of *moti mentali* (mental motions). The representation of the ermine emphasizes still further, through a subtle resemblance of its features, the dynamic quality conferred by Leonardo on the figure of the young woman.

Radiographic examination of the picture shows that a window has been deleted on the right. In all probability

Lady with an Ermine
(*Portrait of Cecilia Gallerani*),
1488–90;
Krakow, Czartoryski Muzeum.

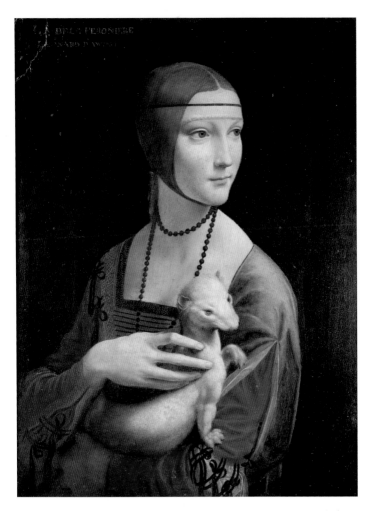

this was done by Leonardo himself, considering that during his time in Milan he was experimenting in his portraits with the phenomenon of a figure emerging from a dark background. In his notes he expressly mentions a courtyard 'with walls painted black' against which to place the subject to be portrayed, in order to achieve the desired effect of three-dimensional relief. In the definition of the figure, the optical phenomenon according to which the parts in shadow receive luminous reflections from the lighter areas is clearly apparent. It can be seen on the neck, the cheek and along the lower edge of the hand; a hand that reveals Leonardo's anatomical studies and investigation of the structure of the body in terms of joints and the ways in which they bend.

The various interpretations of this painting that have been posited – psychological, emblematic and even political – are linked to the presence of the ermine. In a drawing now in the Fitzwilliam Museum in Cambridge, *The Allegory of the Ermine*, Leonardo illustrated the scene of the little animal that lets itself be captured by a hunter rather than soil its white coat with mud.

The ermine also appears in a collection of writings on real and imaginary animals, a kind of bestiary compiled by Leonardo in the pages of one of his manuscripts. It is a small pocket notebook, known today as *Codex H*, which dates precisely from the years he spent in Milan. Leonardo must have used these notes to elaborate allegories and emblems, and the descriptions of the characteristics of each animal, which are sometimes factual and sometimes entirely

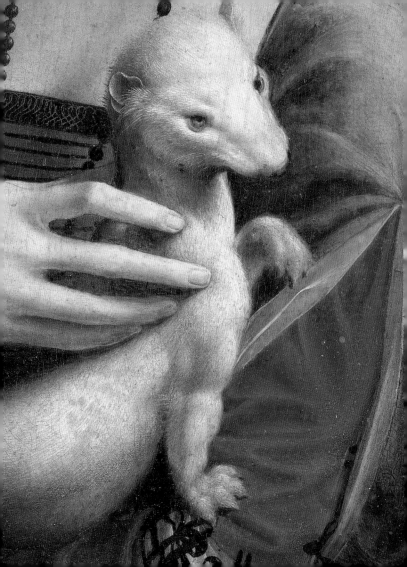

imaginary, often contain a moral teaching applicable to human behaviour. Among the descriptions appears this one, which goes under the title of 'Moderation': 'The ermine, due to its moderation, eats only once a day, and had rather let itself be caught by hunters than flee through the muddy fields, so as not to stain its nobility.'

The ermine, with its pure white coat, thus alludes to the noble spirit of the woman portrayed. A further connection can be seen, between the name of Cecilia Gallerani and the name of the animal in Greek, *galè*. But in addition to revealing the identity of the subject of the painting, like the juniper bush in the *Portrait of Ginevra Benci*, the ermine (*ermellino* in Italian) clearly refers to Ludovico il Moro.

A sonnet on the subject of this portrait by Leonardo, written by the court poet Bernardo Bellincioni, refers to the duke, hailing him as '*l'italico morel, biancho hermellino*', a play on the colour contrast between Ludovico's appellative 'Moro' (or 'black'), and the symbolic associations of the white animal adopted by the duke as his emblem: 'All ermine he is, although his name is black.' Moreover, the King of Naples, Ferrante d'Aragona, had conferred on 'il Moro' the high honour of the Order of Saint Michael, known as the 'Armellino'.

In conclusion, it may be conjectured that, in Leonardo's portrait, the gaze of Cecilia Gallerani is fixed on Ludovico il Moro himself. The whole painting, in fact, alludes to his invisible presence, as well as to her own eloquent, intense personality.

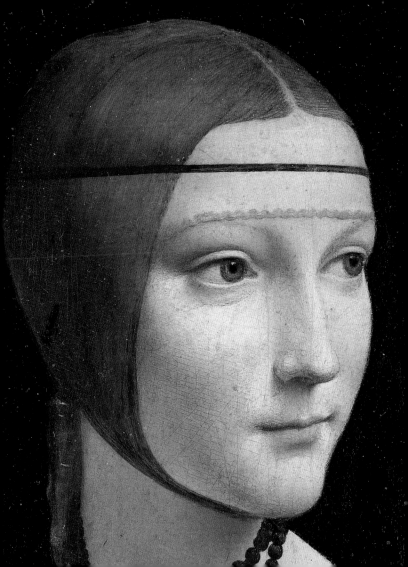

PORTRAIT OF A LADY
(LA BELLE FERRONNIÈRE)

Leonardo painted this portrait, like that of Cecilia Gallerani, for Ludovico il Moro. The subject has been identified as Lucrezia Crivelli, the duke's last mistress, who had a son by him and followed him in his flight from Milan after the arrival of the French troops. The name given to the painting, *La Belle Ferronnière*, derives from a mistaken identification dating from the 18th century, when the work, which had long formed part of the royal collections of France, was thought to be a portrait of the mistress of King François I, and was recorded as such in an inventory. The identification with Lucrezia Crivelli is based on the recognition of this painting as the one mentioned in three Latin epigrams written in the *Codex Atlanticus*, not by Leonardo but by a court poet. Praising the beautiful Lucrezia, they include the line: 'Pinxit Leonardus, amavit Maurus.' ('Leonardo painted her, "il Moro" loved her.')

Portrait of a Lady
(*La Belle Ferronnière*),
c. 1495;
Paris, Musée du Louvre.

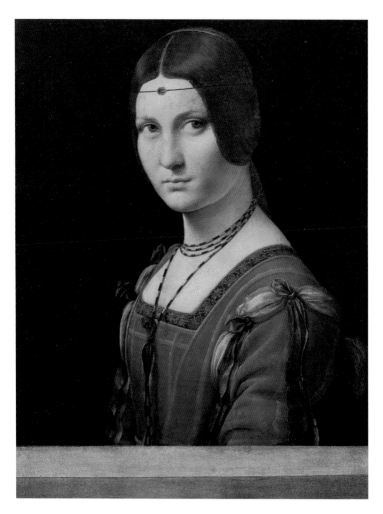

This portrait is of the 'shoulder' type, in which the figure is three-quarters turned toward the observer. With regard to Leonardo's portraits of women, there is a drawing in the Windsor collection that shows the bust of a woman observed from no fewer than 18 different viewpoints. In his theoretical writings, Leonardo formulated the concept of the infinite variety of positions that can be assumed by the eye in relation to the object it is viewing – the idea, that is, that perception is relative to the place from which objects are observed: 'The same attitude can be shown in infinite variety, because the places from which it may be seen are infinite in number.'

Based on Leonardo's theory, moreover, the multiplicity of points of view does not depend merely on the shifting position of the eyes but also on the fact that a body can rotate through space. The two movements are interchangeable, and his suggestion is in fact that of turning either the body or the eye. It is thus clear that, for Leonardo, the choice of a 'shoulder' portrait conveys a dynamic sense of volume, insofar as it alludes to the fact that the position fixed by the painting is merely one among all of the possible positions that may be generated by the rotation of a figure, or of the eye around it.

In this case the lady in the portrait appears beyond a balustrade interposed between her and the observer. Her gaze is projected forward toward the right, so that it seems to move from any position in which she is observed.

The figure appears enveloped in a luminous glow of warm tones, reflecting the scientific observations conduct-

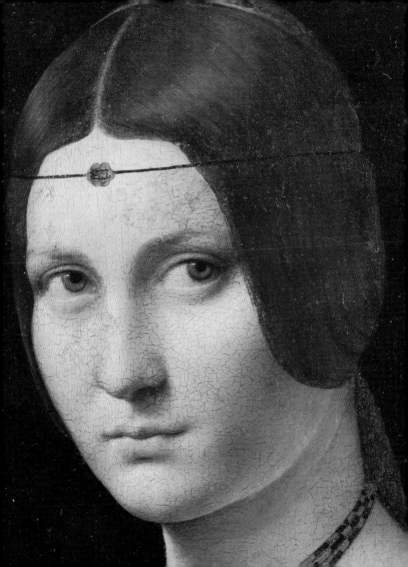

ed by Leonardo on the phenomenon of colour. Here, in fact, some of the results of his research into light and shadow, and especially on the effects of coloured shadows, may be seen. In accordance with the optical phenomena studied by Leonardo, who found that beams of reflected light bear with them the 'similitude of colours', the incident rays of light falling from above to illuminate the flesh tones and the red fabric of the gown cast reflections on the parts in shadow. The colour of the surface from which they come thus contributes to the colour of the shadowed areas.

This is apparent along the lower profile of the cheek, which on the right side, with the rotation of the head, receives a glowing reddish reflection from the illuminated surface of the shoulder. Although the effect is heightened by the colour of the dress, it derives mainly from the reflection of the mirror-like surfaces of the flesh: 'The reflections of the flesh that receive light from other flesh are redder and of more lovely complexion ...'

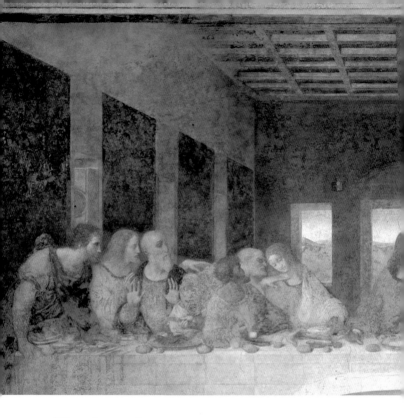

THE LAST SUPPER

The commission conferred on Leonardo, to paint the scene of the Last Supper on the wall of the Refectory of Santa Maria delle Grazie, formed one part of a larger project

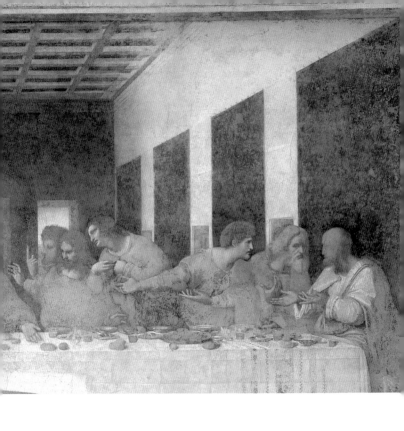

The Last Supper,
1495–8;
Milan, Refectory
of Santa Maria delle Grazie.

initiated by Ludovico il Moro. Explicit reference to his patronage appears in the lunettes above the painting bearing the Sforza coat of arms, surrounded by garlands of symbolic fruit and leaves alluding to the crucifixion (the pear), martyrdom (the palm) and salvation (the apple). The duke intended to transform the church and monastery into a monumental complex serving a precise function: it was here, in fact, that he wished to be buried. On the architectural level, the project had been conceived by Bramante, who had designed the great apse as a central element to be grafted on to the existing late Gothic structure.

Leonardo's painting of *The Last Supper* was to occupy one of the shorter sides of the great elongated hall of the Refectory, while on the opposite side the scene of the Crucifixion, painted by the Milanese artist Giovanni Donato di Montorfano in an archaic style, described by Vasari as 'old-fashioned', had just been completed.

In Florentine painting of the 15th century, the Last Supper was a recurrent subject, and the scene was traditionally distinguished by the orderly arrangement of the participants, seated along a table that extended to occupy space horizontally. In bold contrast with this static scheme, in Leonardo's innovative interpretation the monumental figures of the Apostles are brought together in an impetuous flow of motion. Leonardo's intention was to show the Apostles' disparate attitudes and reactions at the crucial moment described in Matthew's Gospel, at which Christ declares, 'Verily I say unto you: one of you will betray me.'

The first description of this work dates from 1498, the

178

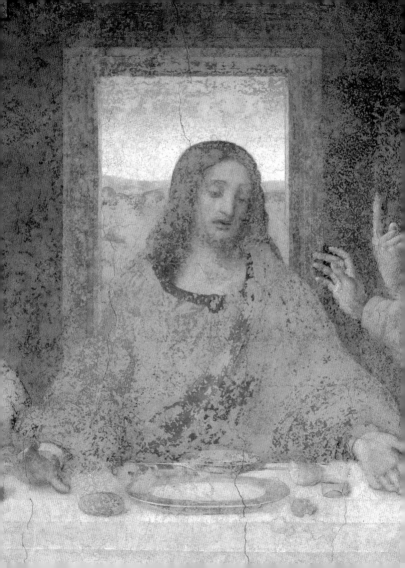

year in which it was completed, and was written by the mathematician Luca Pacioli, a friend of Leonardo, who praises *The Last Supper* in the dedication to Ludovico il Moro that serves as the prologue to his treatise *De divina proportione*. Luca Pacioli confirms Leonardo's precise intention to render the Apostles' chaotic reactions of dismay at the words of Christ. In his eulogy he states: 'It is impossible to imagine the Apostles displaying any greater shocked attention at the sound of the voice of the ineffable truth when He said: "*Unus vestrum me traditurus est.*"' Immediately then, as in the eyes of Pacioli, the newly finished painting appeared to all as a superb theatre of gestures, an eloquent demonstration, through the language of images, of the way in which a complex scene in which each person communicates his own emotional reaction can be rendered so forcefully as to make it seem that only sound is missing: 'With acts and gestures they seem to speak one with another, and that other with still another, with vivid and afflicted admiration ...'

The results achieved in *The Last Supper* illustrate Leonardo's theories on the *moti dell'animo* (motions of the soul), which had been partly developed through his research into anatomy and physiognomy. In his writings he declared the need to confer on figures the capacity to express, through their attitudes, the positions of their hands and the expressions on their faces – 'with their limbs' – what they were thinking, 'the concept of their minds'. The object was to render visible, through the movements of the body, the inner life. In the words of Leonardo, 'No figure

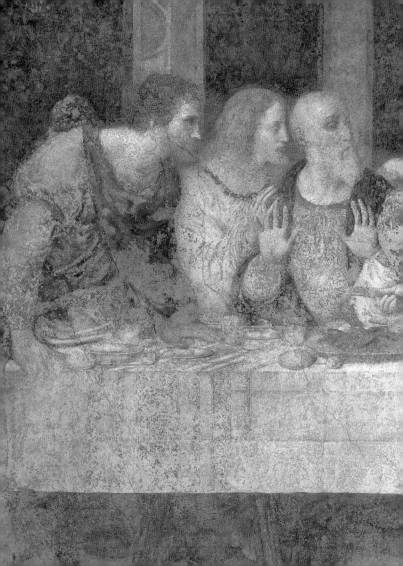

can be deemed praiseworthy unless it expresses through its acts, as far as possible, the passion of its soul.'

On this subject Leonardo noted on a sheet, along with other preparatory studies for the Apostles in *The Last Supper*, a precept for the painter: the procedure to be applied in representing a figure is of a mental, rather than a technical or practical nature, and it consists of focusing on the true character of the subject – that is, on his intent. In a reminder addressed primarily to himself, Leonardo states: 'When you make your figure, consider well who it is and what you want it to do, and make sure that the work resembles the intention and the objective.'

The close-linked chain of gestures, gazes, expressions and pointing hands binds together the figures of the Apostles, who appear rhythmically divided into groups of three. There are two groups on each side of Christ, who remains immobile at the centre, as the fixed point and the origin, through the words he has spoken, of the movement that sweeps like a wave through the figures around him. Starting from the left, the figures in the first group, with their three heads turned toward Christ, are Bartholomew, James the Minor and Andrew; the last is shown in an attitude of dumbfounded amazement succinctly described by Leonardo himself: 'With his hands open, showing his palms, he raises his shoulders toward his ears and makes a mouth of astonishment.'

The second group, uniting Judas, Peter and John, expresses the most complex significance. The figure of the betrayer who, in the foreground, grasps in his right hand the

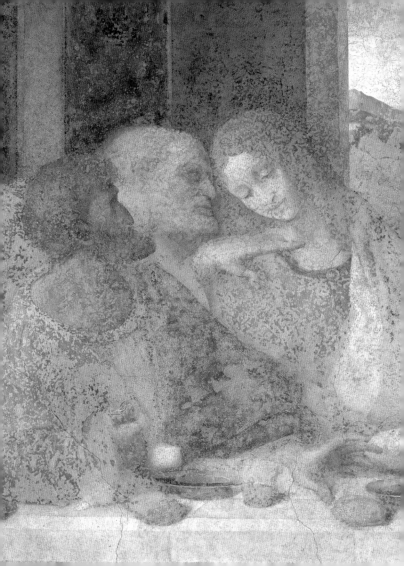

bag of coins, is shown sitting among the other Apostles and not placed in isolation on the opposite side of the table in line with the traditional iconography, by which he was clearly designated as the predestined guilty one. That concept is rejected here, in accordance with the principle of free will, upheld by the Dominical order to which Santa Maria delle Grazie belonged. Peter emerges from behind Judas, his old man's face in close contrast to the youthful, delicate features of John. The latter is bending to the left, parallel to the line softly marked by the landscape in the space opening out in the background between him and Christ, whose arm establishes an opposed oblique line.

Moving to the right, the first group seems to be questioning Christ more directly. Thomas points his finger upward, James the Major throws open his arms in a broad gesture of indignation that measures the depth of space and repeats the diagonal formed by Christ's other arm. Philip points questioningly at himself. On the far right, Matthew, Timothy and Simon are conversing excitedly, with great demonstrative movement of their hands in dynamic succession. Their gestures direct the observer's attention from the edge of the painting back to its centre.

The figure of Christ forms the vertex at which the lines of the perspective construction converge, organizing the space in which the scene is set. By placing the vanishing point at a notable height, well above the observer's viewpoint, Leonardo reveals his intention of using perspective scenographically, to achieve a monumental effect. The head of Christ, intersecting the horizon line, stands out against

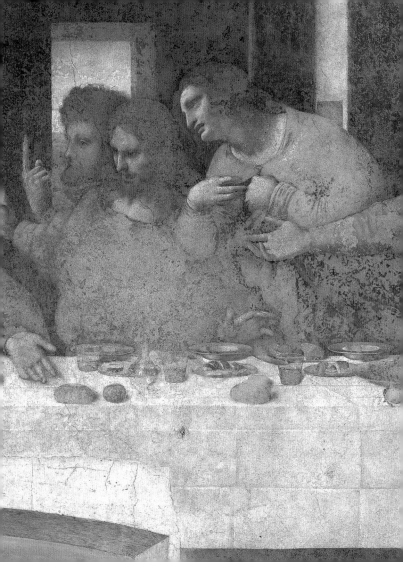

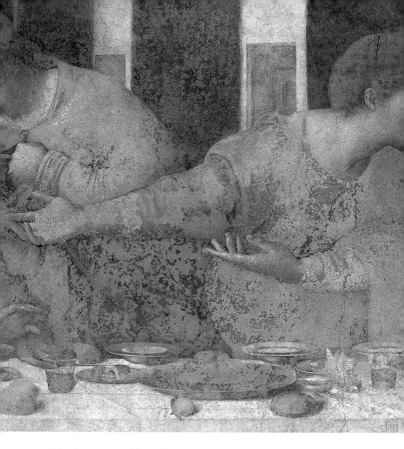

the luminous blue of the sky, framed in the opening of the
door at the centre, through which, as through the two win-
dows, the landscape in the background can be seen.

In the foreground, the table constitutes a magnificent

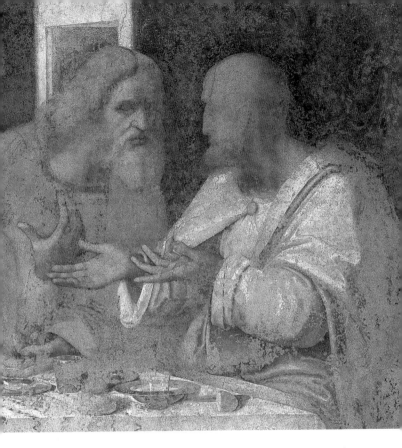

still life in the precision of the details and the clarity with
which the various materials are rendered, as in the regular
pattern of the folds in the tablecloth and the transparency
of the wine glasses.

Unfortunately, due to the experimental technique employed by Leonardo, *The Last Supper* very soon began 'to perish'. Only 70 years after it had been painted Vasari called it 'so badly done that all that can now be seen of it is a glaring spot'. At the risk of jeopardizing the whole work, as was to be the case with the experimentation attempted in painting *The Battle of Anghiari*, Leonardo rejected the durable technique of fresco to satisfy his need to work in successive stages, following the unpredictable timing of bursts of creative inspiration.

Leonardo painted *The Last Supper* in tempera and oil over two preparatory layers, on the dry wall as if it were a wood panel. The erratic rhythm of the undertaking was reported by Matteo Bandello, who witnessed Leonardo at work: 'I have seen him (according to the caprice or whim of the moment) leave [...] and come straight to the Grazie: and having climbed on to the scaffolding, take up the brush, and give one or two brushstrokes to one of those figures and immediately leave and go elsewhere.'

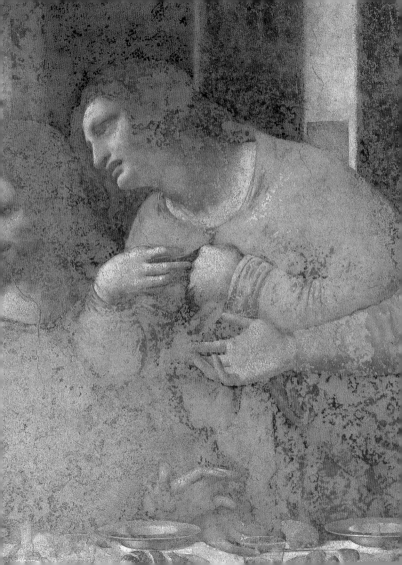

SALA DELLE ASSE

In the same years in which he painted *The Last Supper*, Leonardo decorated the Sala delle Asse in the Castello Sforzesco. This great hall, which occupies the ground floor of the square tower situated to the northeast, must have been used as a cool retreat in summer during hot weather. Leonardo designed a decorative scheme that reproduces an outdoor space, in which great trees with their trunks growing up the walls extend their branches to cover the entire ceiling, where they create a dense pergola with a complex interwoven pattern.

The actual execution of the decoration was probably delegated by Leonardo to some of his assistants, working from his own ingenious design, which conceived the entire decoration of the hall as a challenge to imitate nature. The concept of reproducing a natural setting in paint overlies the celebratory intent of the design. The Sforza coat of arms dominates the room from the centre of the ceiling, and plaques bearing inscriptions appear on the corner vaulting

Painted decoration of the Sala delle Asse, with the Sforza coat of arms at the centre of the ceiling 1497–8; Milan, Castello Sforzesco.

On p. 193: Monochrome decoration of roots and rocks on the northeastern wall of the Sala delle Asse.

supporting it; but the tribute to Ludovico il Moro is expressed most significantly by the plants themselves, with the black mulberry tree (*gelso-moro* in Italian) alluding directly to the duke, not only in its name but also in the qualities associated with it – prudence and wisdom – and in the political symbolism of the tree as the column that bears up the state. Moreover, this vision of the plant world, which in its morphological details reflects the botanical studies conducted by Leonardo, is enriched by a distinctive geometric component, in the elaborate artifice of making the ceiling simulate a pergola. The branches cross one another to form pointed arches and the fronds are tied with cords forming knots in a virtuoso compositional scheme, the entwined willows, or *vinci*, alluding to his own name. This motif replicates the geometrical symmetries worked out by Leonardo in his drawings.

A reading of the original parts is severely hampered today by the heavy repainting of an early 19th-century restoration. A later intervention, in 1954, has brought to light two large monochrome fragments, painted by brush on the plaster, depicting great roots winding through rocks and breaking up their stratified structure. These must be the bases of the trunks that terminate above in the geometrical pattern of branches, the image of organic life and natural forces in action, capable at the same time of both generation and destruction.

Sala delle Asse:
wall with inscription
decorated with
great tree trunks
(gelso-moro,
black mulberry),
whose boughs extend
to the ceiling to create
a pergola effect.

DOVICVS · MEDIOL · DVX
L · DVCATVS · TITVLVM · IVSQVE
MORTVO · DVC · PHILIPPO · AVO
NTE · SFORTIANA · OBTINERE ·
POTVERAT · AB · DIVO · MAX · RO
REGE · IMPERATOREQVE
MAGNIS · E · MVLTIS VS
HONORIBVS · ACCEPTI

Portrait of Isabella d'Este

This is the portrait commissioned by Isabella, Marchesa of Mantua, in whose castle Leonardo stayed when he left Milan, after the French troops had entered the city and driven out Ludovico il Moro. Isabella d'Este, wife of Francesco Gonzaga, was the daughter of Ercole d'Este, Duke of Ferrara. Her sister Beatrice had been married to Ludovico il Moro. In close contact, then, with the Sforza court, Isabella had even borrowed the *Portrait of Cecilia Gallerani* and ardently desired one of herself painted by Leonardo.

The work was to have formed part of the rich collection in her Studiolo. Isabella was, in fact, one of the earliest promoters of the arts. She was a collector in the modern sense, following the principle later to be adopted by all the sovereigns of Europe, that the possession of works of art served to increase a ruler's prestige.

Of the portrait planned by Leonardo only the cartoon has survived, in a precarious state of conservation, together with the preparatory drawing done in charcoal and red

Portrait of Isabella d'Este,
1499–1500;
Paris, Musée du Louvre.

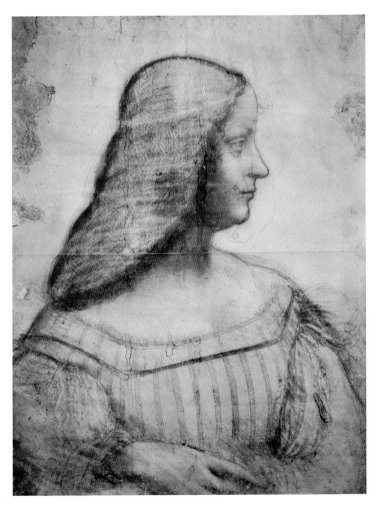

197

chalk, with touches of pastel yellow for the ribbons on the gown. On the cartoon can be seen the holes punched to transpose the drawing on to a wooden panel using the technique of dusting, but the work 'in colour' was never painted. The cartoon, with the punching that newly interprets some of the the outlines for transferring on to a panel, constitutes the tangible trace of that delicate stage in which Leonardo passed from drawing to painting.

The figure of Isabella is placed behind a balustrade, like that of *La Belle Ferronnière*, and here the hands folded one over the other, presaging those of the *Mona Lisa*, are visible in the foreground. The barely indicated gesture of a finger pointing to a book, at the lower right, alludes to Isabella's intellectual interests. The image harmoniously combines the three-dimensional perception of the bust, turning slightly, and the line of the profile, which shows an obvious reference to examples of classical portraiture. The whole figure is turning imperceptibly on itself to assume this complicated pose in which the hands are seen from the front while the face appears in profile.

This solution can be seen as a synthesis of the *Three views of the same head* (Turin, Biblioteca Reale), a drawing in which the same subject is studied from three points of view: front, three-quarters and right profile. Perhaps this drawing too, executed shortly after the cartoon for Isabella, concealed within itself the project for another portrait of an illustrious personage: Cesare Borgia.

HEAD OF A YOUNG WOMAN
(LA SCAPILIATA)

The image portrayed in this unfinished painting expresses Leonardo's idea of beauty linked to the concept of natural grace. In his notes Leonardo suggests focusing attention on the properties generated by changes in the light as it falls on faces. The conditions he deems most congenial for observing the evocative tones of varying light are caused by atmospheric changes – that is, by alterations in the weather and by the different times of the day when the luminosity of the sky varies. And it is in looking directly at the people he meets 'in the streets, as evening falls', that Leonardo suggests acquiring experience by contemplating faces immersed in the subtle nuances of light and shadow. Accordingly, he writes, 'Consider in the streets, at the approach of evening, the faces of men and women during bad weather, how much grace and sweetness can be seen in them.'

Head of a Young Woman
(*La Scapiliata*),
c. 1508;
Parma, Galleria Nazionale.

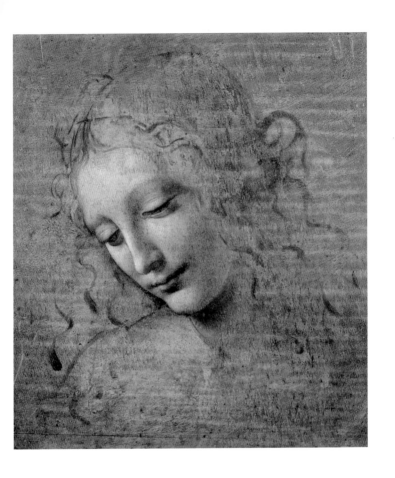

201

Wondrous admiration can be aroused by the sight of a face in a painting, but in real life as well, at its manifestation of grace and sweetness. The contrast arises, then, between these natural gifts and the useless ostentation of artificial ornaments, as noted by Leonardo: 'Do you not see among human beauties how the sight of a beautiful face, and not that of rich ornaments, stops the passers-by?'

But the remark in his notes that is most appropriate to the theme of *La Scapiliata* is his recommendation that heads should be portrayed with the hair blown by the wind. *La Scapiliata* embodies this particular precept for painting: 'Make your heads with the hair tossed by a fictitious wind around youthful faces, and with different turnings graciously adorn them.'

The free play of tousled, wind-blown hair resembles, in Leonardo's theory, the representation of flows of currents of water. The lines of force of whirlpools in their spiralling motion are compared to waving, curly locks of hair. In Leonardo's manuscripts this similarity accords with the fundamental logic of his thought, which recognizes continuous analogies between the forms existing in nature. And this explains the spontaneous, pointed criticism with which Leonardo ridicules those who, on the contrary, oppose to natural beauty a vain search for artificial splendour: 'And they have always as their adviser the mirror and the comb, while the wind, as it tosses and tangles their smartly dressed hair, is their greatest enemy.'

The first account of this work dates from the 19th century, when it entered the collections of the Accademia di

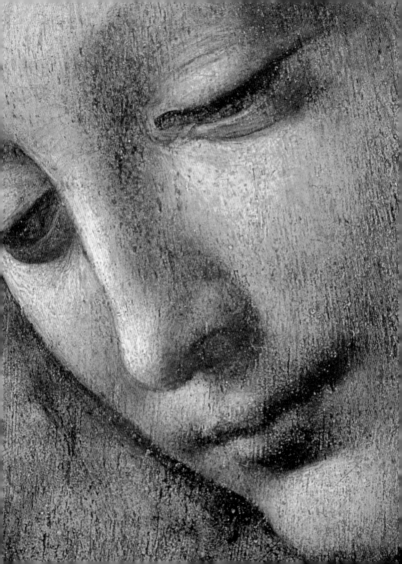

Belle Arti in Parma. The reference to the small panel emphasizes the exceptional nature of the acquisition, calling it 'a little Leonardo da Vinci, an extremely rare thing to find in our day'.

In the 20th century this head of a young woman was identified as a work by Leonardo mentioned in the Gonzaga inventory of 1625. It was here that the term *scapiliata* ('woman with tousled hair') was first used to describe the subject in one word, a word that then became the name of the work: 'A painting depicting the head of a woman with tousled hair, a sketch framed in violin wood, the work of Leonardo da Vinci.'

The monochrome painting was executed in umber, green amber and white lead preparation on a poplar wood panel. Stylistic affinities with the cartoon for the *Saint Anne* in London, painted around the same time, have been recognized, as well as with the second version of *The Virgin of the Rocks*, finished in 1508. In the latter case there is a close analogy with the technique employed by Leonardo to delineate the sketch, still readable in the non-finished parts, such as the left hand of the angel supporting the Child, where brushstrokes applied with the same speed and freedom as those that distinguish *La Scapiliata* have also been observed.

THE VIRGIN AND CHILD WITH SAINT ANNE AND SAINT JOHN THE BAPTIST

It was around the turn of the century, about 1500, that Leonardo, upon returning to Florence after a period of almost 20 years in Milan, began to develop the theme of the *Saint Anne*. The central core of the composition is the figure of Saint Anne, the Virgin's mother; close beside her is her daughter, who holds the Christ Child in her arms. The most striking invention is the way in which the bodies are forcefully linked to one another, rendering visible the relationship between mother and child. The figures in this group are positioned in space according to a logical succession of movements and emotions, of which Leonardo sketches infinite variations in his drawings. The various studies are in fact dedicated to coordinating the poses, inclinations, directions and mutual interweaving of the limbs. The graphic elaboration produces a series of alternative solutions, which reveal continuous research, aimed at

The Virgin and Child with Saint Anne and Saint John the Baptist,
1500 or 1506–8;
London, National Gallery.

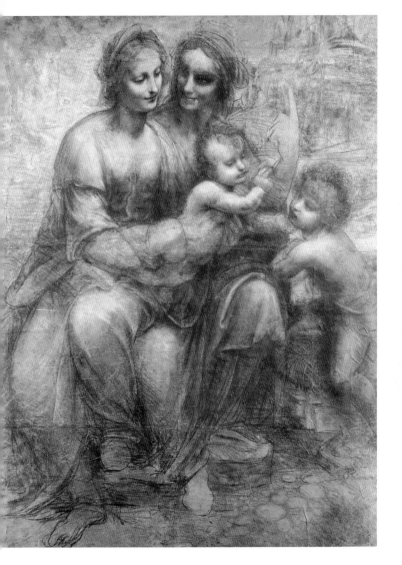

bringing forms into dynamic harmony with one another. Leonardo continued to work on this composition, developing it through sketches and studies, for over ten years, before he finally completed the work now in the Louvre in Paris. In addition to the modes of interaction between the principal figures, a further variation on the theme consists of the presence beside the Christ Child of either the young Saint John, as in the cartoon in London, or the lamb, as in the painting in Paris.

The first record of a picture with Saint Anne on which Leonardo was working dates from 1501 and mentions a cartoon in which there appears 'a Christ Child about one year old who, leaning almost out of his mother's lap, has seized a lamb which he seems to be pressing to him.' This work, now lost, was seen in Leonardo's studio, then located at Santissima Annunziata, by the agent of Isabella d'Este, who reported, 'This sketch is not yet finished.' The iconography he describes, with the presence of the lamb, seems to refer to the solution Leonardo was to adopt for the painting. Regarding the London cartoon, with the young Saint John, critics are divided between the hypothesis that this work also dates from around 1500, and the opinion that it is instead, like the painting now in Paris, the later elaboration of ideas matured over the course of years. A drawing, now in the British Museum, datable at around 1508, constitutes a reference for the composition of the cartoon; here the charcoal lines are so thick and close together as to render the figures barely legible, as if they were in motion before Leonardo's eyes.

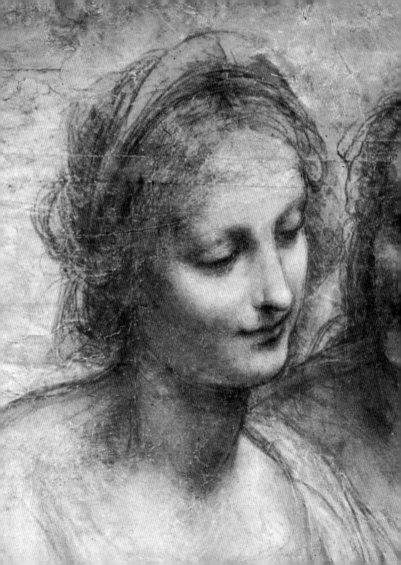

On the other hand, the monumental definition of the group formed by the Virgin and Saint Anne seems to echo the concept developed by Leonardo in the figures of *The Last Supper*, painted in Milan during the last years of the 15th century. Compared to that work the cartoon, with its silent dialogue conveyed by the expressions and glances exchanged between the two women, along with the gesture of Saint Anne's hand, constitutes a sharp turn toward a more intimate, intensified atmosphere.

The sculptural quality that lies at the heart of the composition suggests a direct reflection of the study of classical models; an experience that could date from a journey to Rome made by Leonardo in 1501 before returning to Florence. On that occasion, at Hadrian's Villa in Tivoli, he may have seen the majestic series of the *Muses* (now in Madrid, Prado Museum), great ancient Greek statues just unearthed in the first excavations conducted expressly for the purpose during those years. Saint Anne and the Virgin reiterate the almost architectural structure of the ancient example, from the two heads placed beside one another to the complex articulation in space and the dynamic play of the legs concealed by rich draperies.

In the cartoon, white lead highlighting is used to create the effect of relief on the forms; and, in still another analogy with sculpture, the two figures superimposed, or rather incorporated within each other, seem to belong to a single block of marble, along with the Child brought by encircling arms within the original core formed of the two mothers.

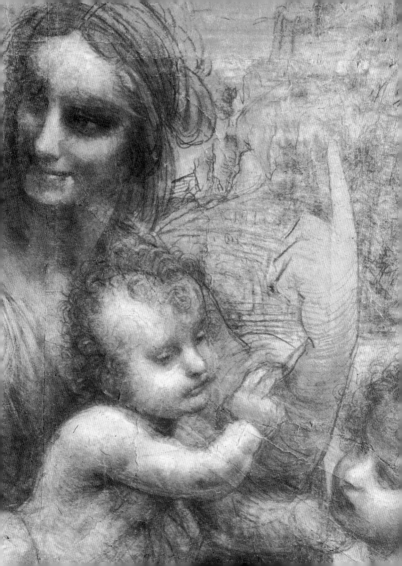

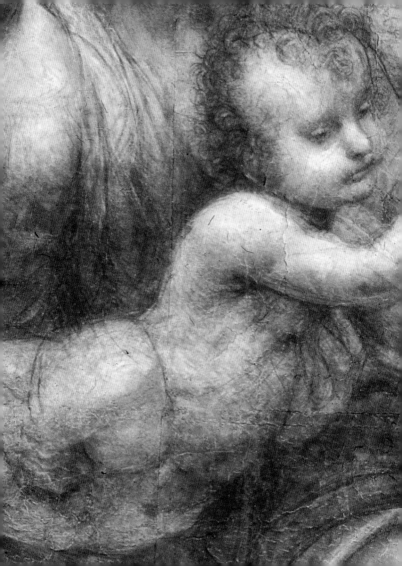

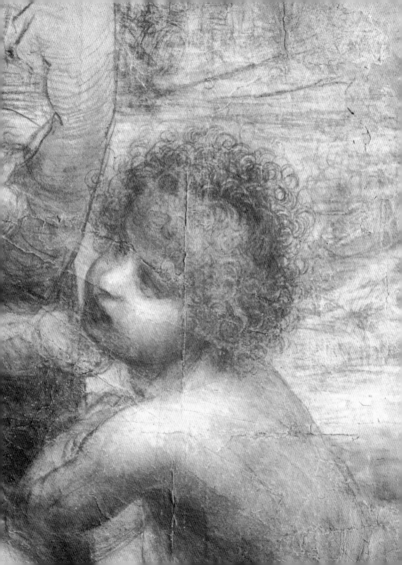

THE VIRGIN AND CHILD
WITH SAINT ANNE AND A LAMB

This painting represents the solution at which Leonardo arrived after a long process of development, which is documented by the drawings and the cartoon now in London. When compared with the cartoon, the painting shows significant differences in its composition. The group, consisting of Saint Anne holding the Virgin, her daughter, in her lap, is structured as a pyramid; the two figures are no longer placed solidly side by side but are shown in more accentuated movement, which generates oblique and opposed lines.

In the graphic experimentation of his drawings, Leonardo portrays the two women as forms inseparable from each other, as if this were the simultaneous representation of two different positions assumed by a single person in successive stages. The group thus achieves a unitary synthesis that encompasses within it, intrinsically, the very principle of movement. The figure of Saint Anne is the

The Virgin and Child
with Saint Anne and a Lamb,
1510–13;
Paris, Musée du Louvre.

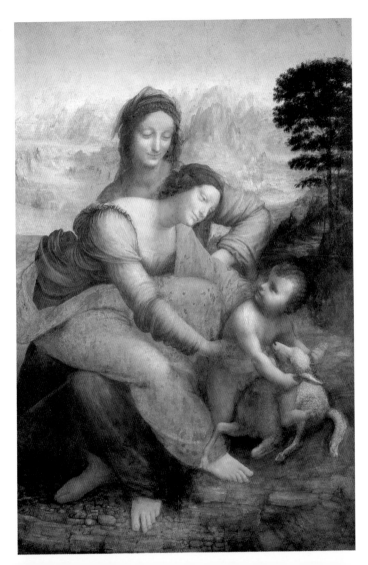

supporting axis of the composition, of which her head forms the vertex. The Madonna's figure is inscribed within the space created by the body of Saint Anne, who stretches out her bent arm and, while she turns her gaze to the right, twists her knees instead toward the left. The tension that enlivens the figure of the Virgin in the London cartoon is transposed here to that of Saint Anne. The Virgin leans forward, her body positioned according to the opposing diagonals of the legs and back, whose directions are reinforced by the lines of the neck and head, and those of her arms stretched out toward the Child.

The interaction of their glances and gestures circulates among the figures and seems to spread like an echo. It starts with Saint Anne, who is lowering her eyes to look down at the Virgin. She leans forward to take into her arms the Child who, turning back, exchanges glances with his mother while he replicates the gesture of her arms, grasping the lamb's ears in his hands. On the face of each of the three people, the intense exchange of glances is accompanied by the barest hint of a smile.

By the early 16th century Leonardo had already drawn a cartoon, now lost, whose subject was the group of the Virgin and Child with Saint Anne and a lamb. The symbolic meaning of the composition, in which the figures are closely bound together, is explained by a contemporary description: 'The mother, almost rising from the knees of Saint Anne, grasps the Child to take him away from the lamb [a sacrificial animal] which signifies the Passion.' The lamb represents sacrifice, the destiny of Christ from which

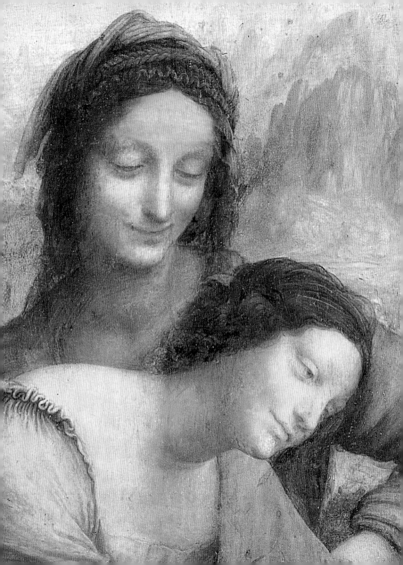

his mother, in an instinctive gesture, tries to save him, while the presence of Saint Anne alludes to the role of the Church, or that of divine grace, which comforts the Mother and the Child.

Leonardo brought this work with him from Italy to France, where the secretary of Cardinal Luigi d'Aragona reported having seen a picture 'of the Madonna and her son who are sitting in the lap of Saint Anne,' and added that the paintings shown them were 'all most perfect'. In reality the *Saint Anne* still has unfinished parts, such as a portion of the Virgin's blue drapery. This intricate drapery is further developed by Leonardo in a drawing, datable to the last year of his life when, as reported by an eye-witness, his hand was no longer able to 'colour with that sweetness of before, although he still works at making drawings'.

From the minute detail of the pebbles in the foreground, on which rest the bare feet of Saint Anne, there opens out behind the figures the vision of a timeless space in which the crags of mountain peaks are lost in an azure glow amid mists and streams. The indefinable distance is rendered through the greater intensity of the azure blue that permeates the entire landscape, in accordance with a practical precept formulated by Leonardo: 'That which you intend to show five times further away, make it five times bluer.' The phenomenon described in his writings occurs due to the interposition of air between the eye and the object observed, so that, 'The blue air makes the distant mountains appear blue.'

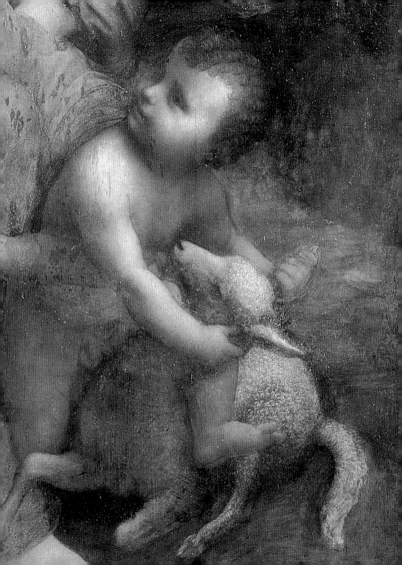

SAINT JOHN THE BAPTIST

When Leonardo was already in France residing in the manor of Clos-Lucé at Cloux near Amboise, he received a visit from the Cardinal of Aragona, whose secretary wrote that he had seen on that occasion a picture 'of Saint John the Baptist as a youth', along with two other paintings that can be identified as the *Mona Lisa* and the *Saint Anne* now in the Louvre. Leonardo had thus brought this painting with him from Italy, and he kept it with him during the last years of his life. But the conception of the *Saint John* probably dates from the years when Leonardo was still in Florence, around 1508, when he collaborated with his friend the sculptor Giovan Francesco Rustici in designing the bronze group called *The Preaching of the Baptist*, destined to be placed above the north door of the Florentine Baptistery, which was dedicated expressly to Saint John. Leonardo must have contributed substantially to the planning of this sculptural work, with the saint at the centre, between the Levite and the Pharisee, raising his right hand to point upward and thus

Saint John the Baptist,
1505–7 or 1513–16;
Paris, Musée du Louvre.

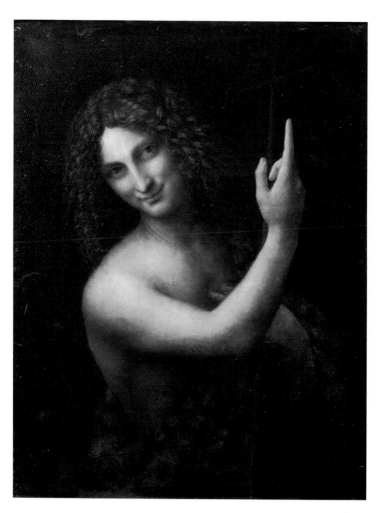

alluding to the concept underlying his message. Vasari states, with regard to Leonardo: 'In statuary he proved himself in three bronze figures' and refers to the work as 'sculpted by Giovan Francesco Rustici, but designed with the advice of Lionardo'.

Immediately prior to this reference to sculpture, Vasari considers Leonardo's contribution to painting, noting the introduction in his paintings of 'a certain obscurity', which represents a crucially important innovation, adopted later by 'modern' painters to confer, as Vasari states, 'great strength and relief on their figures.' That specific effect, invented by Leonardo, finds expression in this work, with the figure emerging gradually from the shadowy background; it is a method that has proved highly effective for rendering in painting the sculptural, solid nature of forms.

Saint John, with his enigmatic smile, emerges from the darkness; the light, coming from a source at the upper left, strikes the figure, revealing the three-dimensional figure by creating light surfaces and shadowy areas that contrast with each other and stand out in strong relief, following the principle expressed by Leonardo himself with great clarity, in formulating a kind of philosophical aphorism: 'White with black, or black with white, the one appears more potent due to the other, and thus the opposites always appear stronger.' The parts of the body shrouded in shadow remain visible and distinct against the undefined space of the background, and suggest a reference to the concept of the *lumen cinereum*, or dark side of the moon, which seems to emit a faint light, making it perceptible to the eye.

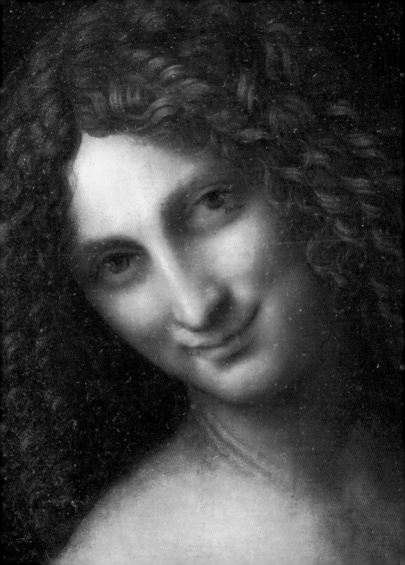

The three-quarters position of the figure emphasizes the projection of the shoulder and arm, which cut through space in the foreground, creating an arc that terminates in the hand raised at the height of the face. The gesture of the finger pointing upward is symmetrically correlated to the meaningful gaze of the subject. This is a recurring attitude in Leonardo's paintings, establishing a relationship between Saint John the Baptist and the other figures who use this gesture to allude to a higher sphere. Earlier, in *The Adoration of the Magi*, a figure among the circle of onlookers was represented in the act of pointing upward; the same pose was later to distinguish Saint Thomas, and his expression of amazement, in the ensemble of mixed emotions that animates *The Last Supper*. And lastly the gesture, accompanied by the same intense gaze, returns in the *Saint Anne* of the cartoon in the London National Gallery. This is therefore a recurrent motif, which Raphael had already recognized as a trademark or distinctive feature of Leonardo's painting, so much so that he replicated it in his own portrait of Leonardo in the guise of Plato in the centre of the *School of Athens* in the Vatican Stanze.

It is only in this painting, however, that the figure portrayed, with his allusive gesture, gazes directly at the observer; it is to us that Saint John addresses his message, without mediation. The pose reiterates an idea conceived by Leonardo for the image of the *Announcing Angel*; that painting is now lost but it was documented by several versions and replicas by followers, as well as by a drawing on a sheet at Windsor done by a pupil. In it, the angel turns

directly toward the observer and is thus portrayed as if seen from the viewpoint of the Virgin – subjectively, it might be said. Leonardo's invention seems to constitute the ideal correlative, as in a cinematic reverse angle, of *Our Lady of the Annunciation* by Antonello da Messina (Palermo, Galleria Regionale della Sicilia).

Compared to the pose for the *Announcing Angel*, in the *Saint John* the figure's arm has completed its rotation, coming to rest against the chest, conferring depth on the various planes of the body. The figure embodies the shining of light amid the shadows and the message he bears refers to something outside the scene that does not pertain to the sphere of the visible: an otherness that can only be evoked, since knowledge of it goes beyond the limitations of rational understanding. On the subject of the mind's ability to penetrate 'through the universe', Leonardo declared, 'Because it is finite it cannot reach the infinite.'

BACCHUS
(SAINT JOHN)

This work has been identified as the painting described as 'Saint John in the desert', which in the first half of the 17th century formed part of the French royal family's collection. The picture was listed again in an inventory from the late 17th century, in which it was defined specifically as 'St. Jean au desert', but the name was then deleted and replaced by that of 'Bacchus dans un paisage' ('Bacchus in a landscape'). Leonardo's original is thus to be found today under the subsequent additions and repainting that have transformed the sacred subject of the saint into the pagan one of the Greek god. The composition corresponds to a red chalk drawing by the hand of Leonardo, where the subject was depicted in a pose distinguished by the dynamic crossing of the legs and the flowing movement of the arm. That drawing is now lost, having been stolen in 1973 from the Museo del Sacro Monte in Varese. The figure appeared

Bacchus (Saint John),
1513–15;
Paris, Musée du Louvre.

230

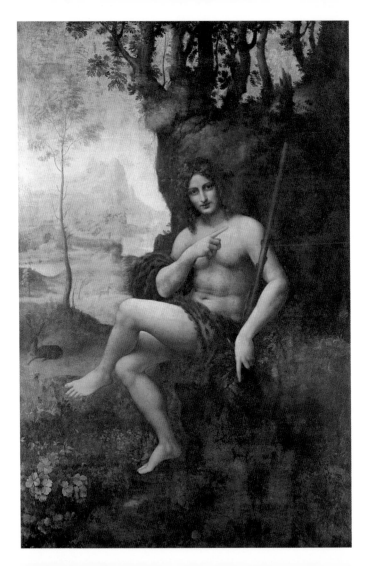

seated on a rocky bench, with trees behind him suggesting flourishing vegetation.

No information on the alterations undergone by the painting over the course of the centuries can be obtained by X-ray examination since the work, originally painted on a panel, was transposed on to canvas in the 19th century, and on that occasion was treated with ceruse (white lead), making it opaque to radiation. The most obvious additions, however, consist of the panther's skin draped around the waist and arm of the figure, and the crown of vine leaves. The cross, held by the hand turned downward and to which the other hand points, must also at some time have been transformed into the thrysus, the emblematic staff of Bacchus.

It almost seems as if the transformation of the figure interpreted the ambiguity that had been implicit since the very beginning in the iconography of this picture, which was probably painted by Leonardo with the collaboration of some of his pupils. The characterization of *Saint John the Baptist*, portrayed here not with the emaciated, suffering features of the traditional figure but through the sculptural rendering of the body's contours, must have suggested the possibility of transforming him into the pagan god. In addition to the reference to classical examples in the portrayal of the nude and the head with its curly hair, Leonardo's innovative style emerges in the setting: not the desolate scenery of a desert but a luxuriant landscape of flourishing vegetation, a vision of primordial nature in which life began.

Mona Lisa, or La Gioconda

This painting, universally known as the *Mona Lisa*, or *La Gioconda*, has always, over the centuries, been attributed without doubt to Leonardo; but at the same time it is still an enigma as regards the identity of the woman portrayed. Her name has been the subject of a vast number of widely varying hypotheses. Depending on the individual recognized in the portrait, moreover, theories about the dating of the work and the place where it was painted must necessarily differ. Among the women who really existed, and who could have been portrayed by Leonardo, have been mentioned not only Monna Lisa del Giocondo, but also Duchess Costanza d'Avalos, Marchesa Isabella d'Este, the noblewoman Pacifica Brandano and Signora Gualanda.

The basic reference point is the story narrated by Vasari, from which comes the name that has always been attributed to the portrait: 'Lionardo began to paint for Francesco del Giocondo a portrait of Monna Lisa his wife.' Vasari goes on to say, 'Having worked on it for four years he left it

Mona Lisa, or *La Gioconda*,
1503–13 and later;
Paris, Musée du Louvre.

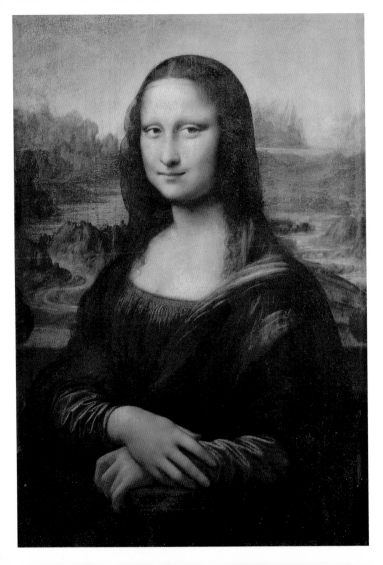

imperfect.' This information does not seem to correspond with the report written by the secretary of the Cardinal of Aragon, who is thought to have seen the portrait in France on the occasion of a visit to Leonardo there. His secretary recorded the words he had heard spoken by the master himself in relation to his paintings: 'In one of the towns the Lord who was with us went to visit Messer Lunardo Vinci Florentine [...] most excellent painter in our times, who showed his Illustrious Lordship three pictures, one of a certain Florentine lady, done from life, at the instance of the late Magnificent Giuliano de Medici ...'

And so, according to information gathered directly from the elderly Leonardo, a year and a half before his death, it seems that the painting, perfectly finished, portrayed a Florentine woman and it had been painted 'from life' at the request of the late Giuliano de' Medici. The reference to this member of the Medici family, under whose protection Leonardo had been during the years he spent in Rome, would advance the dating of the painting to after 1513, unless Leonardo had met Giuliano before then, perhaps at Venice in 1500, but certainly not in Florence, where the Medici had been driven out with the proclamation of the Florentine Republic.

The discrepancy between the two sources could however find an explanation and lead to a single hypothesis. In Rome, perhaps commissioned expressly by Giuliano de' Medici, who wanted to have a painting by him, Leonardo, instead of beginning a new painting, may have continued to work on the portrait that he had begun in Florence.

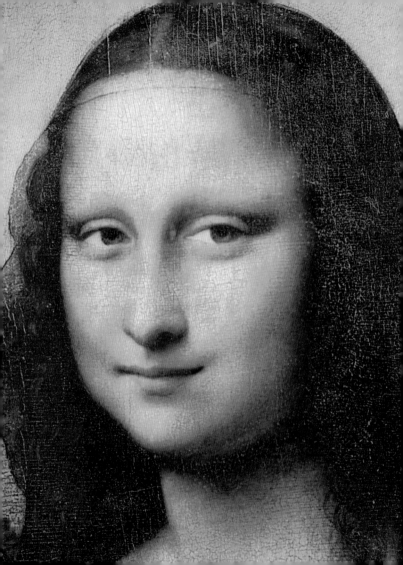

La Gioconda was perhaps never delivered to those who first commissioned it, the del Giocondo family, if the portrait remained unfinished, 'imperfect' as stated by Vasari.

In this case the work would appear to be the result of very lengthy elaboration, begun in the early years of the 16th century and worked on up to the last period of the artist's life; a process of gradual completion carried out by Leonardo, who would have continued to work on the painting over the years, instilling in it the findings of the scientific research he conducted during those same years. This would explain the multiplicity of elements that appear in the painting, from the reference to the *Portrait of Isabella d'Este*, dating from 1499–1500, for the hands and the torsion of the bust – resolved here, however, with the turning of the face suspended at the point of reaching the frontal position – up to the link with the artist's later geological studies, which are reflected in the landscape in the background, where streams of water wind between the rocks and mountains.

Above all, what Leonardo manages to encompass in the painting is the theme, elaborated in his writings, of the profound analogy between the microcosm of the human body and the macrocosm of the earth, both viewed as organisms pervaded by the flow of life. Along with representation through his anatomical studies, such as the one appearing in a complex drawing at Windsor (a study of the circulatory system in a woman's body), Leonardo develops the theme of the 'body of the earth', describing it thus: 'The ramifications of veins of water are all conjoined

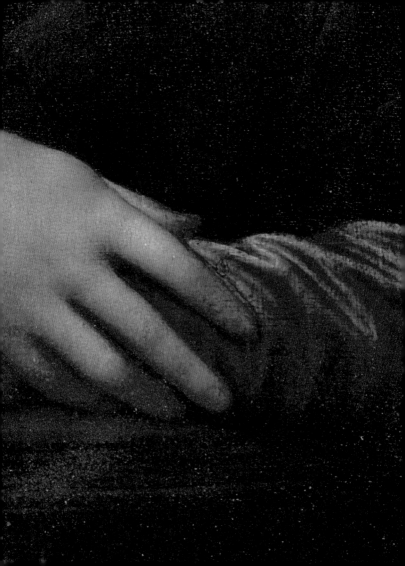

together in this land like those of the blood.' The stream that flows across the broad valley in the background thus alludes, with its incessant flowing, to the same perception of life that pulses, suggested through the rendering of the flesh, in the figure of the woman in the foreground, according to an almost hypnotic suggestion first mentioned by Vasari: 'He who looks at her intently can see the beating of her pulse.'

The painting becomes a cumulative image in which meanings and knowledge are superimposed in layers, analogous with the technique employed by Leonardo, which consisted of superimposing very fine layers of paint on the surface of the picture. The result, through its transparencies and indefinable nuances, clearly reflects the lengthy times of execution Leonardo found so congenial and reveals his inclination toward the 'never finished' rather than toward the 'non-finished'. These progressive layers of veiling, which render the brushstrokes invisible, produce the effect of a total fusion of colours and modulation sensitive to the light, conferring an impalpable, atmospheric quality to the flesh tones, the drapery and the landscape.

Just as the original inspiration for the portrait is a specific person, it has been observed that the landscape, too, probably stems from a precise location. The view that opens out behind the figure, in fact, closely resembles the valley through which the Chiana river flows in the territory around Arezzo. Starting from the left, its winding course meanders across the painting as far as the right side, where it flows into the Arno, immediately after passing under the

arches of the medieval Ponte a Buriano, a bridge that still exists today. This is a territory that Leonardo had studied in detail, plotting, perhaps for Cesare Borgia, a *Map of the Val di Chiana* with precise indications of the mountain slopes and the distribution of water in the area. In the background of the painting, in the remote distance, the rocky cliffs seem to mirror the imposing formation of the eroded gullies in the Upper Valdarno.

The scene unfolds in a broad birds-eye view, beyond a balcony, the bases of whose columns can be glimpsed at the edges of the picture, which must have been trimmed at the sides. And as with the subject herself, the representation of the landscape assumes in its pictorial transfiguration a significance reaching far beyond the factual data from which it started, to become condensed in the vision of the stratified layers of rocks subjected to the erosive action of water. The entire painting is pervaded by the concept of the flowing of time. As such, it reflects the latest developments in Leonardo's research, increasingly focused on dynamic aspects and on processes of transformation. The figure of the woman, with her live presence immersed in the perennial becoming of nature, embodies Leonardo's philosophical thought, 'As the water you touch in rivers is the last [...] of that which went, and the first of that which is arriving, so is the present time.'

The legendary smile of the *Mona Lisa* originated, according to Vasari, from the wish to change her melancholy expression, so that Leonardo, as he painted her portrait, surrounded the sitter with 'people who played or sang, and

made jokes continuously to keep her merry'. In Leonardo's work, the smile becomes the sign of expressive mobility, alluding to the mystery of psychological depths and assuming the nature of the smile of knowledge. Leonardo thus brings to completion the evolutionary process of creating an idealized portrait.

The features of the *Mona Lisa* have been seen as directly related to those of Leonardo himself, and it has even been suggested that the painting could be a sort of self-portrait. But if the *Mona Lisa* can be called a self-portrait of Leonardo, it is surely because it represents the portrayal of his concept of painting. It might even be said that the *Mona Lisa* is a 'self-portrait in the mirror', in the sense that the observer looks in the painting at that face before which the painter himself had stood at length. This is expressly the idea that Leonardo noted among his papers a year before his death, when he wrote, 'That face which in painting gazed at the master who paints it, is always looking back at all those who gaze at it.' In other words, the *Mona Lisa* turns her gaze on the painter who has created her, returning his own gaze. In this intense, silent dialogue between the image and its author, they who observe the *Mona Lisa*, and are in turn gazed back at by her, stand in the place of Leonardo.

The drawings

It was through drawing that Leonardo conducted the experimentation with forms and compositions that was to infuse all the different spheres of his artistic activity: painting, sculpture and architecture. In the words of Giorgio Vasari, 'And not only did he exercise one profession, but all of those in which drawing was involved.' And in another passage, 'Although he worked in such various fields, he never stopped drawing.' In fact, drawing became for Leonardo the tool through which he was to conduct and record, in his papers, his scientific research into the most widely differing fields of knowledge. Drawing was a practice in which the intention of representation was indissoluble from the process of acquiring knowledge. The images created by Leonardo reflect research, experience, inventions and reflections, in keeping with the creative and cognitive processes of his mind; and thus in theoretical definition, visual language assumes for him the significance of 'mental discourse'.

Pupil of Leonardo,
Portrait of Leonardo da Vinci,
first half of the 16th century;
Windsor, RL 12726.

DRAWINGS IN ITALY

FLORENCE, GALLERIA DEGLI UFFIZI, GABINETTO DEI DISEGNI E DELLE STAMPE

In Florence, in the Uffizi, is the earliest known drawing by Leonardo, done by him at the age of 20. It is a bird's-eye view sweeping over a vast plain bordered on the left by a fortified citadel and on the right by a gorge from which springs a waterfall. The water collects below and the landscape, scored and eroded by the passage of water, already seems to presage those processes of slow transformation of the land that were to be the subject of Leonardo's last reflections on nature. The rapid brushstrokes, horizontal or curved, with which the trees are indicated recreates the atmospheric perception of leaves that seem to vibrate in the air and light. The drawing may have been executed by Leonardo on the spot, outdoors, considering that it was done in pen and ink without any underlying sketch, on a summer's day of which

Study for head of a young woman,
1475–80, no. 5r [428E r];
Florence, Gabinetto dei Disegni
e delle Stampe degli Uffizi.

he himself recorded the date in the inscription at upper left: 'Day of St Mary of the Snow/ 5 August 1473.' The obsevation point seems to have been the slopes of Monte Albano, in the vicinity of his native village of Vinci.

The *Head of a young woman*, viewed almost in profile, in a reclining pose, with eyes half-closed and a face framed in wavy hair, recalls the Virgin in the little panel of *The Annunciation* in the Louvre; while the motif of the *Facing busts of an old man and of an adolescent* is repeated on a sheet of notes with *Two sketches of heads in profile*, in which the characteristics of the old man with a frowning expression and those of a youth seen foreshortened are compared. On the same sheet, the mechanism illustrated is a braking device applied to a wheel.

The *Studies of drapery* were executed according to a common practice in the Florentine workshops, which consisted of making 'models of figures in clay' on which were draped 'damp clayey rags' – cloths soaked in water and clay to allow better modelling of the folds. These models were then reproduced using a brush on linen panels. Vasari records that Leonardo 'patiently engaged in painting them

Study from life for 'The Madonna with a Cat', 1480–3, no. 10r [421E r]; Florence, Gabinetto dei Disegni e delle Stampe degli Uffizi.

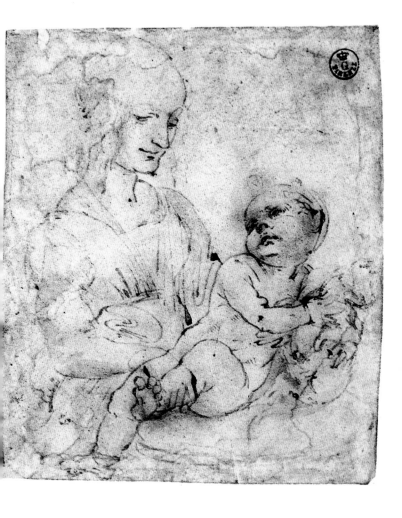

257

on certain very fine canvases', and states that, 'He worked in black and white with the tip of the brush, which was a miraculous thing.' The surviving examples of these extremely accurate exercises in representing reality (almost photographic reproductions), are shared by the Uffizi, the Louvre, the British Museum and other collections. The grazing light falls from above on the folds, which emerge from the uniform background, and the monochromatic rendering confers higher relief on the alternation of light and dark areas. The studies of the kneeling and seated figures can be seen in relation to the figures of the Virgin and the Angel in *The Annunciation* in the Uffizi.

In the *Study for the background of 'The Adoration of the Magi'* the tiers of steps in the foreground, emphasized by touches of white lead, lead the eye into a space defined by a rigorous perspective grid; this determines the architectural structure with pillars, arches and stairways at the top, on which the figures are thronged. In the Uffizi painting, which remained unfinished, Leonardo adopted a solution for rendering space that goes beyond the limitations of linear perspective.

*Study of drapery
for an erect figure,
c.* 1478, no. 4r [433E r];
Florence, Gabinetto dei Disegni
e delle Stampe degli Uffizi.

Study of drapery
for a kneeling figure,
c. 1478, no. 3r [420E r];
Florence, Gabinetto dei Disegni
e delle Stampe degli Uffizi.

Study of drapery
for a seated figure,
c. 1478, no. 2r [437E r];
Florence, Gabinetto dei Disegni
e delle Stampe degli Uffizi.

Leonardo

On pp. 262–3:
*Landscape with
a view of the Arno,*
1473, no. 1r [8P r];
Florence, Gabinetto
dei Disegni e delle
Stampe degli Uffizi.

On pp. 264–5:
*Study for a landscape
with a view of the Arno
and studies of figures,*
1473, no. 1v [8P v];
Florence, Gabinetto
dei Disegni e delle
Stampe degli Uffizi.

*Two sketches of heads
in profile, notes and
details of mechanisms;*
centre, *a braking device
applied to a wheel,*
1478, no. 7r [446E r];
Florence, Gabinetto
dei Disegni e delle
Stampe degli Uffizi.

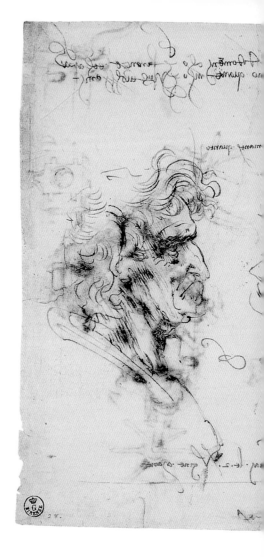

Studies of machines: a device for stretching a bow and a belt for conveying buckets, 1478, no. 7v [446E v]; Florence, Gabinetto dei Disegni e delle Stampe degli Uffizi.

446 F

*Studies for a flying machine
and other mechanisms,*
c. 1480, no. 9v [447E v];
Florence, Gabinetto dei Disegni
e delle Stampe degli Uffizi.

*Studies of figures, notes,
mechanical devices,*
c. 1480, no. 9r [447E r];
Florence, Gabinetto dei Disegni
e delle Stampe degli Uffizi.

On pp. 272–3:
*Study for the background
of 'The Adoration of the Magi',*
c. 1480, no. 8r [436E r];
Florence, Gabinetto dei Disegni
e delle Stampe degli Uffizi.

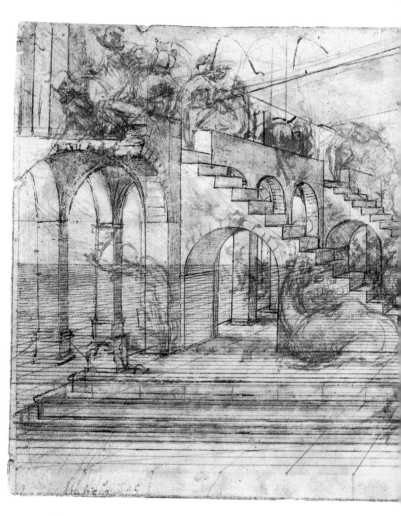

273

TURIN,
BIBLIOTECA REALE

The famous *Self-portrait* in Turin is a large red chalk drawing that shows how Leonardo must have looked in the last years of his life, after the age of 60, although the old man portrayed in the drawing appears somewhat older. If the self-portrait of Leonardo at the age of nearly 30 may be identified in the figure on the far right in the Uffizi's *Adoration of the Magi*, the features of Leonardo at the age of 60 resemble those of an ancient philosopher; the same, then, as those shown in the figure of Plato painted by Raphael in the Vatican Stanze, portraying Leonardo in a way that attributes to him, through the physical characteristics of his face, the significance of the conquest of the human mind. And it is just in this manner that a late 16th-century account describes Leonardo: 'He had a face with long hair, with the eyebrows and the beard so long that he seemed the true nobility of study, as was in other times the druid Hermetes or the ancient Prometheus.'

Self-portrait,
c. 1515, no. 1r [15571r];
Turin, Biblioteca Reale.

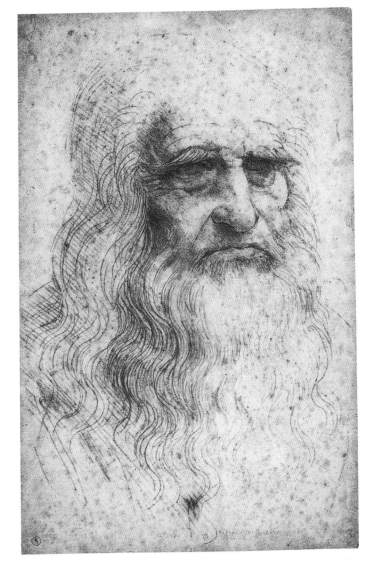

In Turin there are two significant preparatory studies: one is for the angel painted by Leonardo in *The Baptism of Christ* by Verrocchio, viewed from the back, his head turning to follow the direction of his gaze; the other is for the angel in the first version of *The Virgin of the Rocks* who, in a similar movement, turns his head but this time so far as to look directly at the observer, summoning him directly with his gaze. The physiognomy of the figure does not seem to be invented, appearing rather as a study from life, in which psychological introspection is suggested by the use of chiaroscuro. The model could in fact have been the same Cecilia Gallerani whom Leonardo was later to portray in *Lady with an Ermine*.

The terrible *Armed chariots*, drawn by horses and equipped with rotary spikes, are represented along with the devastating effects they provoked. These war machines call to mind the invincible arms promised by Leonardo in his letter to Ludovico il Moro.

The drawing with *Three views of the same head* seems to hurl a challenge at sculpture, demonstrating the possibility of rendering on the two-dimensional surface of drawing

Head of a young man:
study for the angel
in 'The Baptism of Christ'
by Verrocchio,
c. 1475, no. 15 [15635];
Turin, Biblioteca Reale.

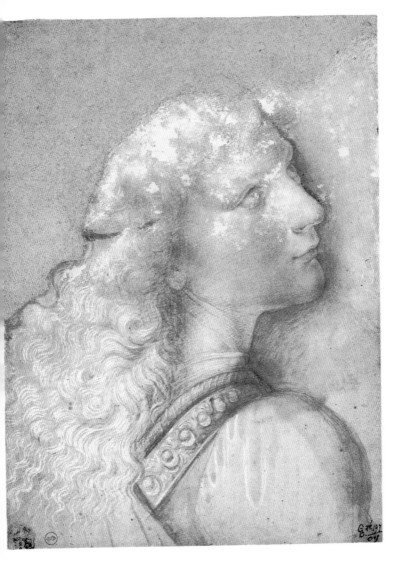

paper a simultaneous vision from different points of view. The multiple representations provide at a single glance the information about the subject that would be acquired in moving around it. The head with its thick beard, shown from the front, in three-quarter view and in profile, may be a portrait of Cesare Borgia.

The *Study for a Hercules with the Nemean lion* reflects the characterization of the warrior developed by Leonardo during the years he spent in Florence working on *The Battle of Anghiari*; the powerful figure is seen standing, viewed from the back to emphasize the relief of his bulging muscles. Also inspired by models of ancient sculptures is the *Herculean profile of a warrior*. The head, with its fierce, proud expression, is crowned with a laurel wreath; on the left, beside the line of the neck and along with the last curls of the hair, we discover that Leonardo has traced, like a cryptic cipher, the letter 'L'.

*Portrait of a young woman,
study for the angel in the first
version of 'The Virgin of the Rocks',
c. 1483–5, no. 2r [15572r];
Turin, Biblioteca Reale.*

On pp. 280–1:
*Armed chariots and warriors
with severed limbs,
1487–90, no. 14r [15583r];
Turin, Biblioteca Reale.*

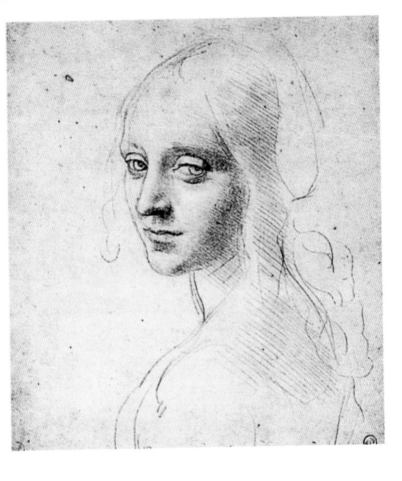

279

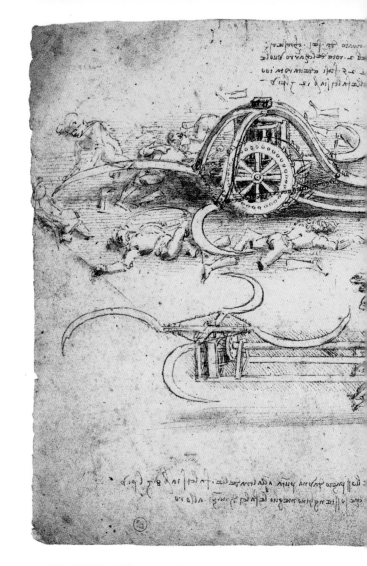

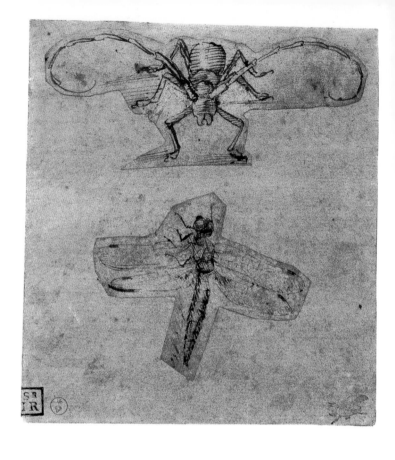

Studies of insects,
c. 1480, no. 13r [15581r];
Turin, Biblioteca Reale.

Studies of horses' hind legs,
for the 'Monument to Francesco Sforza',
c. 1490, no. 12r [15582r];
Turin, Biblioteca Reale.

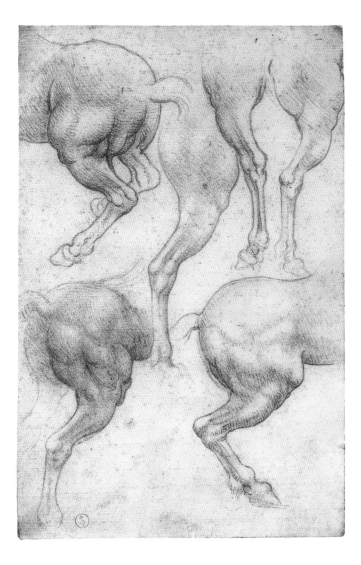

*Studies of horses'
forelegs, for the
'Monument
to Francesco Sforza',
c.* 1490,
no. 11r [15580r];
Turin,
Biblioteca Reale.

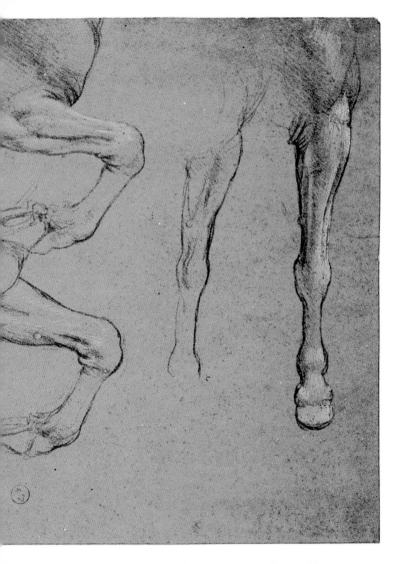

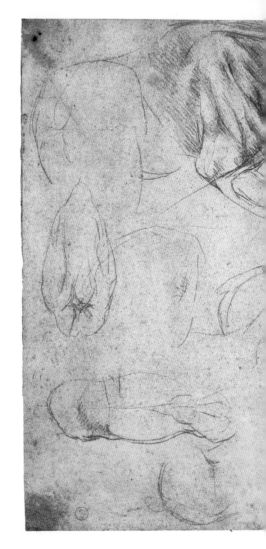

*Study of horses'
forelegs, for the
'Monument
to Francesco Sforza',
c.* 1490,
no. 10r [15579r];
Turin, Biblioteca Reale.

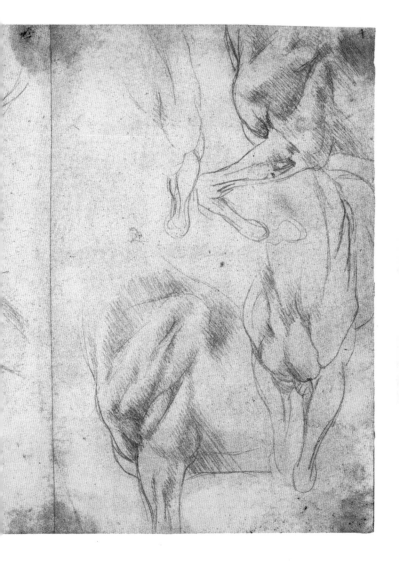

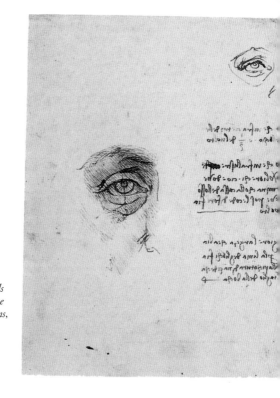

Study of proportions of the face with details of eyes, notes and some arithmetical operations, c. 1489–90, no. 4r [15574r]– no. 5r [15576r]; Turin, Biblioteca Reale.

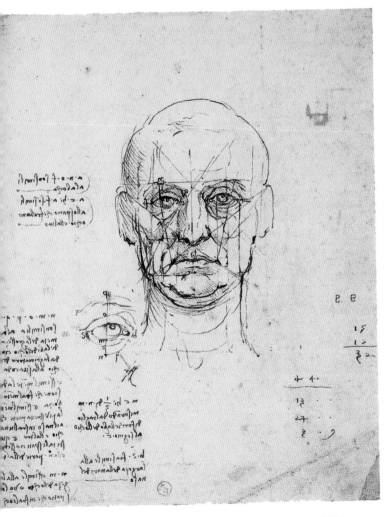

289

Technological studies: a device similar to a drill and a device for making screws, c. 1489–90, no. 4v [15574v]– no. 5v [15576v]; Turin, Biblioteca Reale.

Three views of the same bearded head, presumed to be a portrait of Cesare Borgia, 1502, no. 3r [15573r]; Turin, Biblioteca Reale.

On p. 294:
Study of a Hercules with the Nemean lion, 1505–6, no. 8r [15630r]; Turin, Biblioteca Reale.

On p. 295:
Herculean profile of a warrior, c. 1508, no. 6r [15575r]; Turin, Biblioteca Reale.

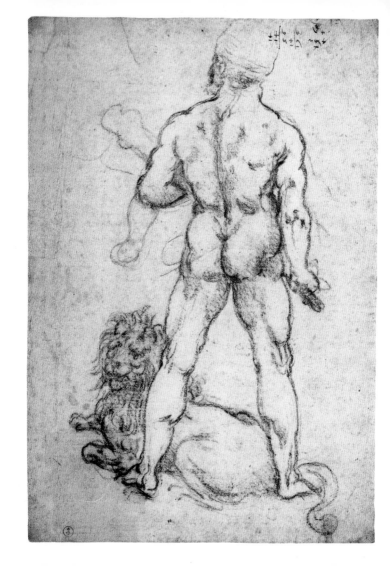

95 L. da vinci

VENICE,
GALLERIE DELL'ACCADEMIA

The representation of the *Homo Vitruvianus*, at the Accademia in Venice, is a paradigm of the proportions of the human body. It dates from the years around 1490 when Leonardo, in Milan, was engaged in studying and measuring the various parts of the body, considered in relation both to one another and to the whole. The text under the drawing reads, 'The span of a man's open arms is equal to his height', and the image shows that the proportional relationships of the human body correspond to those employed in constructing geometric figures. Consequently, according to the theory set forth by Vitruvius (the Roman architect and author of *De architectura*), the human figure can be inscribed in a circle as well as in a square, appearing as the model of perfection and harmony. This model is assumed as the basis for architectural design and is reflected in the classical ideal, celebrated in the Renaissance, of the building with a circular plan. However, in addition to

Homo Vitruvianus:
studies of proportions of the
human body according to Vitruvius,
c. 1490, no. 6r [228r];
Venice, Gallerie dell'Accademia.

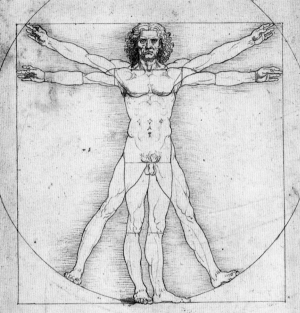

the rigorous measurement of the limbs, the representation of the human body conceived by Leonardo implies an evolution from the static principle of proportion, because it contains within itself the concept of motion. The man with two pairs of arms and legs graphically conveys the kinetic effect of the transition from one position to another in two successive stages.

The study in Venice that relates to the arrangement of the figures in the group of *The Virgin and Child with Saint Anne*, where the Child is playing with a lamb, differs from the solutions that were preferred by Leonardo in the cartoon in London and in the painting in Paris. In this drawing the Virgin is viewed from behind, seated on the lap of Saint Anne, who is shown in two different stages of a single movement.

Leonardo sketched the *Studies of horsemen* freely in red chalk on a sheet on which he had previously drawn the profile of a man with a diagram showing proportions. The horsemen derive from preliminary ideas for *The Battle of Anghiari*, and the one on the right seems to echo the study of proportions made almost 15 years earlier.

*Madonna and Child
with Saint Anne and a lamb,*
c. 1501, no. 14r [230r];
Venice, Gallerie dell'Accademia.

299

Still linked to studies for the composition of *The Battle of Anghiari* are the sketches that Leonardo traced with great rapidity in a series of *Skirmishes of horsemen*. The small figures appear as if in shorthand, barely sketched with a few strokes of the pen that serve to translate ideas into images almost instantaneously.

The *Three dancing women* convey a remarkable sense of movement, expressing with the rhythm of their gestures, their tousled hair and windblown gowns, the flowing motion of bodies caught up in the dance and in the wind. These figures call to mind the animated style of some examples of ancient sculpture, as well as the way in which Leonardo, in the late drawings of the *Deluge*, renders visible the driving impetus of the forces of nature.

The concept of rendering in a drawing the impression of movement pervades all of Leonardo's graphic work and can already be recognized in his youthful project for a scene of the *Nativity watched over by angels in flight*, which is pervaded by a remarkable sense of dynamism.

Study of proportions,
c. 1490,
and *Studies of horsemen*
for 'The Battle of Anghiari',
added *c.* 1503–4,
no. 7r [236r];
Venice, Gallerie dell'Accademia.

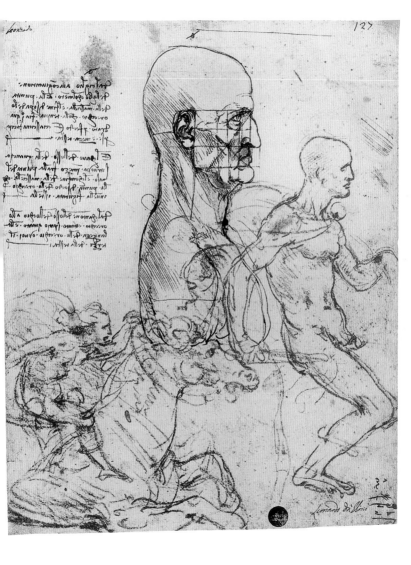

*Study for a Nativity
watched over by flying angels,*
c. 1480, no. 1r [256r];
Venice, Gallerie dell'Accademia.

On p. 304:
*Studies of weapons:
spear points for combat
between horsemen and foot soldiers,*
c. 1485, no. 4r [235r];
Venice, Gallerie dell'Accademia.

On p. 305:
War machine,
c. 1485, no. 4v (235v);
Venice, Gallerie dell'Accademia.

303

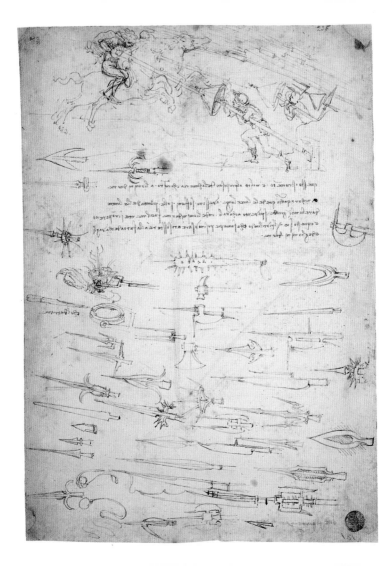

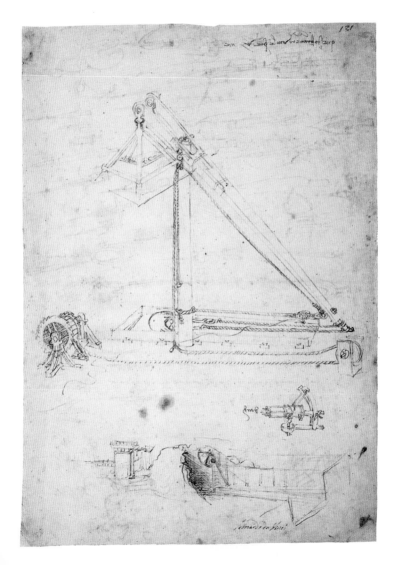

Study of a man's head in profile with mocking sneer as in a 'Christ bearing the Cross', 1493–4, no. 12r (232r); Venice, Gallerie dell'Accademia.

On p. 307: *Study for a 'Christ bearing the Cross',* c. 1495–7, no. 11r [231r]; Venice, Gallerie dell'Accademia.

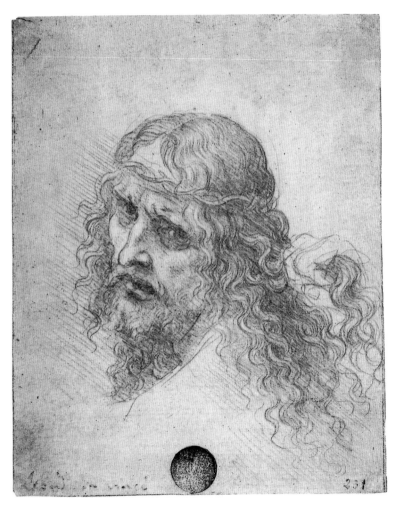

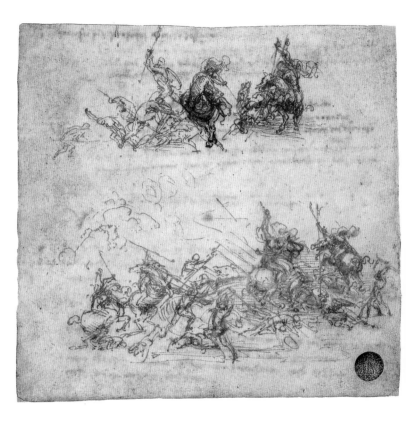

Preliminary studies for 'The Battle of Anghiari': two skirmishes between horsemen and foot soldiers, c. 1503–4, no. 16r [215A r]; Venice, Gallerie dell'Accademia.

Preliminary studies for 'The Battle of Anghiari': skirmish of horsemen and studies of human movements, 1503–4, no. 15r [215r]. Venice, Gallerie dell'Accademia.

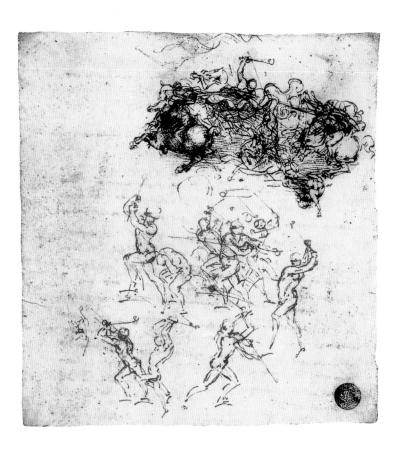

*Study of a horse
and two figures,*
c. 1517–18, no. 25r [258r];
Venice, Gallerie dell'Accademia.

*Three figures of dancing
women and a head,*
c. 1515, no. 26r [233r];
Venice, Gallerie dell'Accademia.

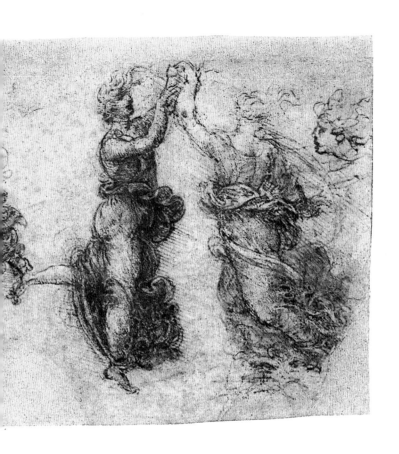

311

MILAN,
BIBLIOTECA AMBROSIANA

ROME,
GABINETTO NAZIONALE
DELLE STAMPE E DEI DISEGNI

The *Profile of a young woman* at the Ambrosiana in Milan is distinguished by the great regularity and delicacy of the features, almost as if the drawing started from the tracing of a perfect circle on which to model the outline of the face. The image created in this way is in striking contrast to the *Caricature studies* in the Gabinetto delle Stampe e dei Disegni in Rome, where the representation emphasizes the accentuated, projecting features of the face and focuses on the characteristic signs of old age. Leonardo's numerous drawings of grotesque heads may be linked to his research into facial expressions, involving physiognomy (the permanent traits) and pathognomy (the traits that vary according to the emotions), two fields of investigation that, within the sphere of anatomical studies, correspond to a complex definition of the relationship between body and soul.

Profile of a young woman,
c. 1490, F 274 Inf. 14;
Milan, Biblioteca Ambrosiana.

Caricature study of an old man, 1490–5, no. 8r; Rome, Gabinetto Nazionale Disegni e Stampe.

Caricature profile of an old man, 1490–5, no. 8v; Rome, Gabinetto Nazionale Disegni e Stampe.

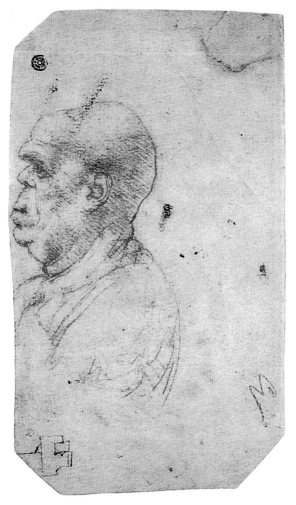

DRAWINGS IN EUROPE

Numerous drawings by Leonardo are to be found outside Italy in Europe's most important museums. At the British Museum the majestic *Profile of a warrior* is a youthful work in which Leonardo takes inspiration from ancient models and the marble bas-reliefs sculpted by his master, Verrocchio. The *Allegory of Victory and Fortune* also dates from his first Florentine period. Here Leonardo represents, with incisive strokes of the pen, a winged figure, Victory or Fame, balanced above a shield held up by Fortune, recognizable by the way her hair is blown forward by the wind. At the Fitzwilliam Museum in Cambridge the *Study of horses and riders*, with its symmetrical, almost mirror-like arrangement, is a preparatory drawing for the figures thronging the background in *The Adoration of the Magi*. In the same museum, the *Allegory of the Ermine* depicts the scene of the little animal that allows itself to be captured rather than soil its coat with mud, which the hunter has spread around its den to catch it. This may be viewed with

Profile of a warrior,
1475–80, no. 1895-9-15-474;
London, British Museum.

reference to the *Portrait of Cecilia Gallerani* (known as *Lady with an Ermine*) painted in Milan for Ludovico il Moro, of whom the white-coated animal was the emblem.

The extensive collection of the Département des Arts Graphiques of the Musée du Louvre includes, among others, the precious *Studies of drapery* drawn on linen. Another *Study of drapery* refers to the figure of the Virgin in the *Saint Anne* painting in the Louvre. This is one of the last drawings of Leonardo, in which the gathering of the folds seems to resemble that of clouds or swirling water.

Leonard's complex development of the theme of the myth of Leda is reflected in two drawings at Chatsworth and Rotterdam; in both, though in different styles, the woman's figure is rendered in a dynamic, spiralling pose, and is caught in the act of rising from a kneeling position, with the swan on one side and the two pairs of twins emerging from their broken eggs on the other.

At Weimar, a folio of *Anatomical studies* contains the striking exploded view of an open cranium, with the brain, the eyeballs and the nerves ('all of the nerves that descend from the brain'). To discover this anatomy, Leonardo

Allegory of Victory and Fortune,
c. 1480, no. 1895-9-15-482;
London, British Museum.

applied the technique of injecting molten wax into the brain, which when hardened showed the conformation of the ventricles.

In the *Heads of warriors* now in Budapest, Leonardo displays all the impetuous fury of the battle. These are preparatory studies for the figures portrayed in the skirmish of horsemen that was to form the central episode of *The Battle of Anghiari*, the great mural decoration for the Palazzo Vecchio in Florence, which was never finished by Leonardo. On the faces of the warriors can be seen the anguish of human beings overwhelmed by violence in the raging fury of war, which Leonardo called in his writings 'discord, or rather most bestial madness'.

On p. 324:
Study of figures; at upper centre,
hygrometer,
c. 1478–80, no. 2022r;
Paris, Musée du Louvre.

On p. 325:
Anatomical studies,
c. 1478–80, no. 2022v;
Paris, Musée du Louvre.

Study of crabs,
c. 1480, no. Z2003v;
Cologne, Wallraf-Richartz-Museum.

*Allegory
of the Ermine,*
c. 1490, no. PD.120-1961;
Cambridge, Fitzwilliam Museum.

*Study of horses and riders
for 'The Adoration of the Magi',*
c. 1480, no. PD. 121-1961;
Cambridge, Fitzwilliam Museum.

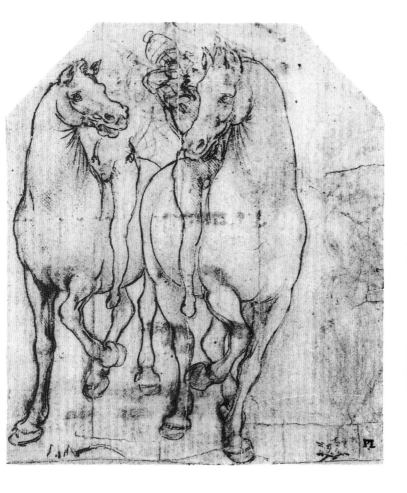

323

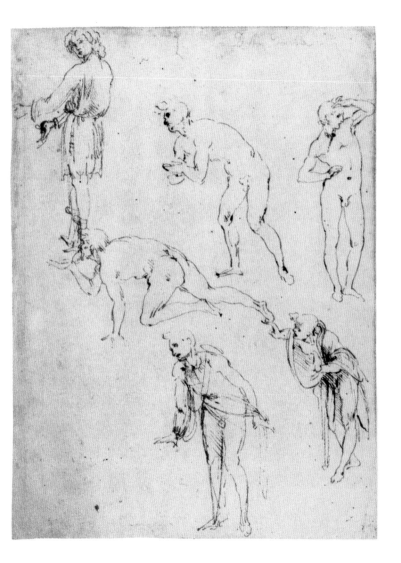

*Imaginary reconstruction
of an Etruscan tomb,
with view from the outside,
layout and underground
chamber,
c. 1507, no. 2386;
Paris, Musée du Louvre.*

327

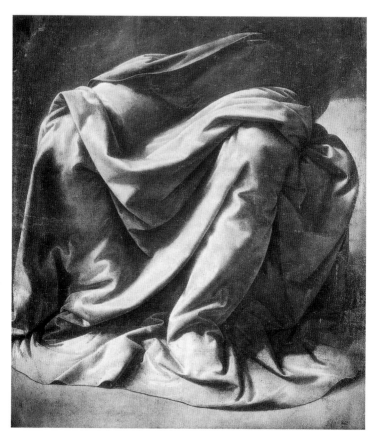

*Study of drapery for the
figure of a seated woman,
c. 1478, no. 2255;
Paris, Musée du Louvre.*

*Study of drapery
for the 'Saint Anne',
c. 1517–18, no. 2257;
Paris, Musée du Louvre.*

*The Hanged Man
(Portrait of Bernardo
di Bandino Baroncelli)*,
1479, no. AI 659; NI 1777;
Bayonne, Musée Bonnat.

*Studies of figures
and ornamental motifs
inspired by antiquity (Siren)*,
c. 1480, no. AI 660; NI 1778;
Bayonne, Musée Bonnat.

Leda with the Swan,
c. 1504, no. I 466;
Rotterdam, Museum
Boijmans Van Beuningen.

Engraving by Giovanni
Vendramini, 1812,
taken from the original
before restoration.

Study for a kneeling Leda,
1503–4, no. 880/717;
Chatsworth, Duke of
Devonshire's Collection.

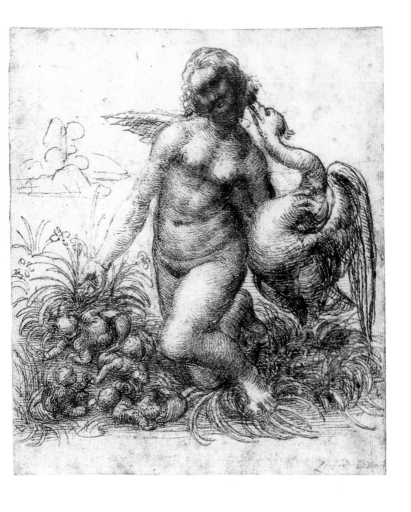

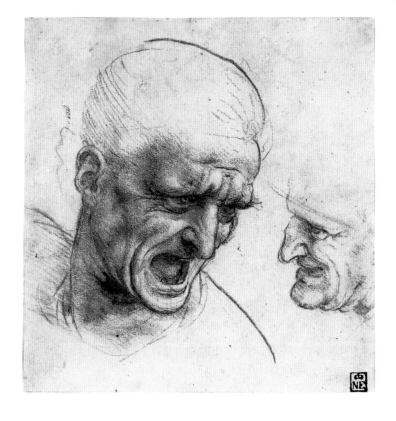

*Study for the heads of two warriors
for 'The Battle of Anghiari',*
c. 1504, no. E.I. 5/A [1775];
Budapest, Szépmüvészeti Múzeum.

*Study for the head of a warrior
for 'The Battle of Anghiari',*
c. 1504, no. E.I. 5/r [1774];
Budapest, Szépmüvészeti Múzeum.

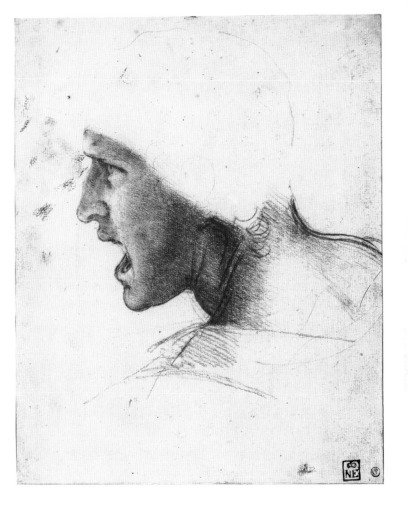

335

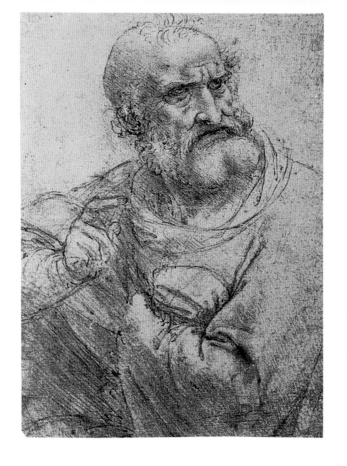

*First idea for the figure
of the Apostle Peter for 'The Last Supper',*
c. 1490, no. 17614;
Vienna, Graphische Sammlung Albertina.

*Caricature study of
curly-headed man,*
c. 1515, no. 0033;
Oxford, Christ Church College.

LIONARDO DA VINCI.

DRAWINGS IN AMERICA

At the Pierpont Morgan Library in New York, the drawing of a *Head of a young man* was done by Leonardo from a young male model; perhaps originally intended as an angel, this study was to be used by him for the face of the Virgin in his youthful painting of *The Annunciation* in the Uffizi, as a demonstration of how the ideal of beauty can be freely transposed from one subject to another in artistic development.

Still in New York, at the Metropolitan Museum, the *Studies for a Nativity* reflect some ideas for composition from *The Virgin of the Rocks*, with the Madonna's arms opening to encompass the meeting between the Christ Child and the infant Saint John. The *Allegory of the Lizard* shows the reptile fighting a snake to defend a sleeping young man. A note explains that the lizard, if it is unable to defeat the snake, runs 'on to the face of the man and awakens him'. On the back of the same sheet is a project for a theatrical stage set: the layout and elevation of a structure with a barrel-vaulted ceiling, with a figure seated on a throne surrounded by flames.

Head of a young man,
study for the Virgin's head
in the Uffizi 'Annunciation',
c. 1475, no. IV, 34a;
New York, Pierpont Morgan Library.

Studies for a Nativity,
c. 1490, no. 7r;
New York, The Metropolitan
Museum of Art.

Allegory of the Lizard,
c. 1495–6, no. 9r;
New York, The Metropolitan
Museum of Art.

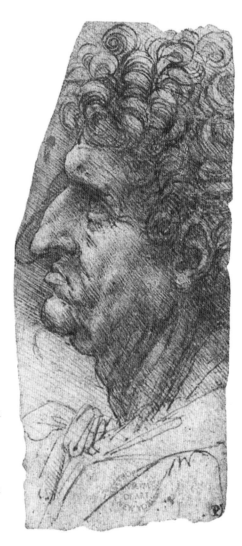

On pp. 342–3:
*Drawings
for a theatrical set,*
c. 1495–6, no. 9v;
New York, The Metropolitan
Museum of Art.

Profile of a Man,
c. 1495, no. 10r;
New York, The Metropolitan
Museum of Art.

*Caricature of a
laughing man,
c.* 1495, no. 12r;
Malibu, California,
The J. Paul Getty Museum.

*Caricature of an old
woman with a carnation,
c.* 1495, no. 11r;
New York, private collection.

On p. 346:
*Studies of a child
with a lamb,
c.* 1497–1500, no. 14r;
Malibu, California,
The J. Paul Getty Museum.

On p. 347:
*Studies of figures,
c.* 1508–10, no. 15r;
Washington, D.C.,
The National Gallery of Art.

On p. 348:
*Study of drapery
for a standing figure,
c.* 1475, no. 2r;
Princeton, New Jersey,
private collection.

On p. 349:
*Study of drapery
for a kneeling figure,
c.* 1475, no. 1r;
Princeton, New Jersey,
private collection.

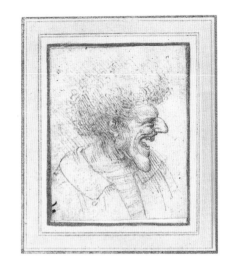

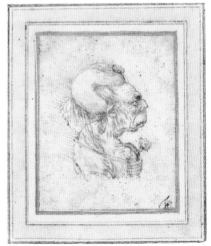

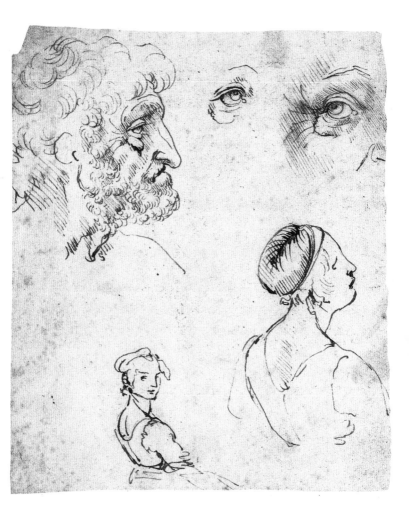

347

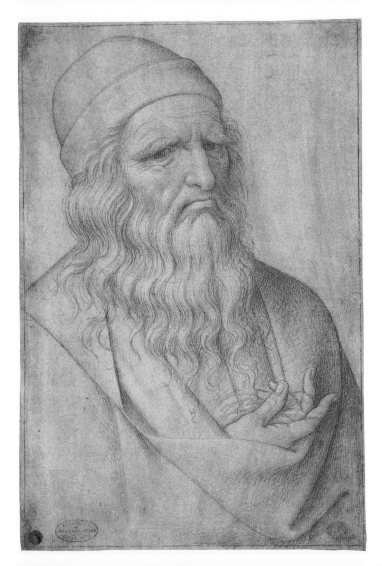

The collections

The *Codex Atlanticus* and the *Windsor Collection* are two great miscellaneous collections containing original drawings, texts and notes by Leonardo. They were created by the sculptor Pompeo Leoni, who purchased in Milan a large quantity of material by the hand of Leonardo: these were the manuscripts and drawings that Leoni took to Spain, where he was court artist, in 1590. Leoni manipulated this vast amount of heterogeneous material by cutting out parts of it and isolating fragments, which he then redistributed and reassembled, pasting the fragments on to blank pages to form volumes. Some of these pages have an opening in them, like a window, to show both sides of the original sheet. The drawings and writings that make up the collections reflect Leonardo's ceaseless graphic and theoretical work, encompassing all the spheres of his research and covering a vast span of time, from the earliest years of his activity in Florence up to the last period of his life in France.

Ambrogio Figino,
Portrait of Leonardo,
c. 1590;
Venice, Gallerie dell'Accademia.

CODEX ATLANTICUS

Milan,
Biblioteca Ambrosiana

This is the most imposing and spectacular collection of papers by Leonardo. Pompeo Leoni compiled it by assembling a total of 1,750 pieces, including sheets and fragments, on 401 pages measuring 65 x 44cm/26 x 17$^{1}/_{2}$in. Since its restoration in the 1960s and 70s, the material has been bound in 12 volumes, but the old binding held the entire contents in a single volume of gigantic size, a veritable atlas. By the 18th century this exceptional collection of Leonardo's work was described as 'Codex of his papers in Atlas form'. It was donated to the Ambrosiana in 1637 by Count Galeazzo Arconati, who had purchased it from the heirs of Pompeo Leoni along with other, smaller codices, which he also donated to the library. But in 1796, with the entry of French troops into Milan, the great book became part of the spoils of war and, along with the other smaller codices, was carried off to Paris.

Original binding of the *Codex Atlanticus*
in red leather with gilt decorations,
16th century;
Milan, Biblioteca Ambrosiana.

DISEGNI·DI·MACHINE·ET

DELLE·ARTI·SECRETI·

ET·ALTRE·COSE·

DI·LEONARDO·DA·VINCI

RACOLTI·DA

POMPEO·LEO

NI

After the fall of Napoleon it was only thanks to the commitment of the sculptor Andrea Canova that the Congress of Vienna made it possible for the *Codex Atlanticus* to be returned to the Ambrosiana. It is known, in fact, that the Austrian commissioner in charge for Lombardy (following the domination of France the region had once again become subject to Austria), on examining the papers with Leonardo's handwriting, had opined that this was a manuscript compiled in Chinese and thus of no importance. Nonetheless, the efforts of Antonio Canova, the commissioner for the Papal State, and of Benvenuti, delegated by the Grand Duke of Tuscany, enabled the precious codex to be recognized and returned, though this was not the case for the other 12 manuscripts that had been removed.

Pompeo Leoni, who had assembled the collection, applied to it the proud inscription of gold letters on red leather that reads: 'DRAWINGS OF MACHINES AND OF THE SECRET ARTS AND OTHER THINGS OF LEONARDO DA VINCI COLLECTED BY POMPEO LEONI.' The selection made by him was thus based on the principle of separating, generically, the drawings of a technical or scientific

Bellows-operated machine for raising water and man drawing an armillary sphere with a perspectograph, c. 1480; Milan, CA f. 5r [386v. a].

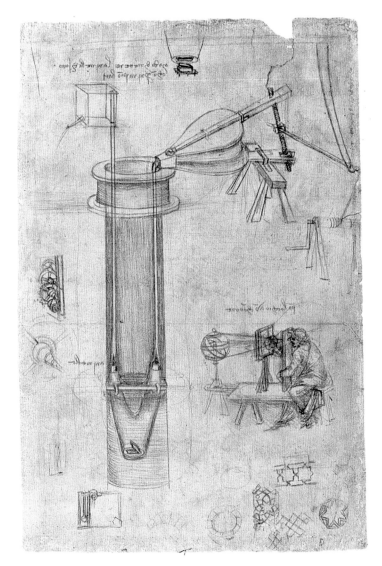

nature, grouped together in the *Codex Atlanticus*, from the naturalist, anatomical and figure studies, grouped together in the *Windsor Collection*. In effect, the papers by Leonardo found in the *Codex Atlanticus* deal with an incredible variety of subjects, including painting, sculpture, geometry, perspective, optics, astronomy, mathematics, engineering, architecture and urban planning.

The drawings and notes appear on sheets of widely differing sizes, from small fragments to great folios on which Leonardo executed, with extreme accuracy and precision, drawings illustrating his technological projects, in which he seems to have conceived real 'portraits of machines'.

Sheet of studies on artificial flight;
at upper right, *Sketch of a parachute*,
c. 1480;
Milan, CA f. 1058v [381v. a].

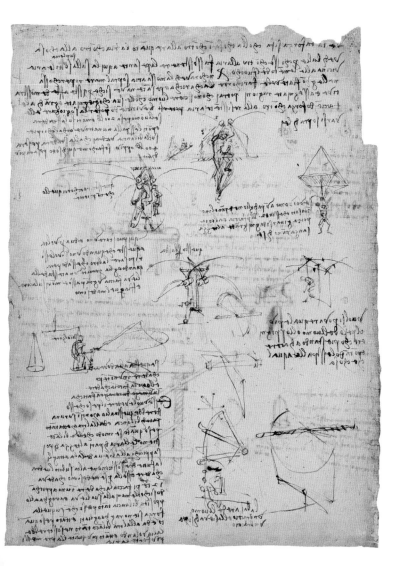

*Systems of locks
for river navigation,
c. 1480–2;
Milan, CA f. 90v [33v. a].*

*Devices for fabricating
concave mirrors,
c. 1478–80;
Milan, CA f. 17v [4v. a].*

System of physiological printing (sage leaf),
1508–10;
Milan, CA f. 197v [72v. a].

Machine gun,
1480–2;
Milan, CA f. 157r
[56v. a].

On pp. 362–3:
Machine for excavating a channel, c. 1503;
Milan, CA f. 4r [1v. b].

'Body generated
by the perspective
of Leonardo da Vinci,
disciple of experience',
inscription
at upper right,
c. 1490; Milan,
CA f. 520r [191r. a].

On pp. 366–7:
Studies on lunules,
c. 1515; Milan,
CA f. 455r [167r. b-167r. a].

On p. 368:
Studies on reflection
caustics and device
for fabricating
parabolic mirrors,
c. 1503–5; Milan,
CA f. 823a-r [301r. c].

On p. 369:
Machine for fabricating
concave mirrors,
c. 1503–5; Milan,
CA f. 1103v [396v. f].

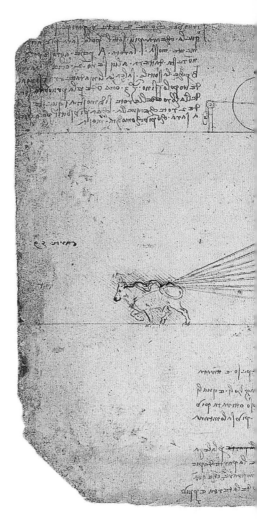

Geometric proportions applied to the study of traction: the force exerted by the oxen is proportionally inverse to the diameter of the wheel to be pulled, c. 1487–90; Milan CA f. 561r [211r. a].

On p. 372:
Studies of architecture for the Cathedral of Pavia, c. 1487–90; Milan, CA f. 362v-b.

On p. 373:
Studies on solid geometry with a memorandum (centre, above): *'Make glasses to see the moon large', c. 1513–14; Milan, CA f. 518r [190r. a].*

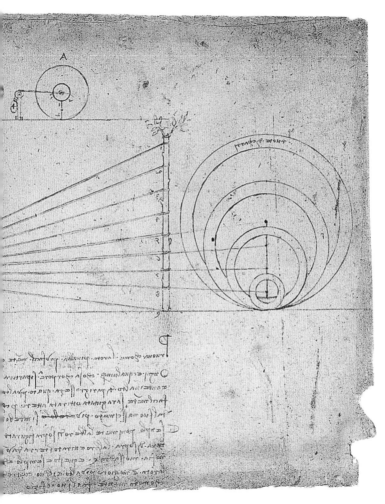

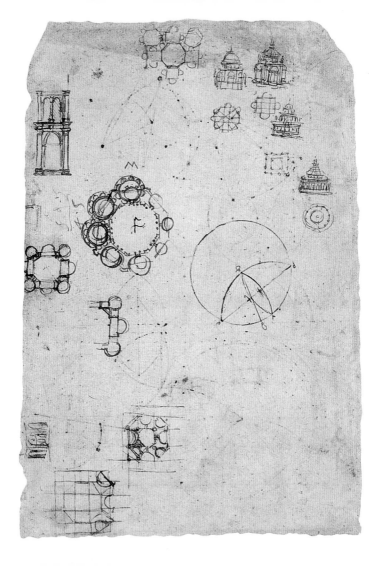

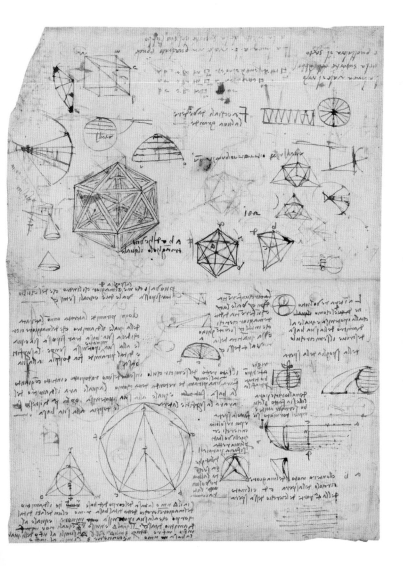

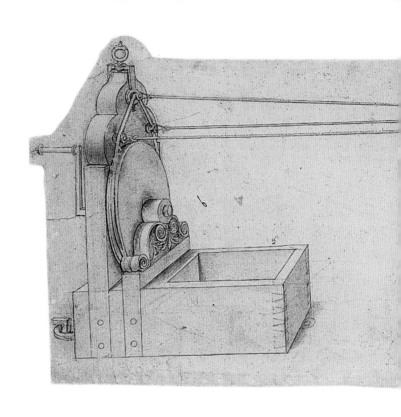

Machine for twisting ropes,
c. 1513–15;
Milan, CA f.13r [2v. b].

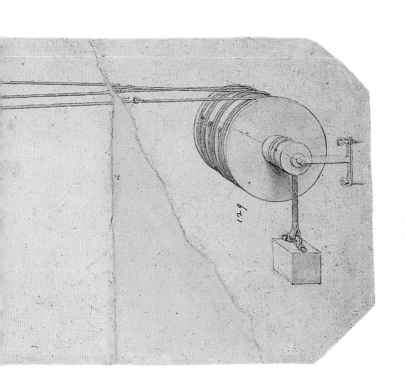

129

375

Study of parabolic mirrors with large radii for exploiting solar energy, c. 1513–15; Milan, CA f. 750r [277r. a].

On p. 378: *Revolving crane, c.* 1478–80; Milan, CA f. 965r [349r. a].

On p. 379: *First ideas for the lantern on the Duomo of Milan, c.* 1490; Milan, CA f. 719r [266r. a-b].

On pp. 380–1: *Studies for an underwater boat, c.* 1485–7; Milan, CA f. 881r [320v. b].

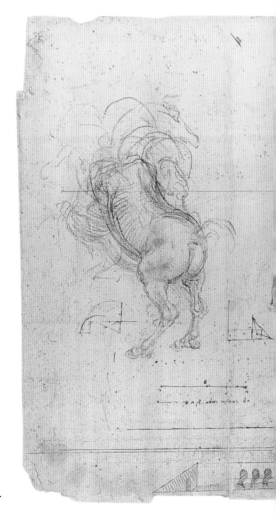

System of defence and studies of horses for 'The Battle of Anghiari', c. 1504; Milan CA f. 72r [24r. a-24v. c].

383

Machine with reciprocating motion: exploded view of the complicated mechanism, c. 1478–80; Milan, CA f. 30v [8v. b].

On pp. 386–7: *Bombards or mortars with mechanisms for adjusting the range: the cannonballs, upon falling to the ground, emit smaller shells, c. 1485; Milan. CA f. 33r [9v .a].*

Hydraulic studies:
above, *devices
for breathing
underwater,*
and left,
*floats for
walking on water,*
1480–2;
Milan, CA f. 26r [7r. a].

388

389

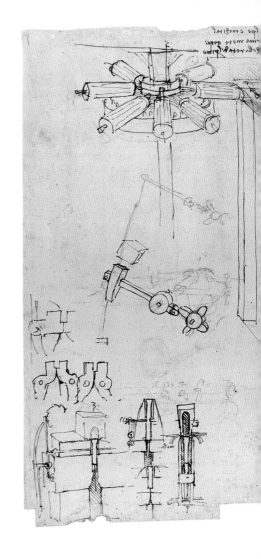

*Studies for a
gold-beating machine,*
c. 1493–5;
Milan, CA f. 29r [8r. a].

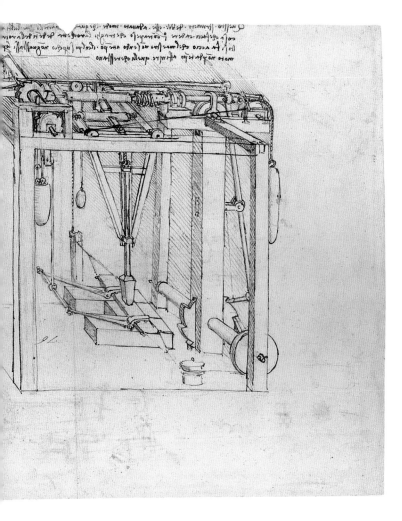

Parabolic compass,
1513–14;
Milan, CA f. 1093r [394r. a].

On pp. 394–5:
*Project for digging canals
of traditional type,*
c. 1503; Milan, CA f. 3r [1v. a].

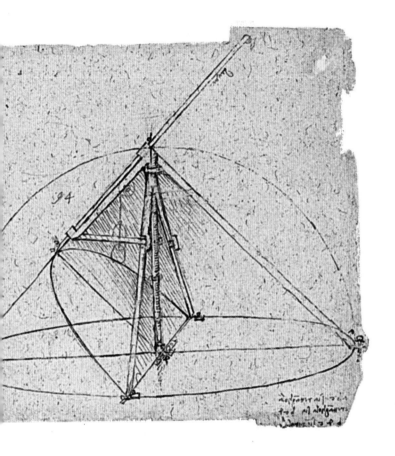

94

393

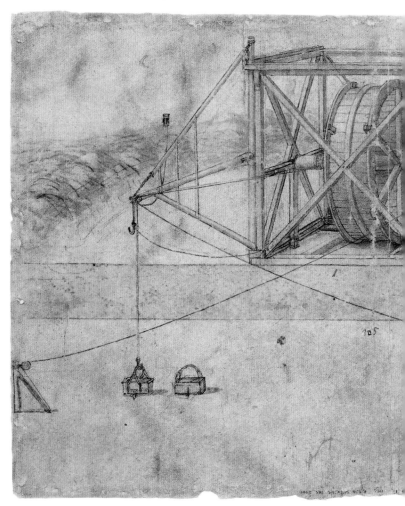

705

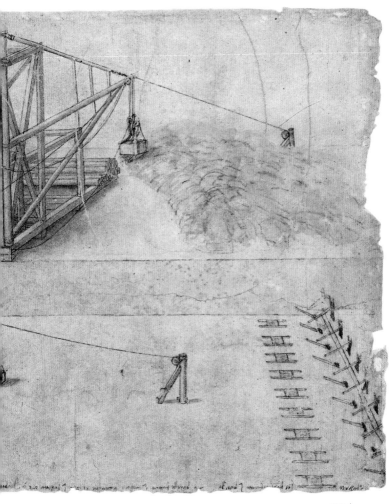

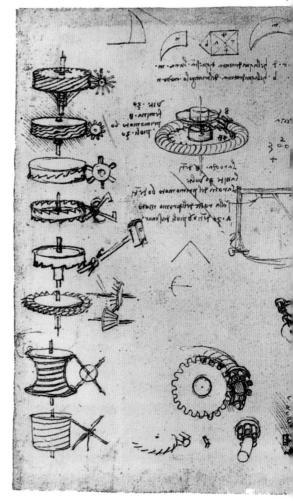

Mechanical studies with details of automatic page inserter for printing press, on a folio reconstructed using two folios from the Codex Atlanticus, c. 1497; Milan, CA f. 1038r [372r. b]; and a fragment from Windsor (standing figure), c. 1497; Windsor, RL 1272.

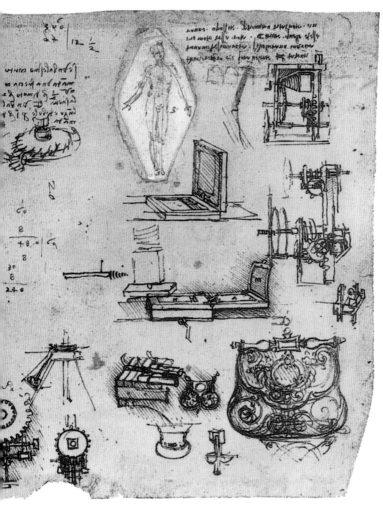

397

Windsor Collection

**Windsor Castle,
Royal Library**

The collection consists of nearly 600 drawings that Pompeo Leoni had mounted on 234 sheets measuring about 48 x 35cm/19 x 14in. The volume, bound in red leather, bore the title in gilt characters: 'DRAWINGS OF LEONARDO DA VINCI RESTORED BY POMPEO LEONI' but the 'restoration' had actually been quite destructive in nature. In fact, the drawings now in Windsor Castle even contain some fragments of very reduced size, often small figures, that Leoni cut out of large folios of studies which, based on the redistribution of the subjects effected by him, now form a large part of the *Codex Atlanticus*. In a modern restoration, begun in the late 19th century and completed in 1994, the volume has been separated into loose folios, each placed between two sheets of perspex (plexiglas). The folios have been divided into five thematic sections: anatomy; landscapes, plants and water studies; horses and other animals; figure studies; and miscellaneous papers.

Original binding of the *Windsor Collection*,
in red leather, with gilt decorations, 16th century;
Windsor Castle, Royal Library.

DISEGNI·DI·LEONARDO·

·DA·VINCI·RESTAV

RATI·

·DA·POMPEO·

·LEONI·

399

Anatomy

The most conspicuous part of the *Windsor Collection* is composed of about 200 folios documenting Leonardo's research in the field of anatomy. The studies of the human body, which he conducted through the practice of dissection, span a period of some 30 years, from 1485 to 1515. His investigation into the mechanics of the body began with his studies of the cranium, in which he attempted to locate the site of the soul. These drawings document the progress made by Leonardo in the acquisition of anatomical knowledge and, at the same time, the gradual perfecting of a graphic language that allowed him to record his observations precisely. Leonardo was fully aware of the force of the images he created and of the possibility of concentrating in a single drawing a vast amount of information, such as no description in words could ever do: 'With how many words could you describe this heart, except by filling a book ...'

Anatomical figure depicting the heart,
lungs and major arteries,
c. 1493;
Windsor, RL 12597r.

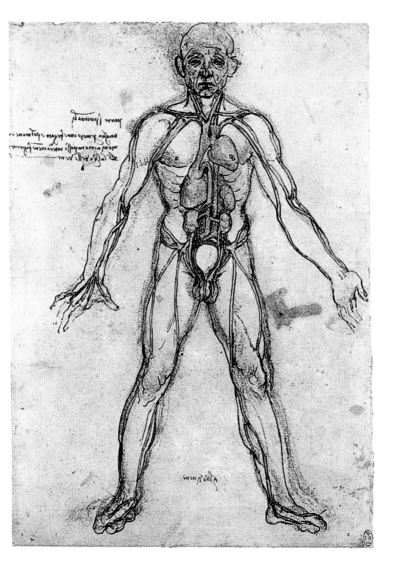

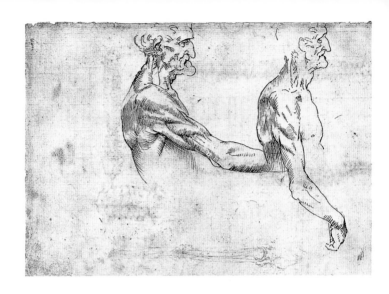

Old man with thin body,
probably the centenarian
dissected by Leonardo in 1507,
c. 1507–8;
Windsor, RL 19007r.

Muscles of the neck, shoulder
and chest in action,
c. 1508–10;
Windsor, RL 19001v.

On p. 404:
Cross-section of a human head,
c. 1493–4;
Windsor, RL 12603r.

On p. 405:
Side view of the cranium,
c. 1489;
Windsor, RL 19057r.

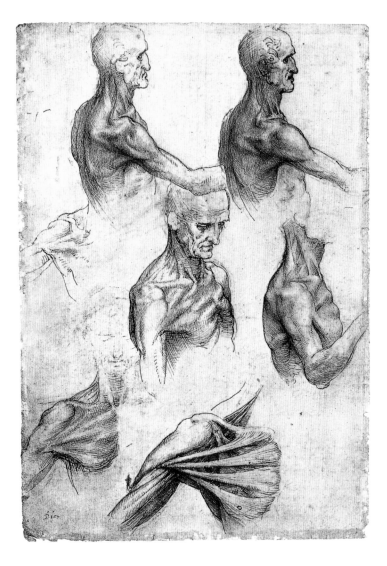

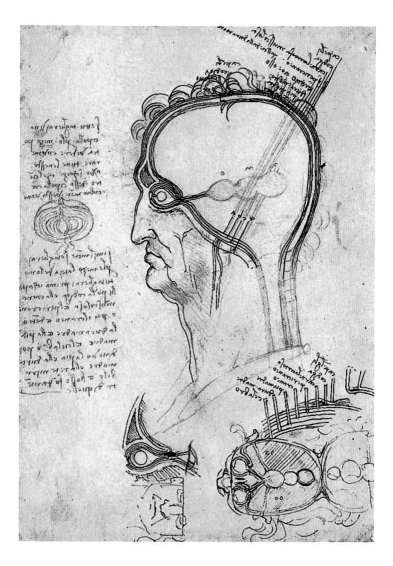

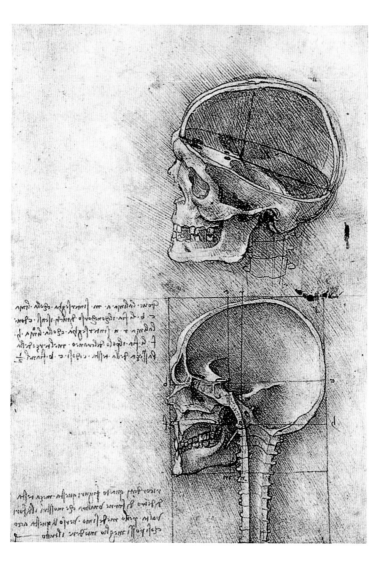

On p. 408:
Muscles of the shoulder,
1509–10;
Windsor, RL 19003v.

On p. 409:
Muscles of the shoulder
at three stages of dissection;
bones of the foot,
c. 1508–10;
Windsor, RL 19013v.

On p. 410:
Male genital organs, bladder,
urinary and seminal canal;
above: *pig's lung,*
1508–9;
Windsor, RL 19098v.

On p. 411:
Muscles of the arm in rotation;
tongue, throat and uvula,
c. 1508–10;
Windsor, RL 19005v.

Bones of the foot
and shoulder,
1508–10;
Windsor, RL 19011r.

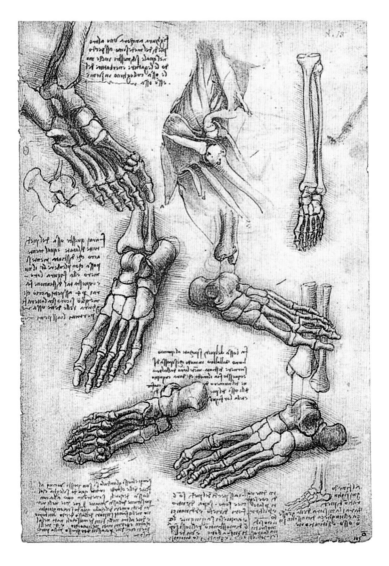

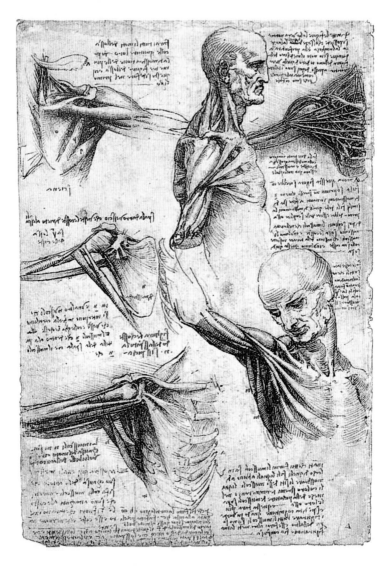

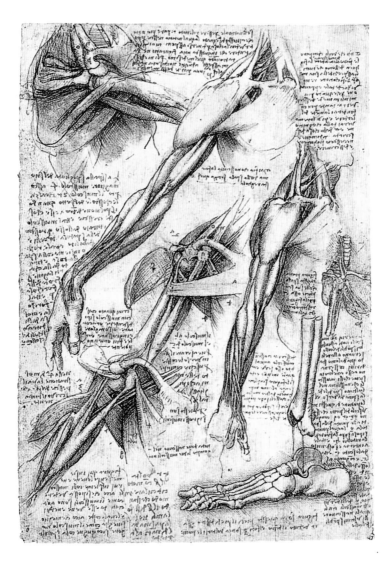

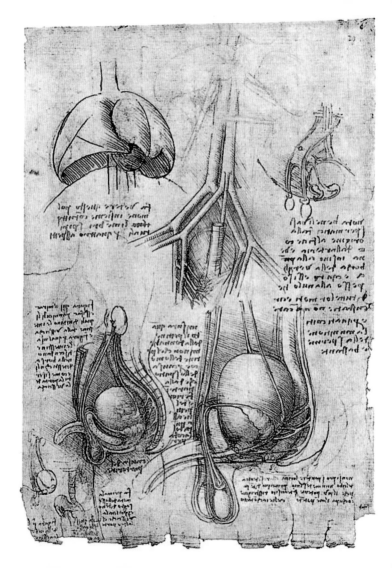

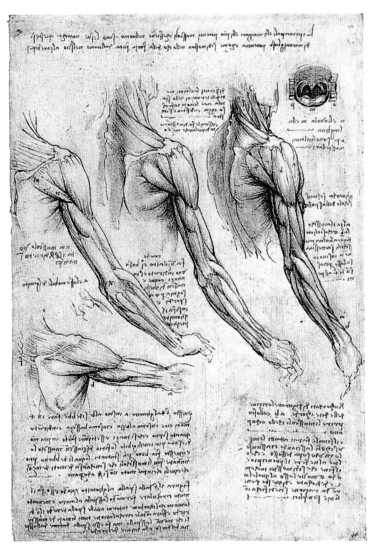

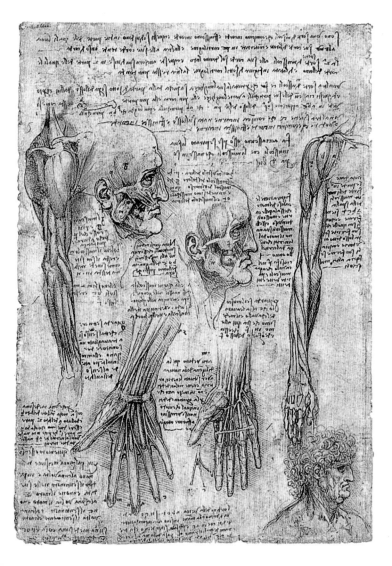

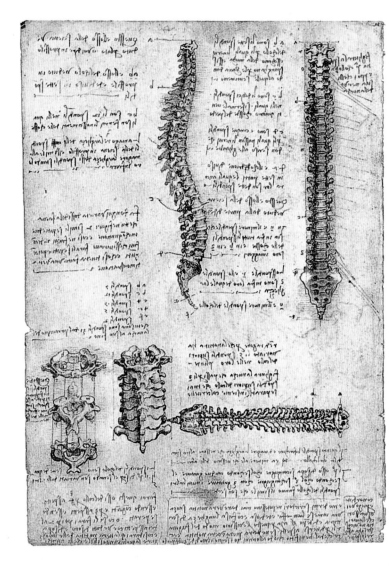

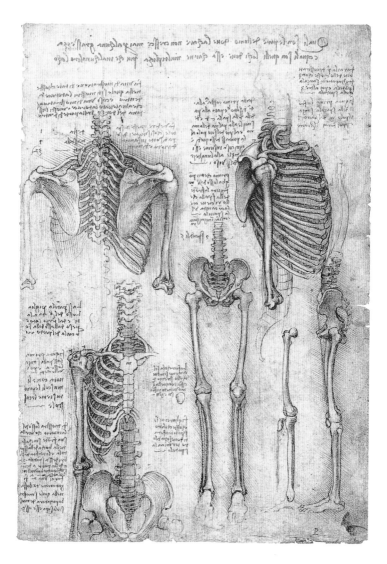

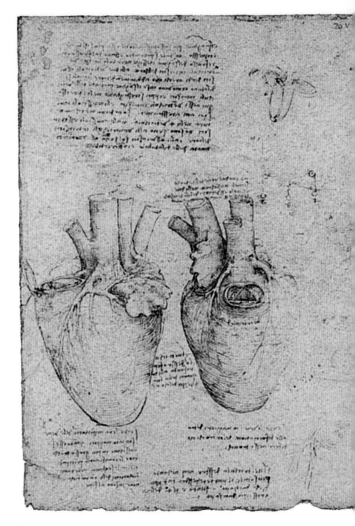

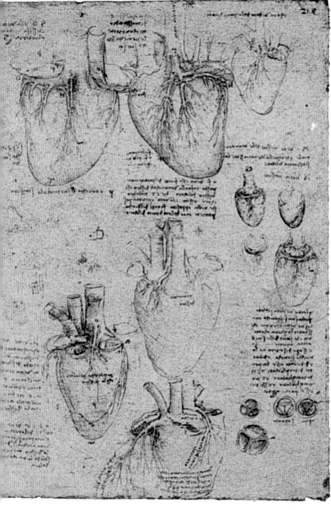

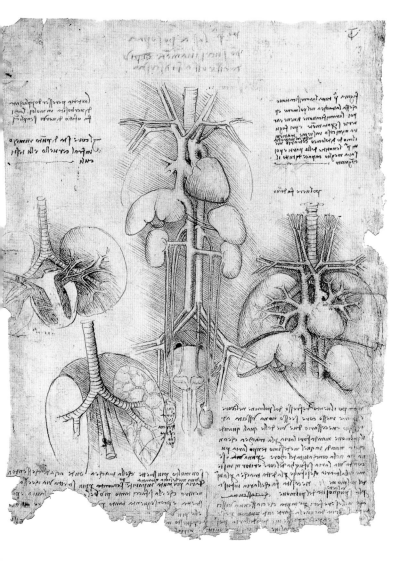

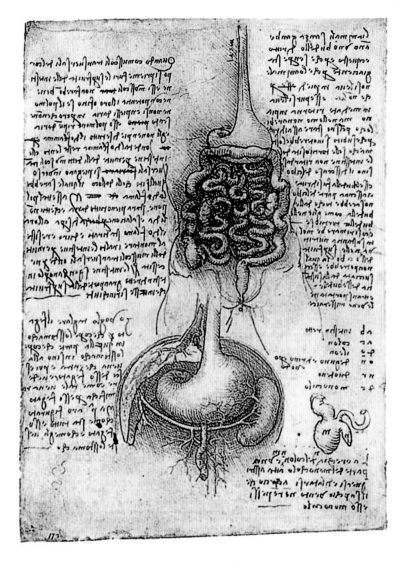

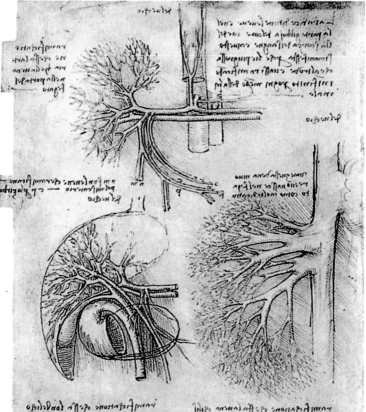

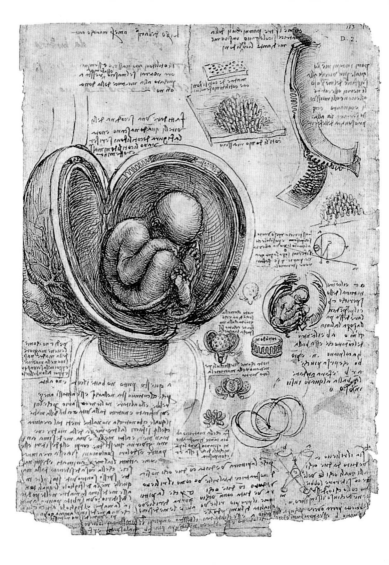

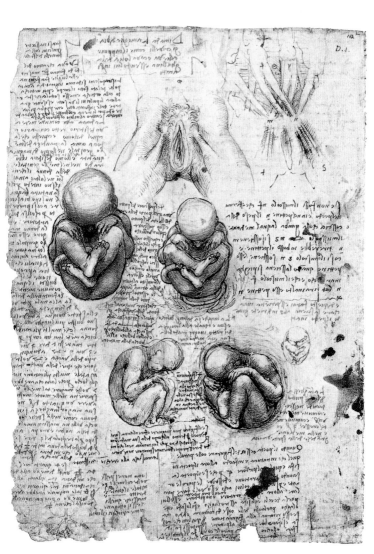

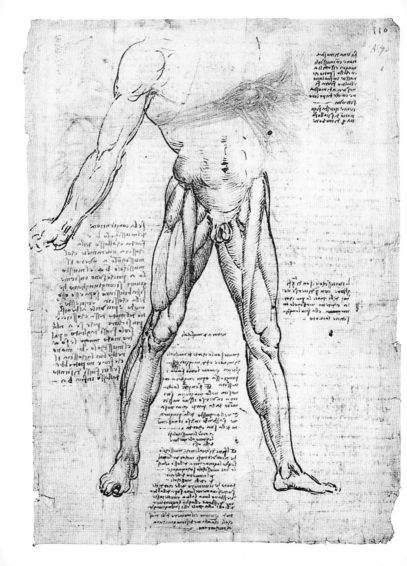

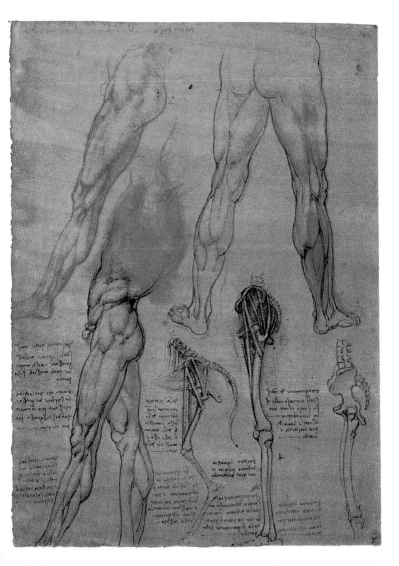

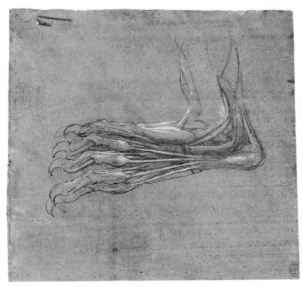

On p. 424:
Anatomical model:
muscles of the thigh,
1510;
Windsor,
RL 19014r.

On p. 425:
Studies of comparative
anatomy between the leg of a
man and the hoof of a horse,
c. 1506–8;
Windsor, RL 12625r.

Anatomical studies
of a bear's foot,
1490–5;
Windsor, RL 12375r.
12373 e 12372.

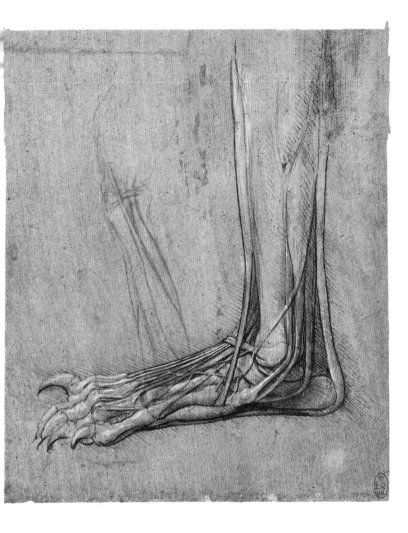

427

LANDSCAPES, PLANTS AND WATER STUDIES

The nearly 70 drawings that make up this section show a number of themes: youthful studies, 'narrated landscapes' (which refer to literary texts), studies of mountains, studies of plants for the *Leda*, drawings executed in red pencil on red prepared paper, studies of water, views of the river Adda, symbolic landscapes and the *Deluges*. The drawing with the *Profile of an old man and studies of whirlpools* seems to portray Leonardo himself, now elderly, seated in contemplation of the analogy between flowing water and tousled hair; an annotation reads, 'Note the motion of the surface of water, which resembles hair ...'

The surprising series of *Deluges* consists of 16 drawings devoted to the theme of the upheaval of the elements brought about by the forces of nature. Here the representation of the infinite movement of transformation of the earth is not so much a graphic record of a real phenomenon as the visualization of it as a symbolic image.

Study of plants,
c. 1506;
Windsor, RL 12424.

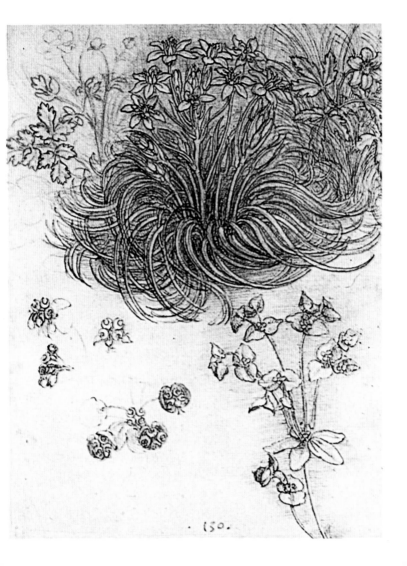

. 150 .

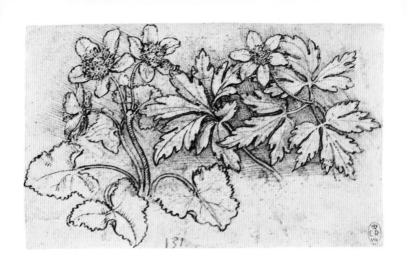

Study of two plants for the 'Leda':
Caltha palustris (left)
and Anemone nemorosa (right),
1508–10;
Windsor, RL 12423r.

Birch woods,
c. 1508;
Windsor, RL 12431r.

On p. 432:
Rushes in flower,
c. 1506;
Windsor, RL 12430r.

On p. 433:
Study of a tree,
probably a fig,
c. 1506;
Windsor, RL 12417r.

432

Branch of an oak tree and detail
of dyer's greenwood, c. 1508;
Windsor, RL 12422r.

Study of reeds,
c. 1508;
Windsor, RL 12428r.

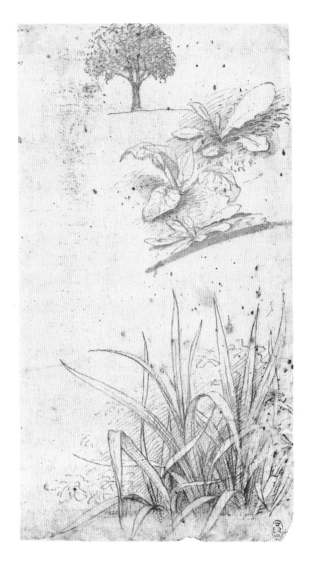

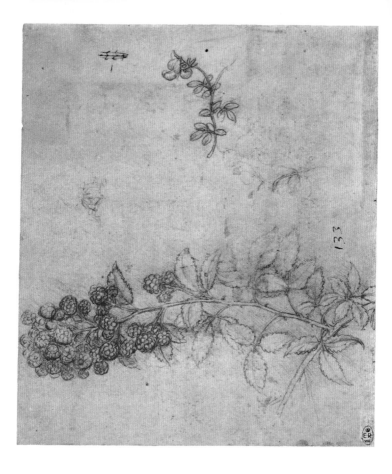

Study of a mulberry branch,
c. 1506;
Windsor, RL 12420r.

Details of two types of reed,
c. 1508;
Windsor, RL 12421r.

153

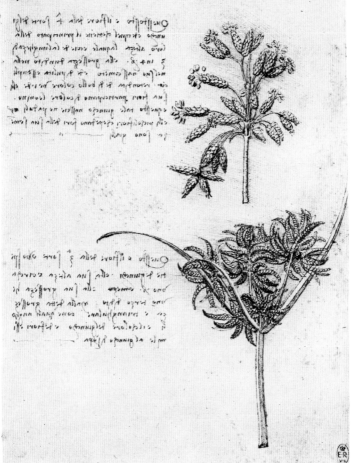

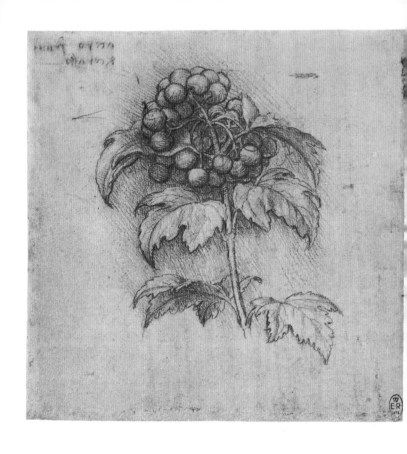

*Sprig of a plant
with berries,
c.* 1508;
Windsor, RL 12421r.

*Branch of a
blackberry bush,
c.* 1508;
Windsor, RL 12419r.

439

Hurricane of wind and rain
over a bay with a castle and viaduct,
c. 1510;
Windsor, RL 12401r.

City on the plain surrounded
by mountain chains,
c. 1510;
Windsor, RL 12407r.

Rolling hills and rocky peaks,
c. 1510;
Windsor, RL 12405r.

Alpine peaks
covered with snow,
c. 1510;
Windsor RL 12410r.

Stream of water flowing through
a chasm with ducks in the foreground,
c. 1483;
Windsor RL 12395r.

Old man seated in profile with studies of whirlpools, c. 1513; Windsor, RL 12579r.

Study of a deluge,
c. 1515;
Windsor, RL 12380.

On p. 448:
Storm over a
mountain valley,
c. 1500;
Windsor, RL 12409.

On p. 449:
Volcanic explosion,
c. 1517–18;
Windsor, RL 12388.

·137·

HORSES AND OTHER ANIMALS

This section contains about 70 drawings. Among the earliest studies of animals are those drawn for scenes in *The Adoration of the Magi*: horses and riders as they appear in the background of the painting in the Uffizi, as well as the ox and the ass. The studies of the proportions of the horse were done in Milan directly from the horses in the stables near Castello Sforzesco, and were worked up in preparation for the monument to Francesco Sforza, of which only the colossal clay model of the horse was realized by Leonardo. Some versions show a group for an equestrian monument and refer to the one planned for Gian Giacomo Trivulzio, on which Leonardo worked during his second stay in Milan: yet another project never brought to completion. On a folio of studies for *The Battle of Anghiari* appears the figure of the Announcing Angel, implicitly suggesting the *Saint John the Baptist* in the Louvre.

Study of a rearing horse,
c. 1504;
Windsor RL 12336r.

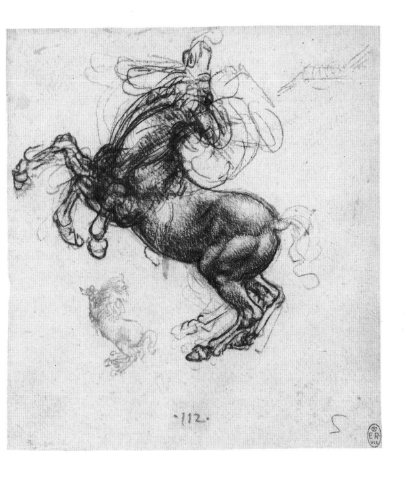

·112·

On p. 454:
Three studies of horses,
c. 1510;
Windsor, RL 12344r.

On p. 455:
Three studies of horses
for an equestrian monument,
c. 1510;
Windsor, RL 12359r.

On pp. 456–7:
Comparison between
the emotional expressions
of a man and some
animals (horses and a lion),
c. 1508;
Windsor, RL 12326r.

Study of cats
and a dragon,
c. 1517–18;
Windsor, RL 12363r.

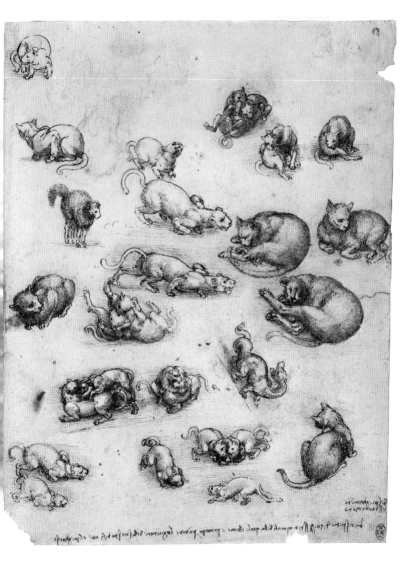

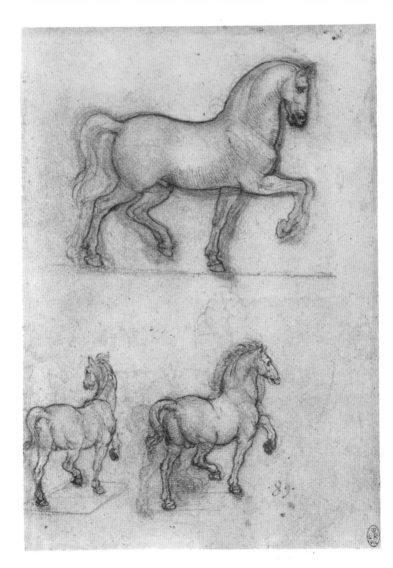

89

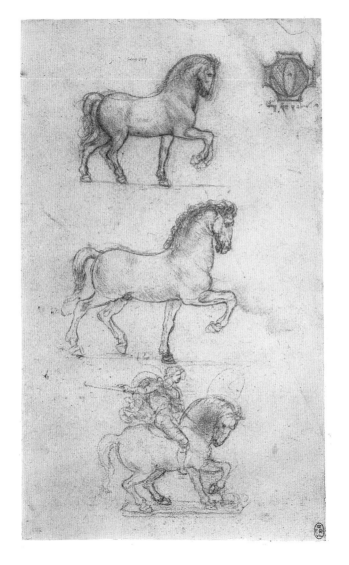

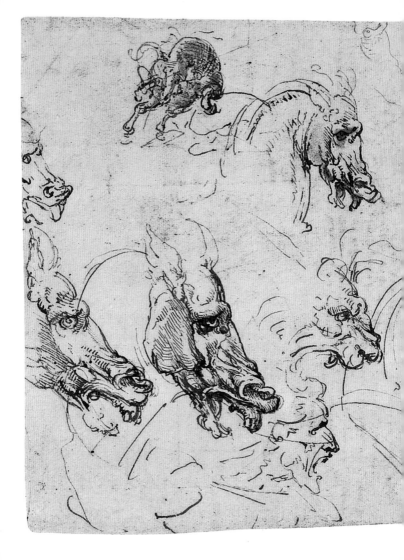

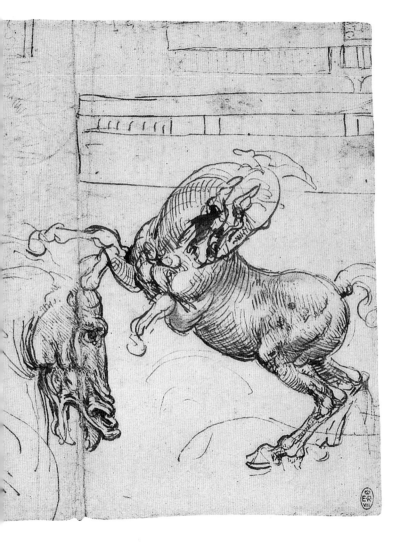

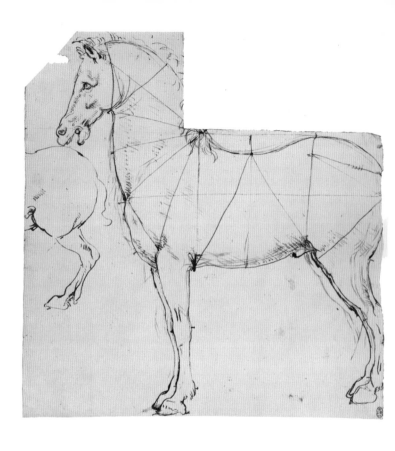

*Study of a horse
with diagram of proportions,*
1478–80;
Windsor, RL 12318.

*Study of rearing horse and rider
trampling a fallen enemy,*
c. 1490;
Windsor, RL 12358r.

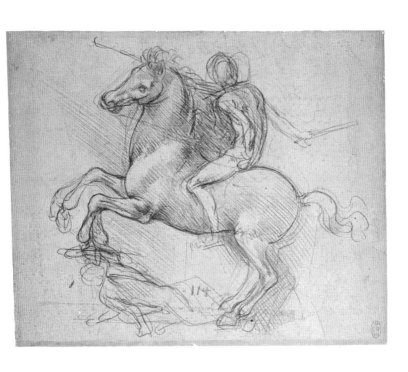

459

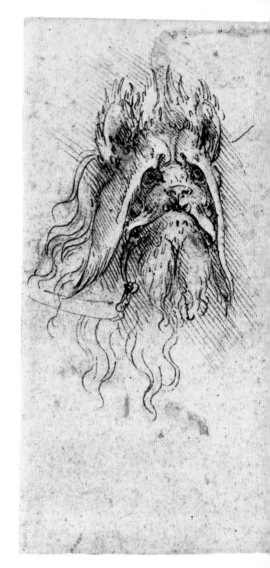

*Two studies
of grotesque animals,
c.* 1510;
Windsor RL 12367r.

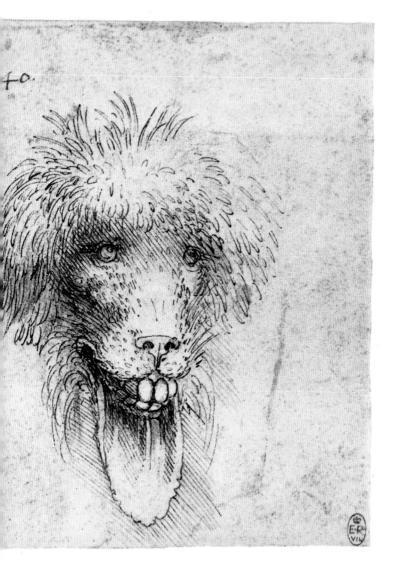

70.

*Study of
a fantastic animal,
probably an idea
for an automaton,
1515–16;
Windsor,
RL 12369.*

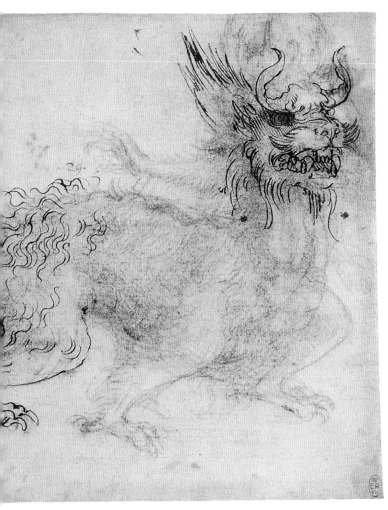

463

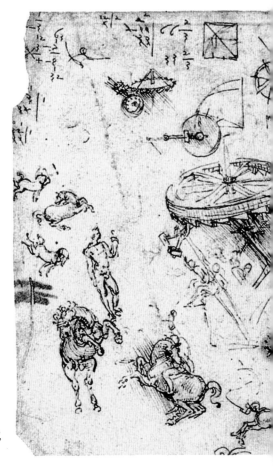

*The Announcing
Angel by a pupil, on a
sheet of studies for
'The Battle of Anghiari',
1503–5;
Windsor, RL 12328r.*

FIGURE STUDIES

The fourth section of the *Windsor Collection* consists of about 100 drawings. Among the studies of figures are the preparatory drawings for *The Virgin of the Rocks* and others for the head of the *Leda*. Among Leonardo's first known drawings, the *Study of hands* reflects an echo of his apprenticeship in Verrocchio's workshop and probably documents the missing lower part of the *Portrait of Ginevra Benci*. In his caricatures Leonardo makes studies of physiognomic and pathognomic traits.

MISCELLANEOUS PAPERS

The themes dealt with in the fifth section range from riddles, emblems and allegories to geographical charts, which form a group of about 20 folios. There are notes of a scientific nature, referring mainly to hydraulic engineering, architecture and technology. The *Neptune with sea horses* constitutes the trace of a large drawing conceived as a work in itself, now lost. The impetus of the horses calls to mind the grandiose dynamism that was to animate the unfinished *Battle of Anghiari*.

Study for the 'Leda' hairstyle,
1506–8;
Windsor, RL 12516.

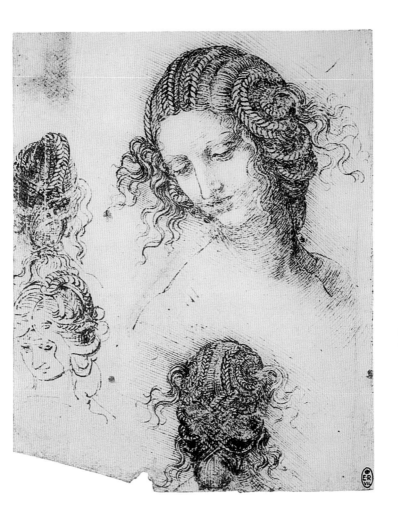

467

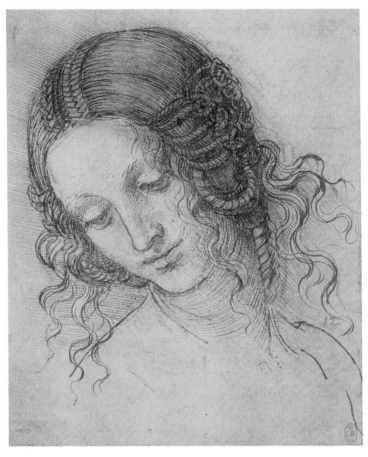

Study of a woman's head for the 'Leda',
c. 1506–8;
Windsor, RL 12518.

Study of a woman's head for the 'Saint Anne' in the Louvre,
c. 1510;
Windsor, RL 12518.

468

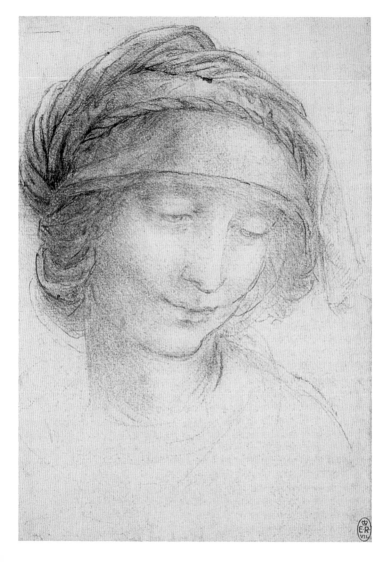

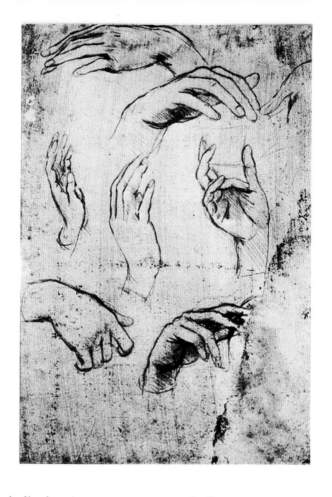

Study of hands, c. 1481;
Windsor, RL 12615.

Study of hands, 1475–8;
Windsor, RL 12558.

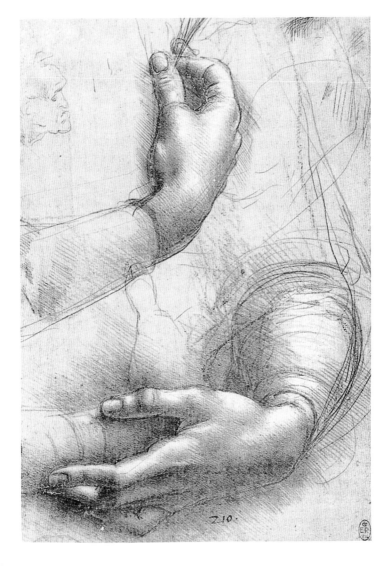

210.

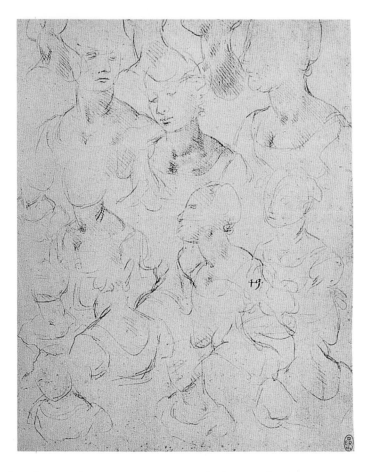

*Bust of a woman shown
in eighteen positions*, 1475–80;
Windsor, RL 12513.

*Study of a woman's bust for 'The
Madonna of the Yarnwinder'*, c. 1500;
Windsor, RL 12514.

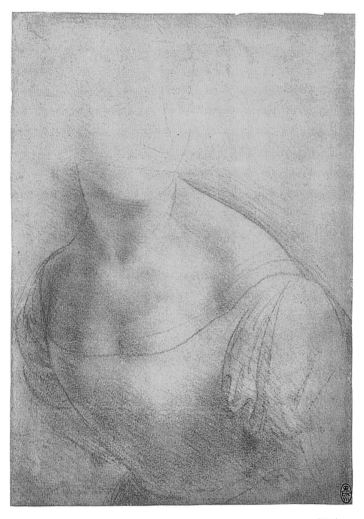

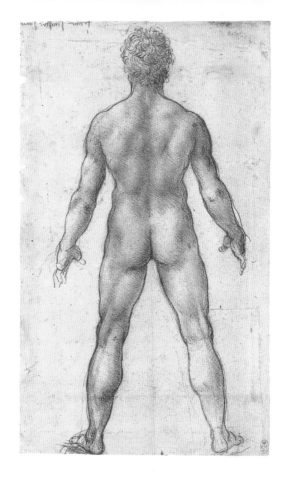

Male nude seen from behind,
c. 1504–6;
Windsor, RL 12596.

Study of a leonine human type,
1508–10;
Windsor, RL 12502.

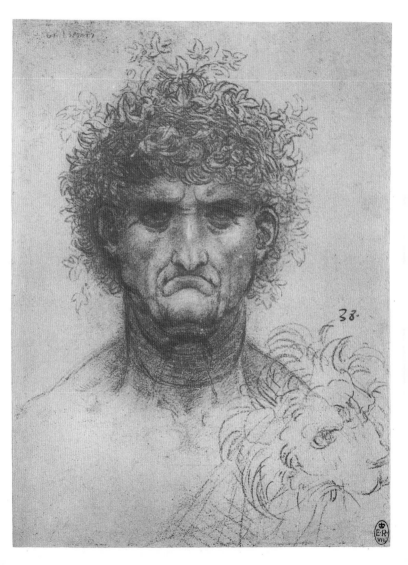

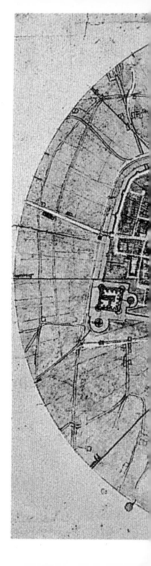

Map of Imola,
1502;
Windsor, RL 12284.

On p. 472:
Studies of naval artillery,
c. 1487–90;
Windsor, RL 12632r.

On p. 473:
Drawings of
military machines,
1487–90;
Windsor, RL 12647r.

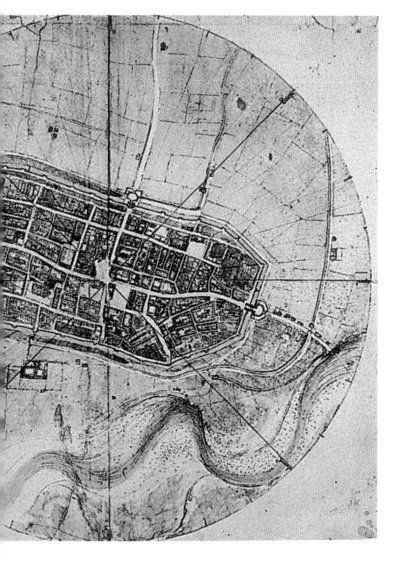

Allegory of Navigation, c. 1517–18; Windsor, RL 12369.

481

Neptune,
c. 1504;
Windsor,
RL 12570.

The manuscripts

After the death of Leonardo, all the manuscripts in which he had recorded the research, projects, theories, personal facts, curiosities and reflections of his entire life, were inherited by his pupil Francesco Melzi, who brought them back to Italy from France. There must have been quite a large number of notebooks. A writer of the time recalled that Leonardo kept with him in his last years 'an infinity of volumes' composed by him. It is thought that the material handed down to us accounts for about one-fifth of the entire bulk of papers left by Leonardo. The rest has been lost. Melzi scrupulously safeguarded Leonardo's heritage, dedicating himself to selecting from it the texts used to compile the *Libro di Pittura* ('Book on Painting') but after his death in 1570, the negligence of his son Orazio led to the dispersal of all of Leonardo's manuscripts, which were variously subjected to theft, sale, donation, appropriation or loss.

Anonymous,
Presumed portrait of Leonardo,
18th century;
Florence, Galleria degli Uffizi.

Codex Trivulzianus

Milan,
Biblioteca del Castello Sforzesco

The format is approximately 20.5 x 14cm/8 x 5½in, and the codex contains 55 pages. Some of the folios are obviously missing, since the complete number was 62. The codex is named after Prince Trivulzio, who acquired it in the mid-18th century. Then in 1935 it was transferred, as part of the Trivulzian collection, to the library of Castello Sforzesco. It is one of the earliest known manuscripts, compiled by Leonardo during the years he spent in Milan from 1487 to 1490. It contains studies of architecture (sketches for the lantern over the Milan Duomo) and military engineering, but also caricature heads. The most significant pages are those that Leonardo filled with long lists of words, during his research into erudite terms, Latinisms taken from books and academic disciplines of various kinds. It was a way for the self-taught thinker, a 'man without letters', as he called himself, to enrich his knowledge of the language.

'The correct position of the axis
that forms the bombard',
1487–90;
Milan, Trivulziano, f. 16v.

Studies on facilitating casting,
1487–90;
Milan, Trivulziano, f. 17r.

On p. 490:
Architectural drawing,
1487–90;
Milan, Trivulziano, f. 22r.

On p. 491:
*Drawings linked to studies
for the Duomo of Milan,*
1487–90;
Milan, Trivulziano, f. 22v.

On p. 492:
*Figure of a building
and its details,*
1487–90;
Milan, Trivulziano, f. 27v.

On p. 493:
Draped male figure,
1487–90;
Milan, Trivulziano, f. 28r.

On p. 494:
Lists of words,
1487–90;
Milan, Trivulziano, f. 37v.

On p. 495:
*Pen and ink drawing
of the head of an old man,*
1487–90;
Milan, Trivulziano, f. 38r.

On p. 496:
Figures of caltrops,
1487–90;
Milan, Trivulziano, f. 53v.

On p. 497:
Drawing of a crossbow,
1487–90;
Milan, Trivulziano, f. 54r.

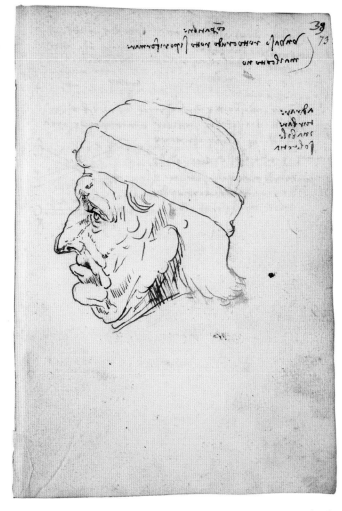

CODEX ON THE FLIGHT OF BIRDS

Turin,
Biblioteca Reale

This codex is entirely devoted to the subject of flight. The notes refer to the direct observation of birds by Leonardo, who analysed their manner of using their wings and leaning into the wind to exploit currents of air. Formed of 17 sheets measuring 21 x 15cm/8$^{1}/_{2}$ x 6in, it was sewn inside the cover of *Manuscript B*, which was taken to France in the late 18th century; subsequently, however, the codex was secretly removed by Guglielmo Libri, a professor of mathematics and distinguished man of science who, while carrying out an official inspection at the Institut de France, appropriated several of Leonardo's papers. After various sales and transfers of ownership, the codex was given to the Savoia family and lodged in its present location. The codex dates from the years around 1505, when Leonardo, in Florence, was designing a flying machine based on his studies. As compared to flight with beating wings moved by human muscle-power, the much more plausible idea of planar flight achieved with some kind of glider was taking shape.

Studies on the flight of birds
and red chalk drawing of a leaf,
c. 1505;
Turin, Codex on Flight, f. 15v.

On pp. 500–1:
Studies on static principles
often applied by Leonardo
to the study of flight, c. 1505;
Turin, Codex on Flight, ff. 1r and 4r.

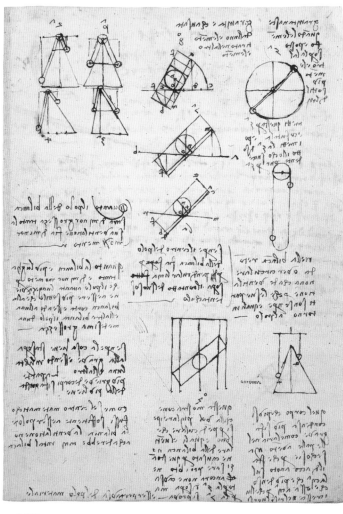

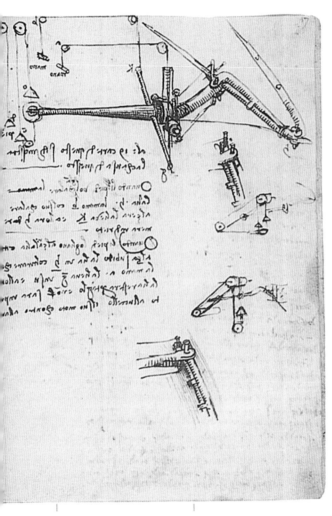

509

MANUSCRIPTS OF FRANCE

Paris,
Institut de France

These 12 manuscripts were almost all donated by Count
Galeazzo Arconati to the Biblioteca Ambrosiana in the 17th
century. From that library they were removed in 1796 at the
express order of Napoleon Bonaparte, then commanding
the French troops who had just entered Milan in triumph.
They were taken to Paris, to the Institut de France, where
they were assigned identifying letters ranging alphabetical-
ly from A to M. The *Codex Atlanticus* was also taken to Paris,
but was returned in 1815 after the downfall of Napoleon,
while the small notebooks remained permanently in
France. The manuscripts have different formats, different
numbers of pages and different bindings. They were com-
piled in various ways, ranging from rapid sketches and
quickly jotted notes to rigorous, accurate text and drawings.
As a whole, they represent the multiplicity of ways in which
Leonardo recorded his observations in writing and images
during the various periods of his life.

Studies on the course of water,
1490–2;
Paris, Ms A, f. 25r.

Manuscript A

The format of this codex is 22 x 15cm/9 x 6in; of the 114 original folios only 63 remain. The missing pages were removed in the 19th century by Guglielmo Libri who, to detach them cleanly from the binding, ingeniously left a wire soaked in hydrochloric acid in the volume as a bookmark. Some of the pages were reassembled by Libri himself who, having fled to England, sold the new volume thus obtained to Lord Ashburnham, along with another that he had made out of sheets removed from *Manuscript B*. This is the origin of the two codices called *Ashburnham 2038* and *2037*, which thus actually consist entirely of pages missing from *Manuscripts A* and *B*. *Manuscript A* dates from 1490–2 and is mainly devoted to subjects linked to painting and physics. It was from here that Melzi took the notes on linear perspective that he transposed to the *Libro di Pittura* ('Book on Painting'). In his studies on physics Leonardo focused mainly on motion, which was also the central motif of his thought in painting: the motions of the body and the motions of the mind.

*Studies of
a human head*,
1490–2;
Paris, Ms A, f. 63r.

On p. 514:
*Circle for constructing
polygons;*
below,
*Method for dividing
a circle into equal parts*,
1490–2;
Paris, Ms A, f. 11v.

On p. 515:
*Circumference divided
into equal parts;*
below, *Method
for dividing a square
into eight faces*,
1490–2;
Paris, Ms A, f. 12r.

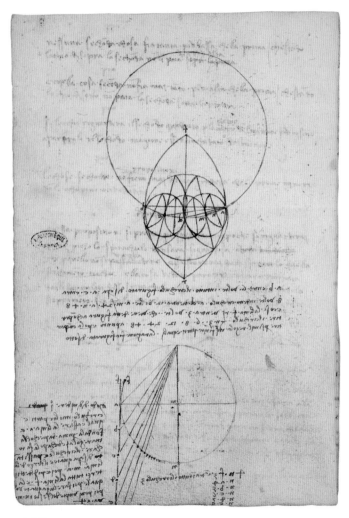

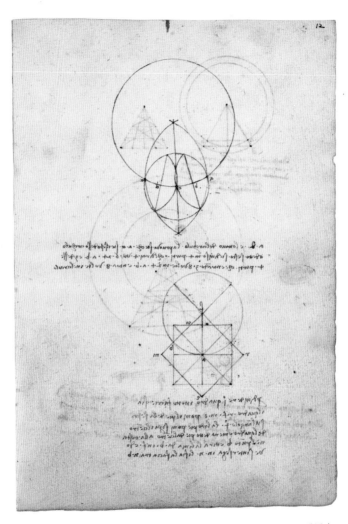

12

o · d · e · comuno deluo uidio tañ palmo fac e g · e · e · la fiplicato tu trento
dro facto fa cco g · la riplicato g · n · g · aguida n · o · e · n · o · e · n · o · a fenghi
f · famta defi tura · o · g · o · g · ñla defe ñ · o · ñ · g · a cañto g · fante la ñ cañto

515

*Experiment
on the falling of weights
and on movement of the air,*
1490–2;
Paris, Ms A, f. 30v.

On p. 518:
*Method for preparing a loom
and studies of the shadow
of a person at a window,*
1490–2;
Paris, Ms A, f. 1r.

On p. 519:
*Studies of the
movement of water,*
1490–2;
Paris, Ms A, f. 24v.

Manuscript B

Originally consisting of 100 sheets (measuring approximately 23 x 16cm/9 x 5¹/₂in), this manuscript was depleted by the hand of Guglielmo Libri, who stole, in addition to these pages, the entire *Codex on the Flight of Birds*, which was inserted in the notebook. The two *Ashburnham Codices* that Libri put together from the pages he removed from *Manuscripts A* and *B* and sold in London were given back to France after lengthy negotiations, and returned to the Institut in the late 19ᵗʰ century.

This is the earliest known manuscript by Leonardo, dating from 1487–90. It reflects his interest in military and civil engineering, with layouts and elevations of fortifications and drawings of churches constructed around a central plan. Of crucial interest are his urban planning scheme, of an ideal city where the various activities are carried out on different levels, and his technological projects for flying machines, a submarine and an 'aerial screw' that winds on itself, rising in the air like a modern helicopter.

*Method for
testing the force
of an artificial wing,*
c. 1487–90;
Paris, Ms B, f. 88v.

On p. 522:
*Studies of churches
with central plan,
reverberation
furnaces and a
'sphere-instrument'
used for fabricating
burning mirrors,*
c. 1487–90;
Paris, Ms B, f. 21v.

On p. 523:
*Study of church
with central plan,*
c. 1487–90;
Paris, Ms B, f. 95r.

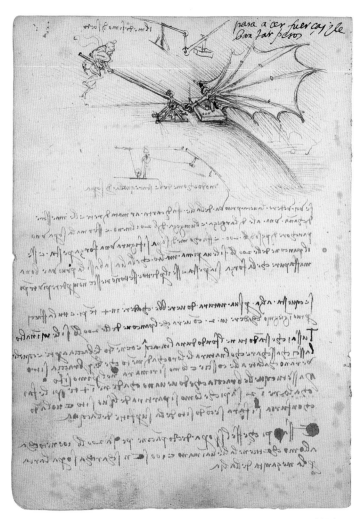

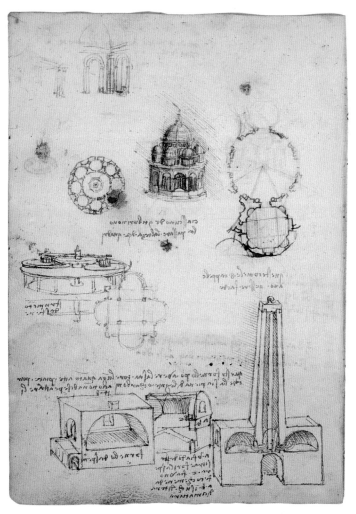

522

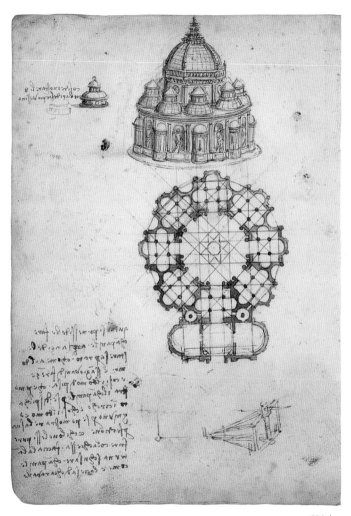

On p. 526:
*Project for ornithopter
(flying machine
with wings
connected directly
to the human body),*
c. 1487–90;
Paris, Ms B, f. 75r.

On p. 527:
*Ornithopter with pilot
in prone position,*
c. 1487–90;
Paris, Ms B, f. 79r.

*Study of
artificial wing,*
c. 1487–90;
Paris, Ms B, f. 74r.

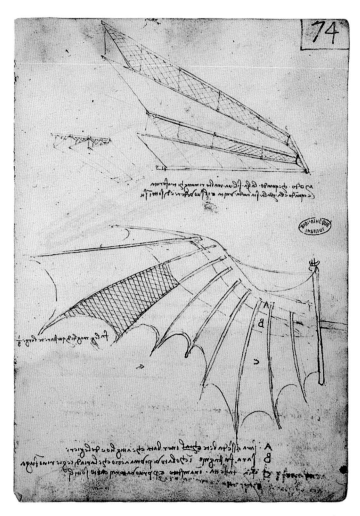

74

525

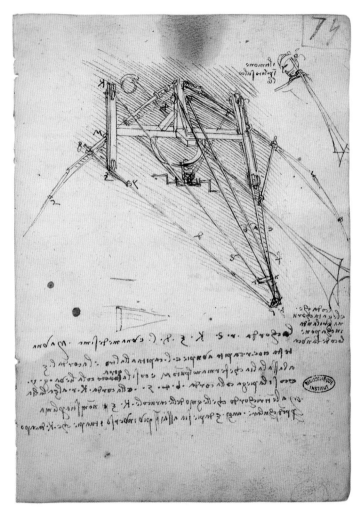

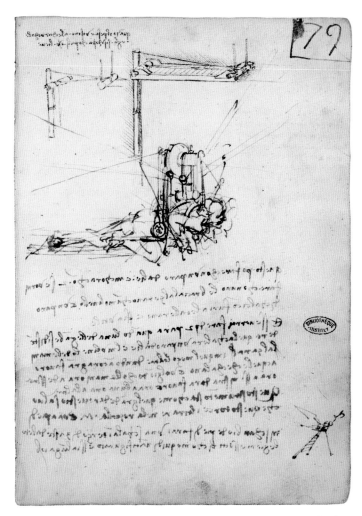

On p. 530:
*Study for a flying machine
(the so-called 'helicopter'),*
c. 1487–90;
Paris, Ms B, f. 83v.

On p. 531:
*Fruits and vegetables,
architectural layouts
and groups
of undeciphered letters,*
c. 1487–90;
Paris, Ms B, f. 23.

Vertical ornithopter,
c. 1487–90;
Paris, Ms B, f. 80r.

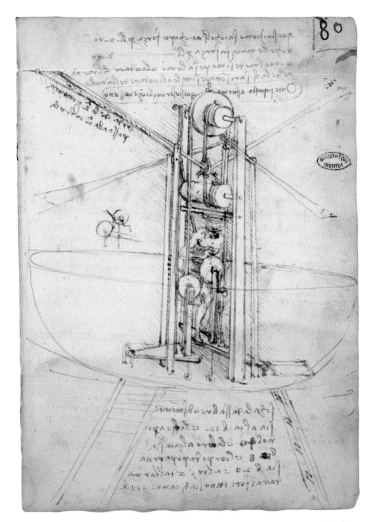

531

Manuscript C

This is the largest of the manuscripts of France, having a format of 31 x 22cm/12$^{1}/_{2}$ x 9in and being composed of 32 sheets. Due partly to the neglect of Francesco Melzi's son, who kept Leonardo's precious codices unsecured in his attic, the codex was stolen, along with others, by the tutor of the Melzi family, who later returned it to Cardinal Mazenta. Because it stayed in the hands of the Mazenta family, it was one of the few manuscripts that was not purchased and taken to Spain by Pompeo Leoni. It was later offered to Cardinal Federigo Borromeo, who presented it to the Biblioteca Ambrosiana, founded by him in 1609. It thus represents the first of Leonardo's manuscripts to enter a public collection, almost 400 years ago. The subject it deals with is shadow and light, those optical phenomena that Leonardo first studied scientifically and then applied to his painting. The manuscript bears the date on which it was begun, 23 April 1490, and Leonardo was to continue to write and draw in it for about one year.

Original binding of *Manuscript C*, 17th century, Paris, Bibliothèque de l'Institut de France.

On p. 534:
Studies on the shadowy body, 1490–1; Paris, Ms C, f. 8v.

On p. 535:
Studies on rays of light, 1490–1; Paris, Ms C, f. 9r.

On p. 536:
Form of shadow dependent on lighted and shadowy bodies, 1490–1; Paris, Ms C, f. 18v.

On p. 537:
Perfect and imperfect shadow, 1490–1; Paris, Ms C, f. 19r.

.VIDI.MAZENTÆ.
PATRITII.MEDIOLANENSIS
LIBERALITATE
.AN. M.D.C.III

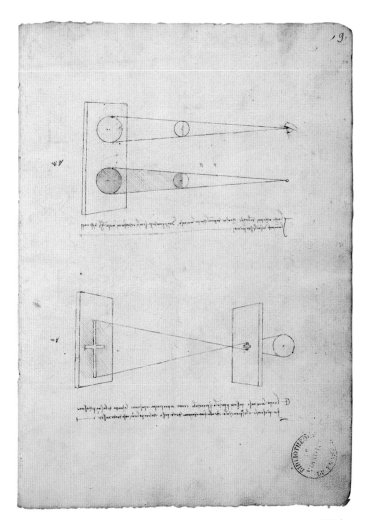

·9·

535

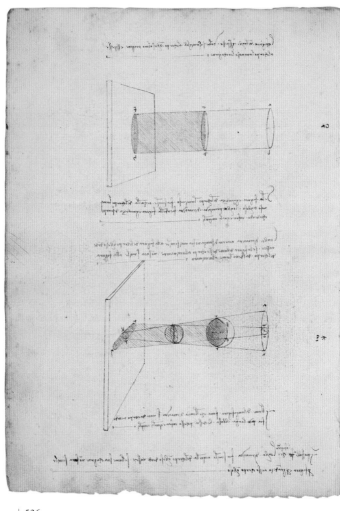

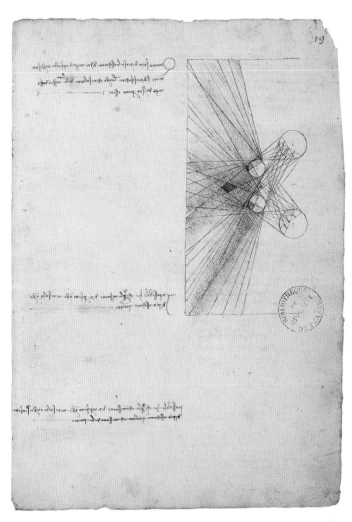

Manuscript D

The manuscript consists of 20 pages measuring 22.5 x 16cm/9 x 6½in. In it, the eye and the science of vision are the principle subjects of Leonardo's investigations. The sheets are compiled with great clarity and precision, in terms of both the images with their detailed figures and diagrams and the compact writing, which is arranged in regular columns on each page. This particular characteristic seems to indicate that the text was probably compiled by copying previous notes.

Leonardo compared his findings on the science of vision with the theories of ancient authors, but what interested him primarily was experimentation. Accordingly, he planned and conducted a series of experiments on the eye and its perception of rays of light. To carry out his experiments he designed a glass model, large enough to hold the observer's head, which replicated the structure and functioning of the human eye. Through his studies and experiments Leonardo discovered and described the phenomenon of the double reversal of images in the eye.

Studies of the human eye,
1508–9;
Paris, Ms D, f. 3r.

On p. 540:
Studies of parts of the eye,
1508–9;
Paris, Ms D, f. 7v.

On p. 541:
Studies of the eye and light rays,
1508–9;
Paris, Ms D, f. 1v.

BIBLIOTHÈQUE INSTITUT

Manuscript E

This manuscript consists of 80 pages, size 14.5 x 10cm/$5^3/_4$ x 4in; the last section of 16 pages was stolen by Guglielmo Libri and has been lost. It dates from Leonardo's last years in Italy when, in 1513, he moved from Milan to Rome. It also contains a record of his journey to Parma in 1514 and continues up to 1515. The main subject of study is mechanical physics, in particular the science known as *de ponderibus*, which corresponds to modern statics, in which Leonardo, by applying accurate proportional formulas, achieved remarkably advanced results. In this codex Leonardo also studies the flight of birds, drawing the various inclined positions assumed by their wings to fully exploit currents of air, in connection with his project for a glider. Other notes deal with painting, geometry and, lastly, water, to which Leonardo dedicated many pages in his manuscripts and which, in other notes, he designates as the subject of a real book: 'Order of the first book of waters.'

Study of the motion of birds,
1513–14;
Paris, Ms E, f. 54r.

On p. 544:
Gliding of birds in the wind,
1513–14;
Paris, Ms E, f. 40r.

On p. 545:
Drawing of a machine for draining canals,
1513–14;
Paris, Ms E, f. 75v.

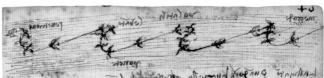

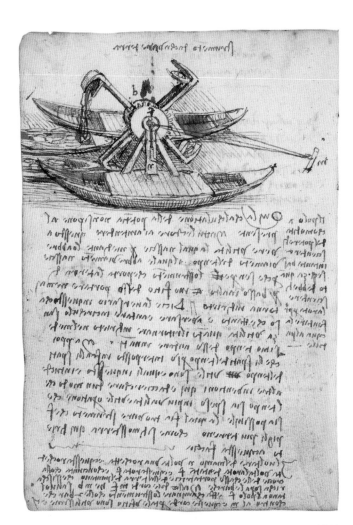

Manuscript F

Composed of 96 sheets, measuring 14.5 x 10.5cm/5³/₄ x 4¹/₄in, this manuscript has remained unchanged since Leonardo compiled it over a very brief period in 1508 (the date that appears at the beginning of the codex is September and the one at the end is October of the same year).

The basic subject is water, whose infinitely changing aspects Leonardo describes superbly. In his observations he examines whirlpools, waves and motion, both on the surface and in the depths, and he coins for water the term *panniculata* ('tissue-like') to define its particular quality, like that of a finely wrinkled cloth. The subjects of optics and cosmology enter into the definition of the reflection of light from the sun and moon on the surface of the sea. Regarding the earth, Leonardo hypothesizes that it originally emerged from the waters of the sea, describes the incessant mutations caused by the action of rain and wind, and lastly imagines the earth's return to the sea, sinking into its abyss.

Study of centrifugal pump for draining swamps,
c. 1508;
Paris, Ms F, f. 15r.

On pp. 548–9:
Studies on water pressure,
c. 1508;
Paris, Ms F, ff. 45v and 46r.

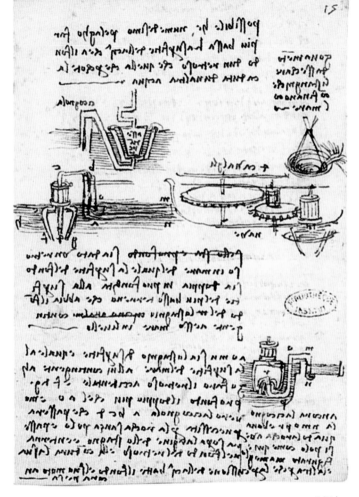

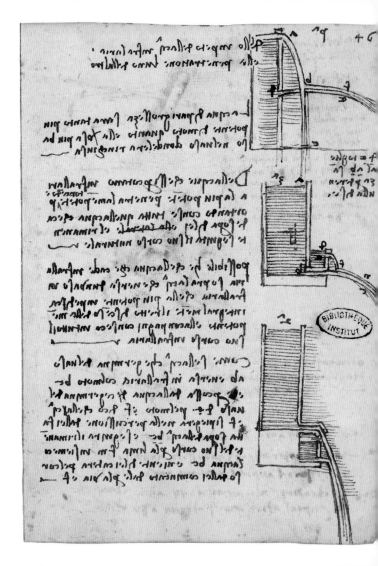

Manuscript G

In octavo format (approximately 14 x 10cm/5^{1}/$_{2}$ x 4in) like *Manuscripts E* and *F*, this codex consists of 96 pages (three are now missing), amounting to what was considered the 'correct' number. It was formed by putting together six sections, each composed of eight double folios. The codex contains notes on botany: the morphology of plants, laws on their birth and growth, and the effects of light, shadow, reflection and transparency on leaves. These are studies of nature to be transposed into painting, and in fact the notes were used in the *Libro di Pittura* ('Book on Painting'). Other sections deal with recurring subjects: geometry, flight, technology, water, optics and motion. Leonardo here recorded the dates 1510 and 1511, during his second stay in Milan, and that of 1515, when he had already settled in Rome. Here, one of his main interests was the fabrication of burning mirrors, and in this codex he developed the techniques for moulding and silvering the concave plates of glass from which they were made.

Machinery
for fabricating
concave mirrors,
c. 1515;
Paris, Ms G, f. 83v.

On pp. 552–3:
Studies and calculations
on parabolic mirrors,
with memorandum
on using burning
mirrors for the welds

executed in 1469
on the copper sphere
for the lantern
of the Florence Duomo,
c. 1515; Paris,
Ms G, ff. 84v and 85r.

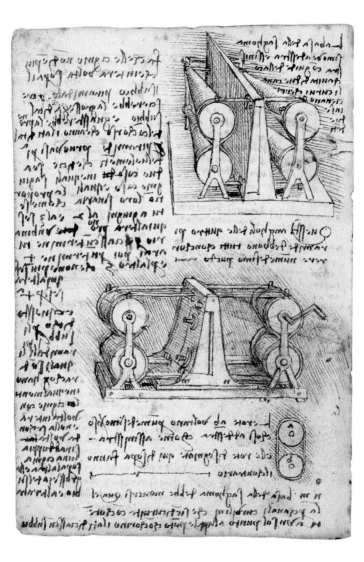

Manuscript H

This manuscript is compiled from three notebooks, all pocket-sized (10.5 x 8cm/4¹/₂ x 3¹/₄in), making a total of 142 sheets. The little books, which must have been bound together later, can be dated as a whole at 1493–4. These were the years when Leonardo, at the court of Ludovico il Moro in Milan, devised for the duke a number of allegories mentioned in the manuscript. Some notes reflect the study of Latin grammar undertaken by Leonardo in order to read scientific texts. Another section is dedicated to a 'bestiary' in which various animals are compared to humans, with morals being drawn from their behaviour. Leonardo also records his observations on the force of currents in rivers, which sweep away the banks: knowledge based on direct observation, perhaps of the tumultuous Ticino in the vicinity of the Sforza family's summer residence at Vigevano. Another subject dealt with is hydraulic engineering, with calculations for excavating the Martesana channel along the course of the Adda river between Lecco and Milan.

*Exercises in words
and device
for generating
reciprocal motion,
1493–4;
Paris, Ms H, f. 133v.*

On pp. 556–7:
*Two types of compass with
adjustable opening; mortar-piece
and mechanical details,
1493–4;
Paris, Ms H, ff. 108v and 109r.*

Manuscript I

The manuscript contains a total of 139 pages belonging to two pocket-sized notebooks in a format of 10 x 7.5cm/4 x 3in. It is datable to Leonardo's last two years in Milan, from 1497 to 1499 when, just before the invasion of the French troops, he was working on the 'duchess's bathroom', for which he designed a heating system. Other notes refer to the measurements of 'Leonardo's vineyard', the land he had been given by the duke in the San Vittore district of the city. The codex contains notes and drawings on various subjects: Euclidean geometry, architecture, and the concept of motion that is common to research on both mechanics and hydraulics. As regards his studies on water, Leonardo records his intention of writing a book entirely devoted to this subject: 'Beginning of the book of water.' With the allegories, the drawings of ornamental motifs also fall within the series of projects in different spheres carried out by Leonardo for Ludovico Sforza's court.

Parchment binding
of *Manuscript I*,
16th century;
Paris, Bibliothèque
de l'Institut de France.

On pp. 560–1:
Studies of ornamental motifs
and proportions of a dog's head,
1497–9;
Paris, Ms I, ff. 47v and 48r.

559

Manuscript K

This codex consists of three different manuscripts, very small (about 9.5 x 6.5cm/3^3/$_4$ x 2^1/$_2$in) and numbering 48, 32 and 48 pages respectively. They were bound into a single small volume in the 17th century, when they were in the possession of Count Orazio Archinti, who then presented the manuscript to the Biblioteca Ambrosiana. The first two notebooks belong to the same period, 1503–5; the third dates instead from the years immediately following, 1506–7. It contains notes on Euclidean geometry, such as the solution to the problem of squaring the circle, then studies on water, flight and a drawing that rapidly sketches the dynamic pose of a horseman for *The Battle of Anghiari*. The notes also reflect research on hydraulics, architecture and comparative anatomy. A note at the beginning records a scientific query on the moon, a dense and therefore heavy body, which nevertheless appears as if suspended in the sky. The question asked by Leonardo is intensely poetic: 'The moon is dense. All dense bodies are heavy. How stays, then, the moon?'

Binding of
Manuscript K,
16th century;
Paris, Bibliothèque
de l'Institut de France.

On pp. 564–5:
*Balanced scales
and notes; studies
on comparative
anatomy,* 1506–7;
Paris, Ms K,
ff. 109v and 110r.

On p. 566:
Bird with wings

stretched forward,
1506–7;
Paris, Ms K, f. 9r.

On p. 567:
*Two studies
of a bird beating
its wing,*
1506–7;
Paris, Ms K, f. 7r.

LEONARDI

VINCII

Manuscript L

This codex, which is in sextodecimo (10 x 7cm/4 x 3³/₄in), was composed of the 'correct' number of 96 pages, two of which are missing today. Leonardo compiled it over a rather long timespan starting from 1497, his last year in Milan, with notes referring to *The Last Supper*. There is an interruption after the downfall of Ludovico il Moro; the notes are then resumed with numerous studies of fortifications dating from the time when Leonardo was engaged in military architecture in the service of Cesare Borgia.

Between 1502 and 1504, Leonardo carried the manuscript with him on his travels through Romagna, the Marche and then Tuscany. Other pages are dedicated to notes on arithmetic, based on Luca Pacioli's treatise, the *Summa*. A vast section deals with the flight of birds and projects for a flying machine. It is here that we find the drawing for a great single-span bridge conceived by Leonardo to unite Pera and Constantinople.

Original binding
of *Manuscript L*,
16th century;
Paris, Bibliothèque
de l'Institut de France.

On pp. 570–1:
*Diagram of artillery
fire and military
architecture, c.* 1498;
Paris, Ms L,
ff. 45v and 46r.

On p. 572:
*Clockwork
for planetary clock,
c.* 1498;
Paris, Ms L, f. 92v.

On p. 573:
*Two figures of a young
man kneeling,
c.* 1498;
Paris, Ms L, f. 2r.

L

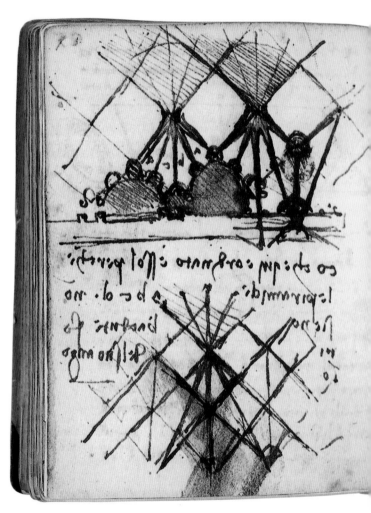

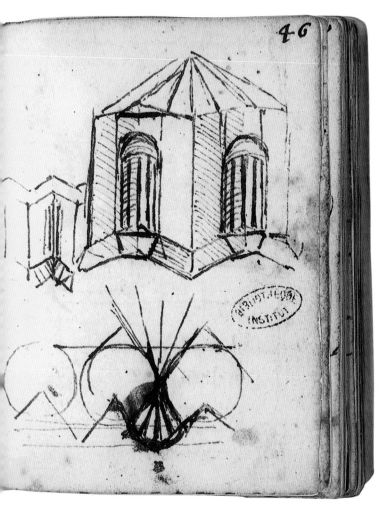

46

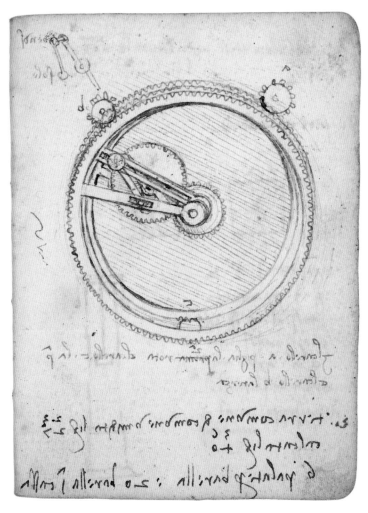

Manuscript M

This small-format notebook (10 x 7cm/4 x 2³/₄in) contains the complete number of 96 pages. It was used from 1495, but the notes are concentrated mainly in the years 1499–1500 and refer in particular to the investigations into geometry and physics that Leonardo made in relation to the classical texts. For geometry, he started from the teachings of Euclid, mediated through those of his friend Luca Pacioli; for physics, he referred to Aristotle. Documenting the development of his scientific knowledge, the notes also reveal Leonard's firm belief that experience is more important than the theories found in books. And so, in various spheres, Leonardo's contributions were founded on his direct observations, in particular of the falling of weights, the falling of liquids and the resistance of the air. In this codex he also studied bridges, designed emblems and drew diagrams of the growth of branches of trees.

On p. 576:
Drawings of trees,
1499;
Paris, Ms M, f. 78v.

On p. 577:
*Diagrams of trees
and part of a branch,*
1499;
Paris, Ms M, f. 79r.

*Studies of column
on beams and wedge,*
1499;
Paris, Ms M, f. 56v.

corno

canolo

urgine

braccia

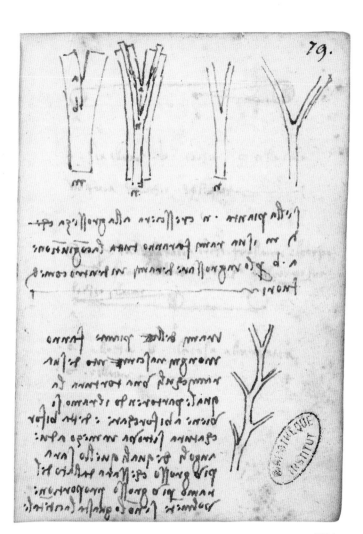

MADRID CODICES

Madrid,
Biblioteca Nacional

These two original manuscripts by Leonardo constitute a recent and surprising rediscovery. They were found in 1966, entirely by chance, in the Biblioteca Nacional of Madrid where they had been languishing for years while all trace of them had been lost. This was due to the erroneous transcription of the marking, so that they no longer matched the number recorded in the inventory. Catalogued for the first time around 1830, they had already been documented 200 years earlier, in Spain, in the possession of Don Juan Espina. This unexpected discovery raised hopes that it may still be possible to find more of the rich legacy left by Leonardo that has been dispersed over the course of time, in particular those manuscripts that were taken by Pompeo Leoni from Italy to Spain in the late 16th century. The two Madrid volumes, bound in red leather, were presented to the King of Spain, and were considered of great value in that they were 'rich in doctrine and curious things'.

Studies for a device
for a hand-operated
elevator,
c. 1495–9;
Madrid I, Ms 8937, f. 9r.

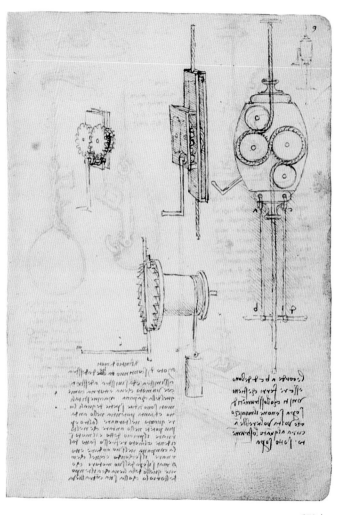

579

Madrid I

It has been estimated that, with the discovery of the two *Madrid Codices*, our knowledge of the whole of Leonardo's original material was augmented by 20 per cent. *Madrid I* must have consisted of 192 pages, eight of which have been missing since, perhaps, the time of Leonardo. The format is 21 x 15cm/8^1/$_2$ x 6in and the notes belong mainly to the years from 1490 to 1499, the last decade spent by Leonardo in Milan at the court of Ludovico il Moro; but the codex also contains some notes from a later period, up to 1508. The first part is entirely dedicated to a description of mechanical devices, especially in the fields of clockwork and hydraulic engineering. In particular, Leonardo represents a series of mechanisms, which he calls 'machine elements', that are basic to the development of more complex devices. Mills, presses and machine tools of various kinds are illustrated. The second part is devoted mainly to notes on the mechanical theory of motion.

Drawings for clockwork mechanisms and notes, c. 1495–9; Madrid I, Ms 8937, f. 14r.

On p. 582:
Clockwork mechanisms: example of drawing in the format of a printed page, c. 1495–9; Madrid I, Ms 8937, f. 27v.

On p. 583:
System of counterweights applied to the arms of a crane, c. 1495–9; Madrid I, Ms 8937, f. 96r.

On pp. 584-585:
Studies of 'machine elements' (levers and springs), c. 1495–9; Madrid I, Ms 8937, ff. 44v. and 45r.

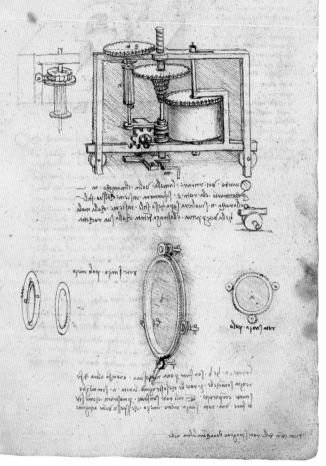

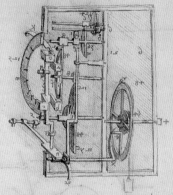

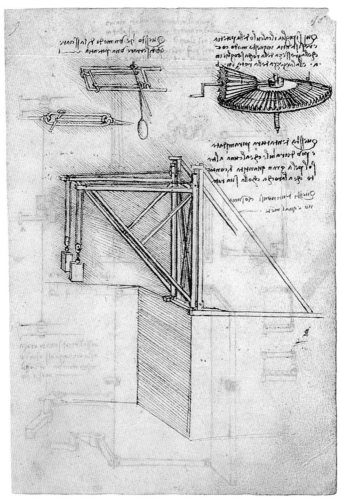

583

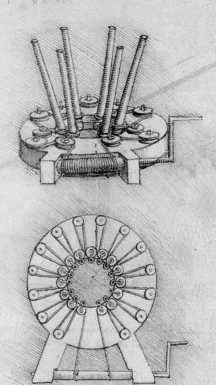

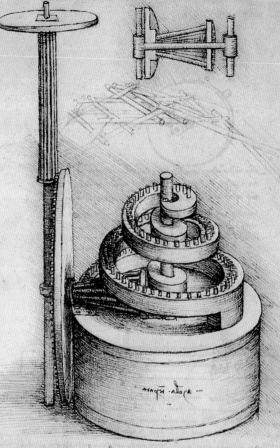

madra alhora

madra ...
..
..
..

On pp. 588–9:
Clock spring and device
for automatic release
of loads; set of linked chains,
c. 1495–9;
Madrid I, Ms 8937,
ff. 9v and 10r.

On p. 590:
'Theatre of Curius',
mobile amphitheatre formed
from two semicircles,
c. 1495–9;
Madrid I, Ms 8937, f. 110r.

Reverse screw
and steering wheel for cart,
c. 1495–9;
Madrid I, Ms 8937, f. 14r.

On p. 591:
Ball bearings,
c. 1495–9;
Madrid I, Ms 8937, f. 20v.

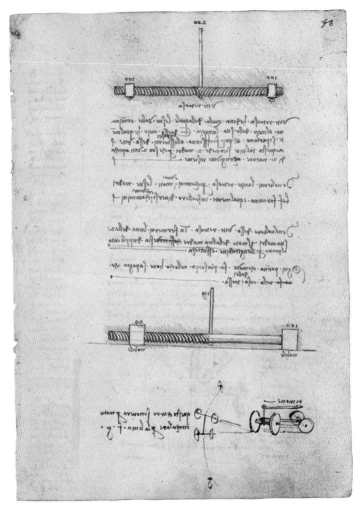

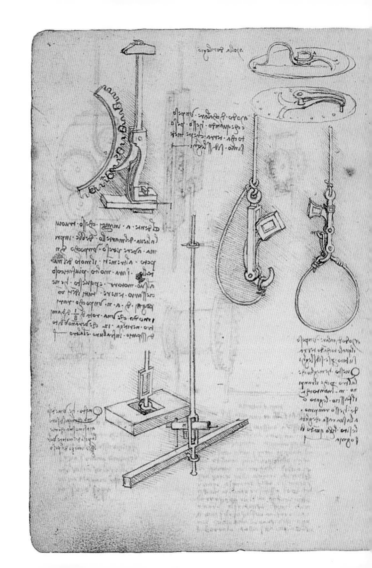

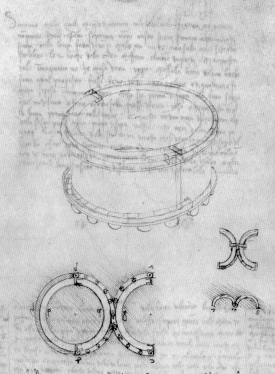

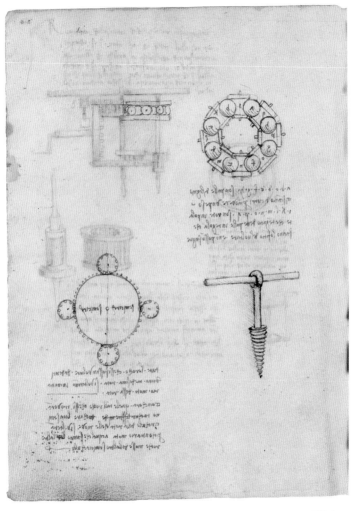

Madrid II

Of the same dimensions as *Madrid I*, the second volume is composed of two different codices, making a total of 157 folios. The first was compiled in the period between 1503 and 1505 and contains significant notes on *The Battle of Anghiari*, on which Leonardo was working during these years. Also linked to Leonardo's work for the Florentine Republic is a project for channelling the waters of the Arno river, which is reflected in the map of Tuscany showing the course of the river from Florence down to Pisa and then to the sea. The pages also contain studies of architecture, stereometry (the study of volume), waves and the flight of birds. The notes on perspective and optics were transcribed in the *Libro di Pittura* ('Book on Painting').

The last part of the volume consists of a notebook datable to 1491–3, when Leonardo was in Milan and was engaged on the project of the equestrian monument to Francesco Sforza. The notes concern the development of techniques for casting the colossal statue.

Frontispiece of
Codex *Madrid II*,
1491;
Madrid, Biblioteca Nacional.

On pp. 594–5:
*Map of Tuscany
(Valdarno)*,
c. 1504;
Madrid II, Ms 8936,
ff. 22v and 23r.

Tratados varios de Forti-
ficacion Estatica
y Geometria
Escritos en Italiano

Por los Años de 1491 como se
vé à la vuelta del fol. 157.

Advirtiendo que la Letra de este
Libro está al reves

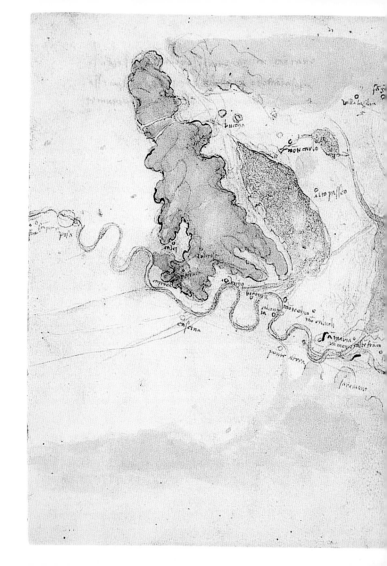

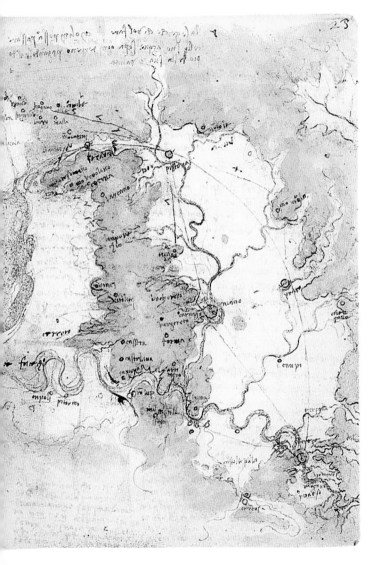

On p. 598:
*Text and sketches
of figures in movement,*
1503–5;
Madrid II, Ms 8936, f. 78v.

On p. 599:
Studies of fortifications,
1503–5;
Madrid II, Ms 8936, f. 79r.

On p. 600:
*Witty remarks and beam
tied with rope,*
1503–5;
Madrid II, Ms 8936, f. 126v.

On p. 601:
Studies of solids,
1503–5;
Madrid II, Ms 8936, f. 127r.

Studies of fortifications,
1503–5;
Madrid II, Ms 8936, f. 37r.

$$\frac{3}{8}$$

CODEX ARUNDEL

**London,
British Museum**

This is not a true codex but a miscellaneous collection, which however, instead of bringing together loose sheets and fragments like the *Codex Atlanticus* and the *Windsor Collection*, consists mainly of a series of sections that have remained intact. The sheets, of different sizes, are mainly in the format 21 x 15cm/18$^1/_2$ x 6in, and number 283 pages in total. The codex was probably put together by Pompeo Leoni and was purchased in Spain in the first half of the 17th century by the great English art collector Thomas Howard, Earl of Arundel. His heirs presented it to the Royal Society and it was in the 19th century that it came to the British Museum. The sections cover a span of time from 1478, during Leonardo's youth in Florence, to 1518, the time of his old age in France. From these last years date the drawings in which Leonardo developed his plans for the residence of the King of France at Romorantin, designing

Breathing apparatus for divers,
1508;
London, Arundel, f. 24v.

a palace complex with gardens, fountains and an artificial lake. In fact, François I was later to build his magnificent new palace at Chambord.

The primary subject of the codex is mathematics, although it deals with a wide range of themes: physics, optics and astronomy as well as notes and personal memorandums. Significant is the tone of the note in which Leonardo, who was 52 at the time and living in Florence, records his father's death: 'On the day of 9 July 1504, a Wednesday, at the 7th hour, died Ser Piero da Vinci, notary at the Palagio del Podestà. My father, at the 7th hour. He was 80 years old. He left 10 sons and 2 daughters.'

In a series of notes Leonardo describes elaborate systems for breathing underwater, but explains why he is refusing to divulge the details of a submarine he has designed; it is due to the 'evil nature of men, who would use them for assassinations underneath the sea ...'

Device for fabricating parabolic mirrors, 1503–5; London, Arundel, f. 87r.

On pp. 606–7: *Studies of staging for Poliziano's 'Orpheus',* c. 1506–8; London, Arundel, ff. 231v and 224r.

On pp. 608–9: *Studies of shadows,* 1510–15; London, Arundel, ff. 246v and 243r.

On pp. 610–11: *Studies of caustics of reflection and device for fabricating parabolic mirrors,* 1503–5; London, Arundel, ff. 86v-87r.

B.M.

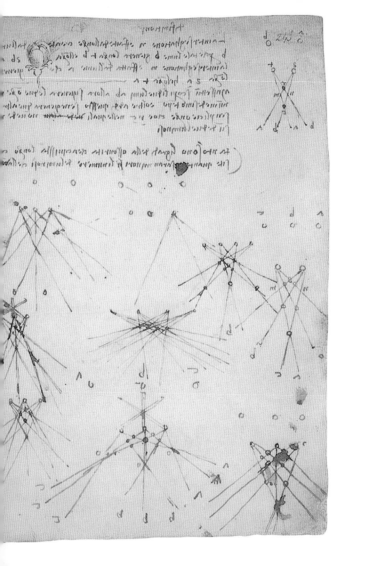

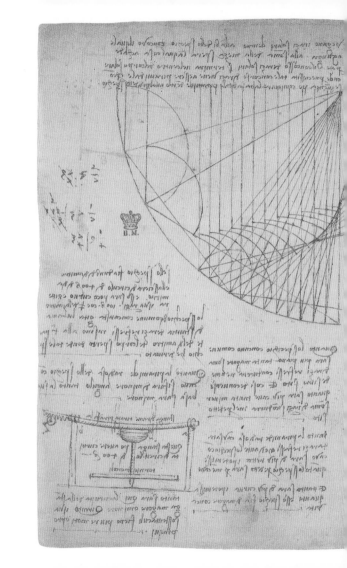

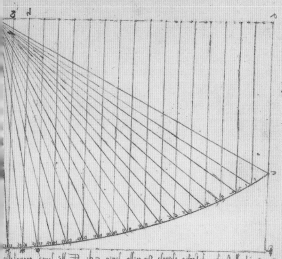

FORSTER CODICES

**London,
Victoria and Albert Museum**

The three *Forster Codices* are small pocket notebooks used by Leonardo at various times in his life. First owned by Pompeo Leoni, after changing hands a number of times they were donated, in the second half of the 19th century, to the Victoria and Albert Museum in London.

Forster I consists of two manuscripts measuring about 14.5 x 10cm/5³/₄ x 4in. The first is datable to 1505, when Leonardo, in Florence, was dedicating himself entirely to studying geometry. It shows a rigorous structure and order rarely found in his writings, and is divided into three sections: plane geometry, solid geometry and transformations of the pyramid. Leonardo was interested in stereometry – the transformation 'of one body into another body without decreasing or augmenting its material'. The authors to whom he referred were Euclid and Luca Pacioli. The second manuscript dates from earlier years, when Leonardo,

*Mechanisms for actuating
hydraulic pumps,
c. 1487–90;
London, Forster I, f. 45v.*

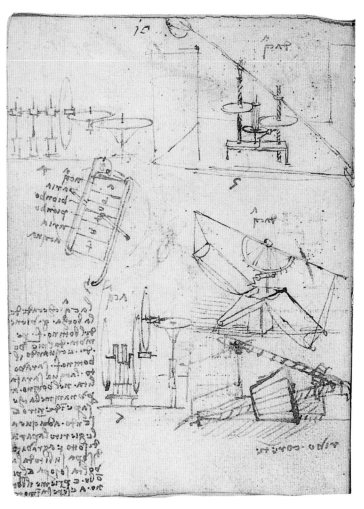

613

in Milan, was engaged in hydraulic engineering projects: Archimedes screws and other devices for lifting water.

Forster II is also composed of two different manuscripts. The format is very small (9.5 x 7cm/3³/₄ x 2³/₄in). The first manuscript, compiled in the years around 1497, contains notes on *The Last Supper*, architectural sketches of Bramante's work in Santa Maria delle Grazie and, always drawn in red chalk, motifs of intertwining plants, figures, portraits, technological and mathematical studies. The second codex dates from two years earlier. In it Leonardo carried out a series of exercises relating to a theoretical treatise on physics, written by him but unfortunately lost.

Forster III is even smaller (9x6cm/3¹/₂ x 2¹/₂in) and dates from a still earlier period (1493–6). In it Leonardo record-ed notes on a vast range of subjects, which are freely inter-mingled and superimposed on the pages.

*Figure of a seated woman
with a child in her lap,
c.* 1497;
London, Forster II, f. 37r.

On pp. 616–17:
*Solid geometry and polyhedrons,
c.* 1505;
London, Forster I, ff. 13r and 13v.

616

Pages and binding
of *Codex Forster II*,
c. 1497; London,
Victoria and Albert Museum,
ff. 62v and 63r.

On pp. 620–1:
*Drawings of hats, ribbons and other
objects for masquerade costumes,*
c. 1493–6;
London, Forster III, ff. 8v and 9r.

18

Codex Hammer (Codex Leicester)

Seattle,
Bill Gates Collection

This codex consists of 36 sheets (18 double sheets) measuring approximately 29.5 x 22cm/12 x 9in, which Leonardo compiled mainly in the years from 1504 to 1506, with some sheets added up to 1510, according to the principle of filling each of the double sheets separately and keeping them one within another as unbound units. It is not known whether Leonardo himself decided to put them together in the form of a bound volume; however, in recent times the sheets have been disassembled and are now kept loose as they were originally. The manuscript is also known as the *Codex Leicester*, from the name of the former owner, the Earl of Leicester, who purchased it in Italy in the early 18th century. It was kept at Holkham Hall in England until 1980, when it was sold at auction to the American oil magnate Armand Hammer. Then in 1994 it was auctioned again, and was purchased by Bill Gates, the present owner, for $30 million. In this codex, dedicated to the theme of

Studies on astronomy
and movements
of the earth's surface,
c. 1506–8;
Seattle, Hammer, f. 1v.

the motion of water, Leonardo investigates the various aspects of whirlpools and currents. The codex also includes astronomical studies on the illumination of the earth, the sun and the moon, with a description of the '*lumen cinereum*' of the new moon, that faint glow emitted by the part in shadow. On the subject of water, Leonardo's geological observations concern its erosive action, the cause of the slow but progressive changes in the surface of the earth, a series of transformations that could bring the earth to be submerged in water again as it was in the beginning, before the land emerged. For his theory Leonardo found confirmation in his discovery of fossils in the mountains, revealing the presence of the sea in primordial ages. The idea of the incessant upheaval and eternal flow of the elements is reflected in the series of *Deluge* drawings, and in the concept pervading the landscape of the *Mona Lisa*; it thus represents a profound synthesis in Leonardo's thought between the science of nature and the science of painting.

On pp. 626–7:
Studies on astronomy
with explanation of the
'lumen cinereum' of the new moon,
c. 1506–8;
Seattle, Hammer, ff. 2r and 35v.

On pp. 628–9:
Page of notes on watercourses
and drawings of obstacles
to deviate the current,
c. 1506–8;
Seattle, Hammer, ff. 13v and 24r.

Experiments with siphons
of various kinds for studies
on communicating vessels,
c. 1506–8;
Seattle, Hammer, f. 34v.

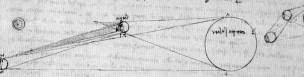

LIBRO DI PITTURA
(BOOK ON PAINTING)

Codice Urbinate lat. 1270
Vatican City, Biblioteca Apostolica Vaticana

This volume was assembled by Francesco Melzi, the pupil to whom Leonardo had left in his will, along with his drawings, 'each and all of the books' in his possession. Melzi, upon returning to his villa at Vaprio d'Adda in the vicinity of Milan, carefully safeguarded his master's legacy for 50 years, until his death in 1570. Moreover, interpreting an intention nourished over the years by Leonardo himself but never carried out, he selected his master's writings on painting for a volume that he intended to publish. But the *Libro di Pittura* was not printed immediately and in the second half of the 16th century it was circulated in incomplete manuscript copies. Only in 1651 did the first printed edition appear in Paris, under the title of *Trattato della pittura di Lionardo da Vinci* ('Treatise on painting by Leonardo da Vinci'), edited by Raphael du Frèsne and printed by

Francesco Melzi,
First page of the *Libro di Pittura,
di M. Lionardo da Vinci. Pittore,*
c. 1530–50;
Vatican City, Biblioteca
Apostolica Vaticana.

.1.

LIBRO DI PITTVRA DI M.
LIONARDO. DA VINCI. PITTORE.

ce scultore fiorentino

Se la pittura e scienha o no

Scienha è detto quel discorso mentale, il qual hà origine da
suoi ultimi principy, o quali in natura nell'altra cosa
si protrouare che sia parte d'essa scienha, come nella quanti-
tà continua, cioè la scientia de Geometria, la quale comin-
ciando dalla superfitie de corpi, si trua hauere origine
nella, linea, termine d'essa superfitie, & in questo non restiamo
satisfatti perche che noi conosciamo la linea hauere termine
nel punto, il punto essere quello, del quale nulla cosa
può essere minore. Adunque il punto è il p.º principio della Geo-
metria; & niuna altra cosa può essere ne in natura ne in
mente humana, che possa dare principio al punto, perche
se tu divisi nel contatto fatto sopra una superfitie da una ulti-
ma acutini della punta de lo stile, quello essere creatione
del punto; questo non è vero, ma diremo, questo tale contatto
essere una superfitie che circonda il suo mezzo, & in esso mez-
zo è la residenha del punto, il qual punto non è della matte-
ria d'essa superfitie, ne lui, ne tutti li punti dell'uniuerso, so-
no in potentia, anchor che sien uniti, dato che si potesse-
ro unire, comporrebbono parte alcuna d'una superfitie e da-
to che tu ce immaginassi un altro essere composto de mille punti
qui ci uidente alcuna parte da essa quantici de mille si
può dire molto bene che cal parte sia eguale al suo tutto e que-
to si proua cel zero ouer nulla cioè la decima figura de la

1270. Vol.

Jacques Langlois. The abundant scientific appendices that accompanied the work consisted of a series of engravings taken from drawings by the famous painter Nicolas Poussin. Contemporaneously, the work was also published in a French translation. This was followed by numerous editions and translations published in other countries, and the treatise became, although always printed in abbreviated versions of the original text, the fundamental reference for the practice and theory of art.

The *Libro di Pittura* is a unique document in that it transmits notes by the hand of Leonardo, transcribed by Melzi, including some from originals that have now been lost. At the end of the volume is an index listing all the manuscripts from which parts have been copied: 'Memorandums and Notes of all of the parts of books by the hand of Leonardo which compose as a whole this book, the *Treatise on Painting*.' The surprising fact is that only some of the codices indicated can be identified with known codices, demonstrating how many documents are missing today. The *Libro di Pittura* is divided into eight sections bearing the titles: 'Of poetry and painting', 'Of precepts for

Study of proportions of the head, from the 'Libro di Pittura', f. 219r, c. 1530–50;
Vatican City, Biblioteca
Apostolica Vaticana.

Scia, sia il lume e la Testa e sara il corpo da quello
aluminato e quella parte d' essa Testa che riceue so
fra di se il razo fra angoli piu eguali sara piu alu

la p.ª
linea 5ie
b — 1.ª
c — 2.ª
d — 3
E — 4.ª
F — 5.ª
G — 6.ª
H — 7.ª
I — 8.ª
K — 9.ª
L — 10.ª
M — 11.ª

-minata e quella parte che riceuera i razi infra
angoli meno eguali fia meno luminosa e fa
questo lume nel suo uficio a similitudine del colpo

the painter', 'Of the various accidents and movements of man and the proportion of members', 'Of draperies and how to dress figures with grace and of the nature of cloths', 'Of shadow and light', 'Of the trees and plants', 'Of the clouds' and 'Of the horizon'. At the beginning, in the so-called *Paragone delle arti*, Leonardo claims the supremacy of the language of painting as compared to that of words, music and sculpture. He then goes on to precepts, and through the following sections, the notes on painting increasingly develop implications linked to scientific aspects. They reveal the central nature assumed by the question asked since the opening paragraph of the *Libro di Pittura* with the title, 'Whether painting is science or not', and demonstrate all the complex meaning that Leonardo assigned to painting, considered as science and philosophy, as 'mental discourse'.

Repertoire of noses,
from the 'Libro di Pittura', f. 108v,
c. 1530–50;
Vatican City, Biblioteca
Apostolica Vaticana.

diritta, La fronte ha, due uarietà, o'che le piana o'che
se' concaua o che le colma, la piana si diuide in due
parti cioe', o'che le' conuessa nella parte disopra, o'che le'
conuessa nella parte disopra sotto, o'ueramente ele con
uessa disopra e'di sotto, o, ueramente piana disopra e'disotto
 del fare una effiggie humana
 inprofilo solo col sguardo d'una l° A. car. 23
 sol uolta —

In questo caso ti bisogna mettere à'mente le uarietà di
di quatro membri diuersi inprofilo, come sarebbe, naso
bocca, mento, e'fronte, diremo prima de nasi li quali
sono di tre sorti, cioe diritto, concauo, e'conuesso, de diritti
non ue altro che quatro uarietà cioe', lungo, corto, alto
con la punta e' basso, i nasi concaui sono di tre sorti

diritto . concauo . quello . e'disopra . e'in mezo . c'disotto . disopra . in mezo . di sotto

de li quali alcuni hanno la concauità nella parte
superiore alcuni nel mezo et altri nella parte inferiore
li nasi conuessi, ancora si uariano in tre modi cioe' alcu
ni hanno il gobbo nella parte disopra, alcuni in mezo
e d'altri nella parte disotto, li sporti che mettono in mezo
il gobbo del naso siuariano in tre modi cioe, o'sono diri-
ti o'sono concaui o'ueramente sono conuessi,

il Gobbo in mezo fra rette il Gobbo in mezo fra curue, il Gobbo in mezo fra
 linee, linee conuesse, linee concaue,
 .L.T.

BIBLIOGRAPHY

GENERAL STUDIES

The enormous bibliography on Leonardo has been collected in the 20 volumes of the *Raccolta vinciana*, founded in Milan in 1905, and in the *Bibliografia vinciana 1493–1930*, edited by E. VERGA (Bologna 1931), supplemented with an article by L. H. HEYDENREICH in the *Zeitschrift für bildende Kunst*, 1935. Also in the bibliographical field is the contribution of A. LORENZI and P. C. MARANI, *Bibliografia Vinciana 1964–1979* (1979–82) and the ten volumes of the yearbook *Achademia Leonardi Vinci* (1988–97).

To Leonardo the architect, L. H. Heydenreich has dedicated a large part of his studies. More recent is the work by C. PEDRETTI, *Leonardo architetto*, Milan 1988. For an overview of Florentine art at the time of Leonardo, see A. CHASTEL, *Arte e Umanesimo a Firenze al tempo di Lorenzo il Magnifico. Studi sul Rinascimento e sull'Umanesimo platonico*, It. trad. Turin 1964. See also: VV. AA., *Leonardo. La pittura*, Florence 1985; P. C. MARANI, *Il Cenacolo di Leonardo*, Milan 1986; P. C. MARANI, *Leonardo. Catalogo completo dei dipinti*, Florence 1989; J. SHELL, *Leonardo*, London–Paris 1992; M. CIANCHI, *Leonardo*, Florence 1996; VV. AA., *Leonardo. Il Cenacolo*, Milan 1999; C. PEDRETTI, *Leonardo. The machines*, Florence 1999; VV. AA., *Leonardo. Art and science*, Florence 2000; D. LAURENZA, *Leonardo. On Flight*, Florence 2004; D. LAURENZA, M. TADDEI and E. ZANON, *Le Macchine di Leonardo*, Florence 2005.

For publications of popular nature, but of high level, see the numerous articles in the review *Art e Dossier*:

C. PEDRETTI, A. CHASTEL and P. GALLUZZI, *Leonardo*, no. 12, April 1987; C. PEDRETTI, *Leonardo. Il disegno*, no. 67, April 1992; C. PEDRETTI and M. CIANCHI, *Leonardo. I Codici*, no. 100, April 1995; C. PEDRETTI, *Leonardo. The portrait*, no. 138, October 1998; C. PEDRETTI, *Leonardo. Il Cenacolo*, no. 146, June 1999; P. C. MARANI, *La Gioconda* (with introductory text by C. PEDRETTI, 'Gioconda in volo'), no. 189, May 2003; C. PEDRETTI, D. LAURENZA and P. SALVI, *Leonardo. L'anatomia*, 207, January 2005; C. PEDRETTI, *Leonardo. La pittura*, now being published.

Noteworthy among monographs dedicated to Leonardo in his historical, artistic and cultural context are: C. PEDRETTI, *Leonardo. A Study in Chronology and Style*, London 1973 (2nd ed. New York 1982); M. KEMP, *Leonardo da Vinci. The Marvellous Works of*

Nature and Man, London 1981; D. ARASSE, *Léonard de Vinci. Le rythme du monde*, Paris 1997; C. VECCE, *Leonardo*, presentation by C. Pedretti, Rome 1998; P. C. MARANI, *Leonardo. Una carriera di pittore*, Milan 1999.

STUDIES ON PAINTING

On Leonardo the painter:

Fundamental is the book by K. CLARK, *Leonardo da Vinci. An Account of his Development as an Artist*, London 1939 (2nd ed. 1952) with essential bibliography. The publications are analysed in the *Bibliografia Vinciana 1493–1930* edited by E. VERGA, Bologna 1931; and the listing in E. VERGA, *Gli studi intorno a Leonardo da Vinci dell'ultimo cinquantennio*, 1882–1922, Rome 1924. See also the contribution of G. CASTELFRANCO, 'Momenti della recente critica vinciana', in the volume by VV. AA., *Leonardo. Saggi e ricerche*, Rome 1954, pp. 415–17; G. CASTELFRANCO, *La pittura di Leonardo*, Milan 1980, and on Leonardo in relation to his collaborators and followers, see W. SUIDA, *Leonardo und sein Kreis*, Munich 1929, re-edited with commentary and updating by M. T. FIORIO.

On Leonardo's technique:

M. HOURS, 'Étude analytique des tableaux de Léonard de Vinci au Laboratoire du Musée du Louvre', in *Leonardo. Saggi e ricerche*, edited by G. CASTELFRANCO, Rome 1954, pp. 14–26; *Leonardo da Vinci. Libro di Pittura*, edited by C. PEDRETTI, critical transcription by C. VECCE, Florence 1995; B. FABJAN and P. C. MARANI, *Leonardo. La Dama con l'ermellino*, Cinisello Balsamo 1998; P. C. MARANI, 'Il problema della 'bottega' di Leonardo: la 'praticha' e la trasmissione delle idee di Leonardo sull'arte e la pittura', in *I Leonardeschi. L'eredità di Leonardo in Lombardia*, Milan 1998, pp. 9–37.

On *The Last Supper*:

L. H. HEYDENREICH, *Invito a Leonardo. L'Ultima Cena*, Milan 1982; C. BERTELLI, 'Il Cenacolo vinciano', in *Santa Maria delle Grazie a Milan*, Milan 1983; P. BRAMBILLA BARCILON and P. C. MARAN, *Leonardo. L'Ultima Cena*, Milan 1999.

On the *Mona Lisa*:

R. LONGHI, 'Le due Lise', in *La Voce*, a. VI, 1, 1914, pp. 21–5, now in *Opere complete di Roberto Longhi. Scritti giovanili*, 1912–1922, Florence 1961, pp. 129–32; M. SÉRULLAZ, *La Joconde. Léonard de Vinci*, Paris 1947; C. DE TOLNAY, 'Remarques sur la Joconde', in *Revue des Arts*, 2, 1952, pp. 18–26; K. D. KEELE, 'The Genesis of Mona Lisa', in *Journal of the History of Medicine and Allied Sciences*, vol. 14, 2, April 1959; K. CLARK, 'Mona Lisa', in *The Burlington Magazine*, vol. CXV, 840, 1973, pp. 144–50; R. HUYGHE, *La Joconde*, Frieburg 1974; F. BERDINI, *La Gioconda chi è*, Rome 1989; C. STARNAZZI, *Il paesaggio della Gioconda*, Arezzo 1993; F. ZÖLLNER, 'Leonardo's Portrait of Mona Lisa del Giocondo',

in *Gazette des Beaux-arts*, 1490, March 1993, pp. 115–38; C. STARNAZZI, 'La Gioconda nella Valle dell'Arno', in *Archeologia viva*, XV, 58, March–June 1996; C. SCAILLIÉREZ, *La Joconde*, Paris 2003.

For interpretations of the *Mona Lisa*:
A. C. COPPIER, 'La "Joconde" est-elle le portrait de Mona Lisa?', in *Les Arts*, January 1914, pp. 2–9; A. VENTURI, in *Storia dell'arte italiana. La pittura del Rinascimento*, vol. IX, part I, Milan 1925; H. TANAKA, 'Leonardo's Isabella d'Este. A New Analysis of the Mona Lisa in the Louvre', in *Annuario dell'Istituto Giapponese di Cultura in Rome*, 13 (1976–1977), 1977, pp. 23–35; D. A. BROWN and K. OBERHUBER, 'Monna Vanna and Fornarina. Leonardo and Raphael in Rome', in *Essays Presented to M. P. Gilmore*, edited by S. BERTELLI and G. RAMAKUS, Florence 1978, pp. 25–86; D. STRONG, 'The Triumph of Mona Lisa. Science and the Allegory of Time', in *Leonardo e l'età della ragione*, edited by E. BELLONE and P. ROSSI, Milan 1982, pp. 255–78; C. VECCE, 'La Gualanda', in *Achademia Leonardi Vinci. Journal of Leonardo Studies and Bibliography of Vinciana*, vol. III, 1990, pp. 51–72.

STUDIES ON DRAWINGS
The first study of Leonardo's drawings with an annotated catalogue was by B. BERENSON, *The Drawings of the Florentine Painters*, London 1906, extended and revised in the subsequent editions published in Chicago (1938) and in Milan (1961).

Fundamental are the studies of A. E. POPP, *Leonardo Zeichnungen* (1928), recovered by K. CLARK in his catalogue of the Windsor collection, published in Cambridge (1935), revised and extended with the assistance of C. Pedretti (London 1968–9). Clark also had the idea of cataloguing all of Leonardo's drawings, an idea realized by A. E. POPHAM, *The Drawings of Leonardo da Vinci*, London 1946.

From 1957 are the contributions of C. PEDRETTI: *Leonardo da Vinci. Fragments at Windsor Castle from the Codex Atlanticus*, London 1957; the catalogue of the folios in the *Codex Atlanticus* after its restoration (Florence and New York 1978–9), and the facsimile edition of the Windsor archive, of which the following have already been published: the *corpus* of the *Anatomical Studies* (1978–9), that of the *Studies on Nature* (1982) and that of *Studies on the Horse* (1984), a programme carried out in an Italian edition by Giunti Editore, Florence, which has also published the series of catalogues of exhibitions of the aforesaid Windsor archives edited by C. PEDRETTI.

Specific is the catalogue: *Studi per il Cenacolo dalla Biblioteca Reale nel Castello di Windsor*, edited by C. PEDRETTI, Milan 1983.

To these works should now be added the series edited by the same author, which presents in facsimile the widely

dispersed drawings of Leonardo and his school found today in various archives: those of Florence and Turin have already been published (Florence 1984 and 1990).

STUDIES ON THE CODICES

Useful compendiums and texts on the content and the dates of the individual codices and manuscript folios dispersed in various collections can be found in the anthology in two volumes by J.-P. RICHTER, *The Literary Works of Leonardo da Vinci*, London 1883 and Oxford 1939, updated by another two volumes by C. PEDRETTI, *Commentary*, Oxford 1977. Specialized studies of the codices exist, such as the one by G. CALVI, *I manoscritti di Leonardo da Vinci dal punto di vista cronologico, storico e biografico*, Bologna 1925, while the often adventurous aspects of their history have been described by several scholars on various occasions, especially in the introductions to the facsimile editions, for which reference should be made to the above-mentioned *Bibliografia* by E. VERGA.

A contextual view of the nature and vicissitudes of the codices is found in the fundamental contribution of A. MARINONI, 'I manoscritti di Leonardo da Vinci e le loro edizioni', in *Leonardo. Saggi e ricerche*, Rome 1954, pp. 229–63. Marinoni has also been entrusted with the monumental edition of the *Codex Atlanticus*, the manuscripts of the Institut de France and other codices reproduced in facsimile by Giunti Editore in the *Edizione Nazionale delle opere di Leonardo*.

Two important contributions from abroad have been made by the Elmer Belt Library of Vinciana at the University of California at Los Angeles: E. BELT and K. T. STEINITZ, *Manuscripts of Leonardo da Vinci. Their History, with a Description of the Manuscript Editions in Facsimile*, Los Angeles 1948 and K. T. STEINITZ, *Bibliography of Leonardo da Vinci's Treatise on Painting*, Copenhagen 1958. A review of the codices containing studies on architecture is found in a book by C. PEDRETTI, *Leonardo da Vinci. The Royal Palace at Romorantin*, Cambridge (Massachusetts) 1972, pp. 138–47.

The first document on the dispersal of Leonardo's papers kept in the 16th century at Villa Melzi in Vaprio d'Adda is the *Memorie di don Ambrogio Mazenta* published in critical form and with facsimile by L. GRAMATICA in 1919.

For the history of the manuscripts prior to their dispersal, and thus many hitherto unknown aspects of the diffusion of Leonardo's ideas, see the introduction to the edition by C. PEDRETTI and C. VECCE of the *Libro di Pittura*, compiled on the basis of Leonardo's manuscripts by his pupil and heir Francesco Melzi, reproduced for the first time in facsimile in the Vincian editorial programme of the publisher Giunti Editore (1995).